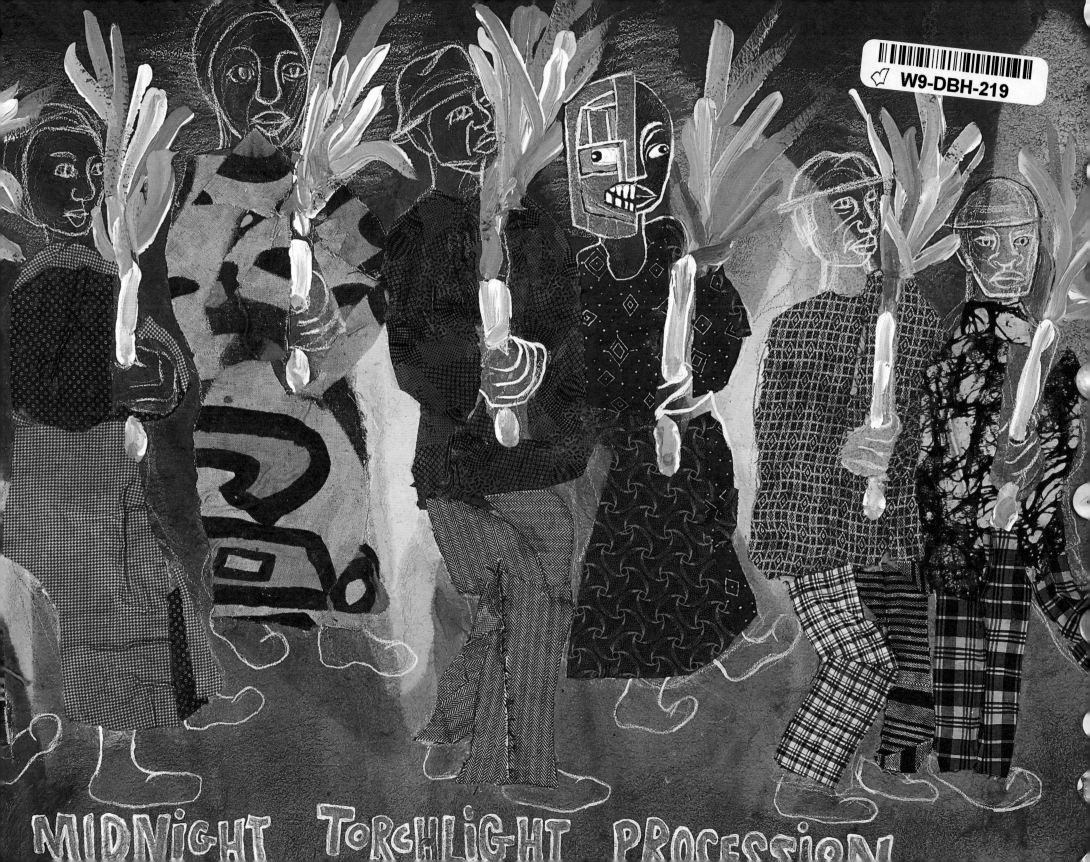

MIDNIGHT TORCHLIGHT PROCESSION

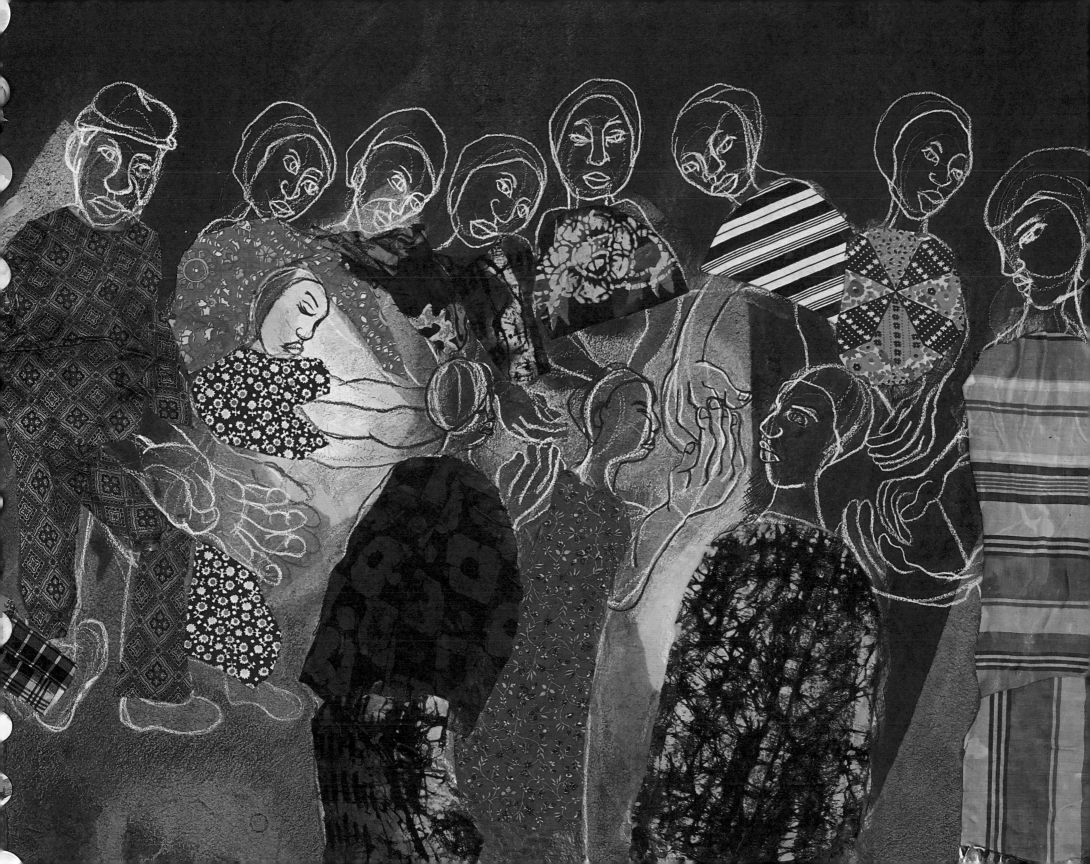

# RAGGIN' ON

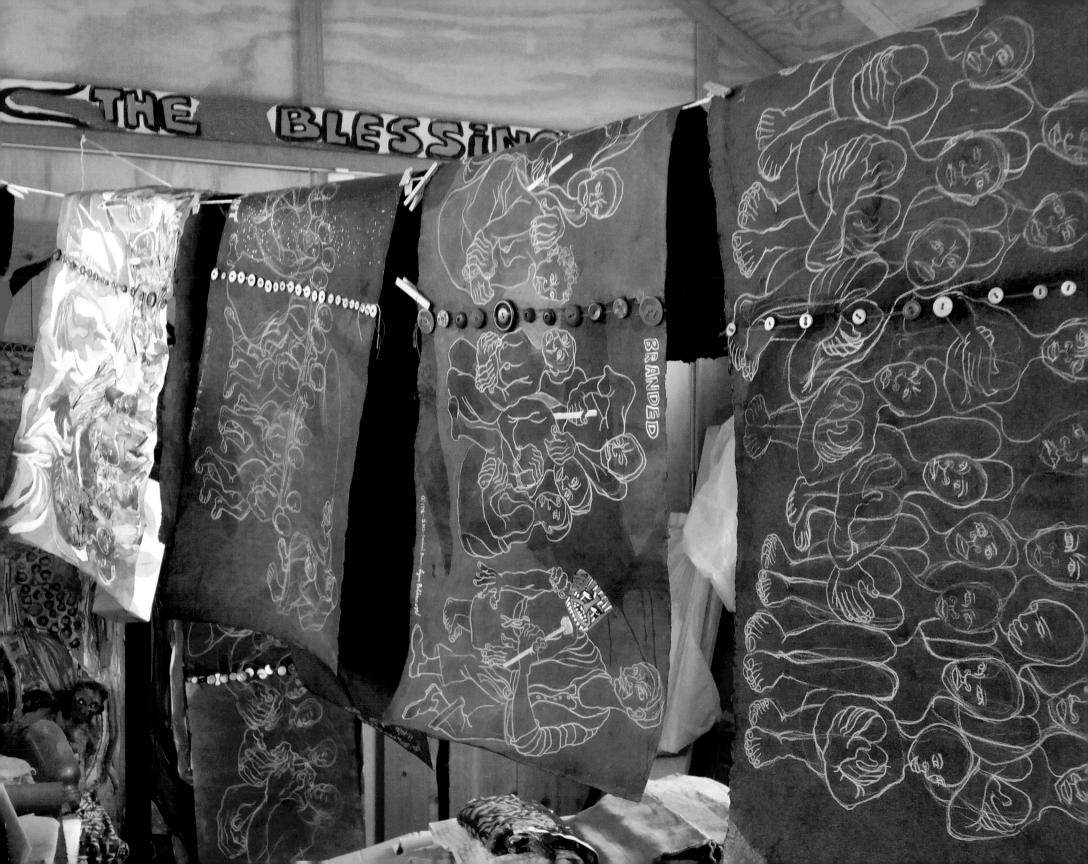

# RAGGIN' ON

## The Art of Aminah Brenda Lynn Robinson's House and Journals

**Edited by**
Carole M. Genshaft

**Essays by**
Ramona Austin
Lisa Gail Collins
Lisa Farrington
Carole M. Genshaft
Deidre Hamlar
Nannette V. Maciejunes
William "Ted" McDaniel
Debra Priestly

**Columbus Museum of Art**
Columbus, Ohio

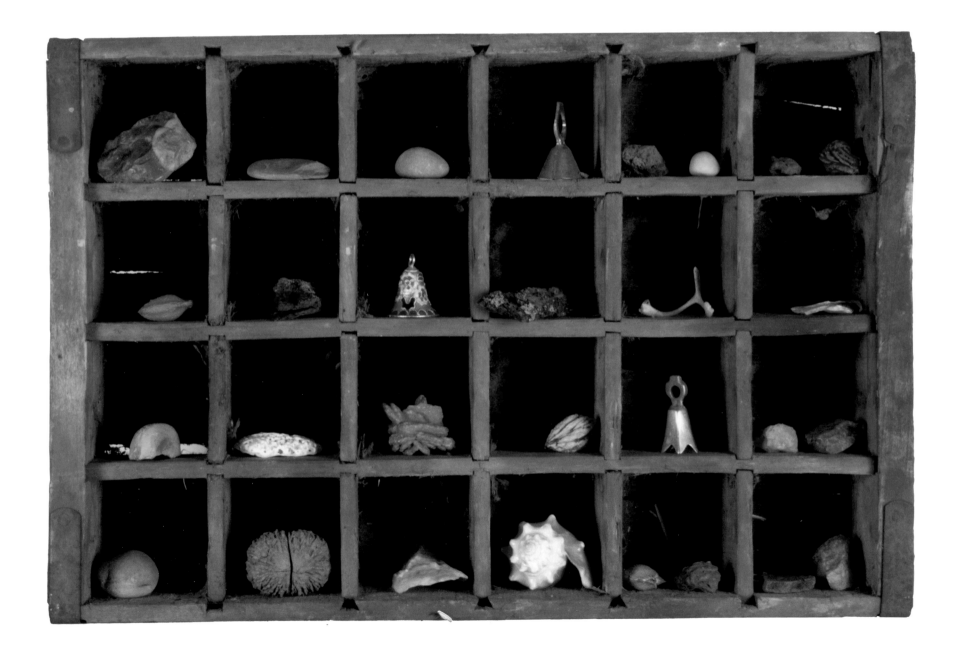

# Contents

**Curators' Introduction and Acknowledgments**

9    Carole M. Genshaft and Deidre Hamlar

**Aminah and the Museum**

13    Nannette V. Maciejunes

SECTION I

## AMINAH'S HOUSE

**Sacred Sanctuary**

21    Deidre Hamlar

**Stay on the Path**

27    Debra Priestly

SECTION II

## AMINAH'S JOURNALS

**Songs from the Ocean**
*The Journals and Memoirs*

35    Carole M. Genshaft

SECTION III

## AMINAH'S ART

**Passing On What Was Handed Down**
*The Gifts of Aminah*
*Brenda Lynn Robinson*

51    Lisa Gail Collins

***Sankofa* and Contemporary Art**

59    Lisa Farrington

**Aminah's Music**

69    William "Ted" McDaniel

**A Song of Being**
*Challenges of the Art*
*of Aminah Robinson*

73    Ramona Austin

SECTION IV

## PORTFOLIO

80    Home as Sanctuary

98    Beginnings

110    Street Cries

126    Ancestral Voices: From Bondage to Freedom

158    Raggin' On: A Clutch of Blossoms The Circus Journeys

184    Journals, Texts, and Music

202    Material Matters

218    Chronology

227    Glossary

228    Credits

230    Contributors

232    Index

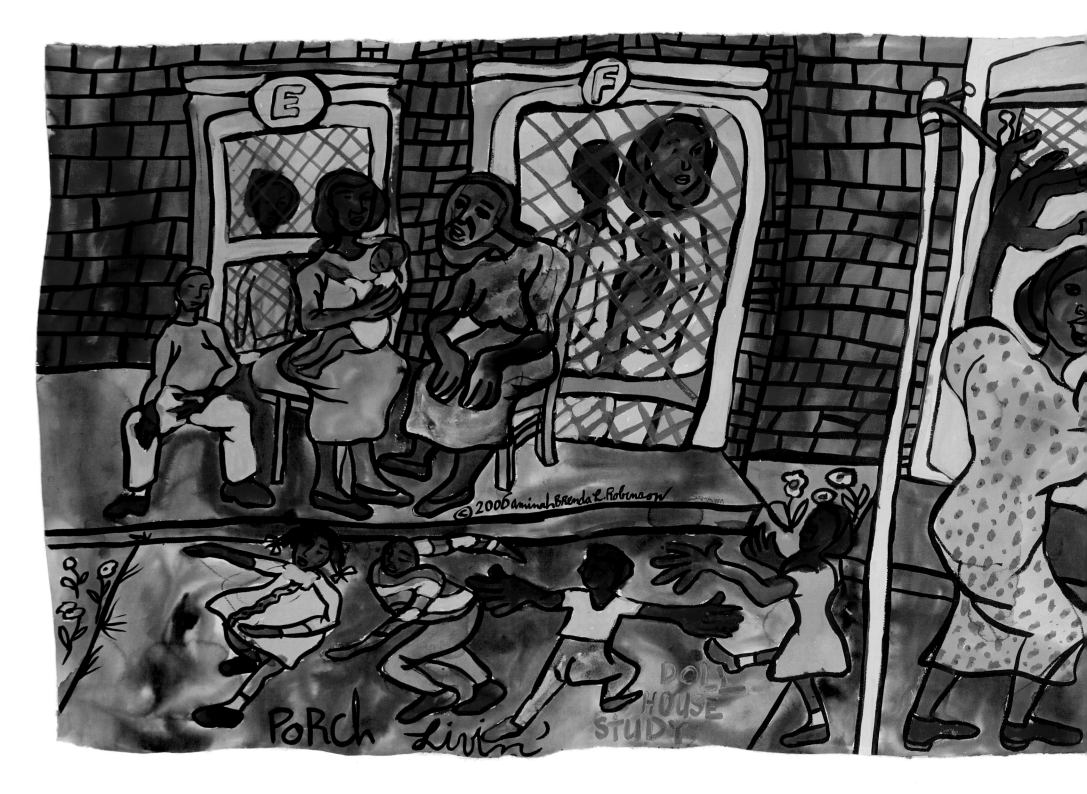

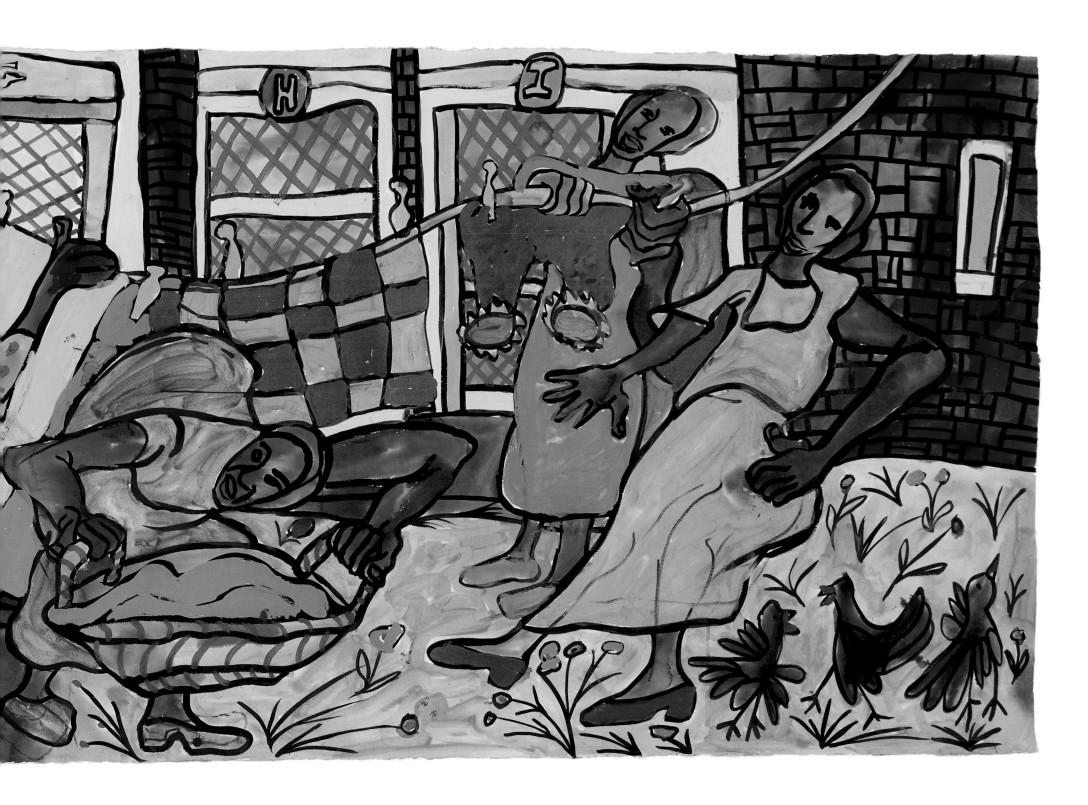

# Curators' Introduction and Acknowledgments

Carole M. Genshaft and Deidre Hamlar

WHEN Aminah Brenda Lynn Robinson died in 2015 and entrusted her estate to the Columbus Museum of Art, Museum staff soon realized the enormity of assessing and organizing the art and other contents of her Sunbury Road home. What became apparent as we worked was the prodigious amount of Aminah's writing: poetry and prose in journals; illustrated historical and biographical texts she called "Sacred Manuscript Pages"; notations in the books in her extensive library; and endless file folders of handwritten research. We knew the art, the house and its furnishings, and the writings would constitute a compelling major exhibition and book.

*Raggin' On: The Art of Aminah Brenda Lynn Robinson's House and Journals* is an invitation to you to "enter" Aminah's house and engage with the art and journals we have documented during the last five years. Because Aminah believed in the concept of "raggin' on"— that her art and writing never end because the next viewer or reader adds new perspectives—we chose that title for this exhibition in the hopes that you, too, will contribute your perspectives and ensure her work never ends. We chose the cover image for the book because it represents the *Themba* series that consumed Aminah for many years until the end of her life; it captures in dramatic fashion the complexity of both her own hopeful spirit and an inner passion that propelled her to write and make art.

## Essays

We have engaged excellent writers to explore Aminah's art: Nannette V. Maciejunes, Debra Priestly, Ramona Austin, and we curators had the privilege of knowing Aminah well for many years. Art historians Lisa Gail Collins and Lisa Farrington took this opportunity to study Aminah's work in depth for the first time, as did music scholar William "Ted" McDaniel.

In her essay, Columbus Museum of Art Executive Director Maciejunes provides a personal account of the warm relationship Aminah and the Museum shared for six decades, and how this relationship led the artist to entrust her legacy to the Museum. Deidre Hamlar's observations about Aminah's home provide an overview of the physical space made sacred by the artist and introduce the concept of Aminah's home as her muse. In describing her personal relationship with the artist, Debra Priestly reveals the inspirational mentorship Robinson provided, her fun-loving nature, and her spirited sense of humor. Carole Genshaft's "Songs from the Ocean" introduces themes that emerge from the prose, poetry, and drawings from more than 125 of Aminah's journals.

Lisa Gail Collins captures the essence of Aminah's childhood and family and how those early influences impacted the artist she became. Collins also emphasizes the connections in style, subject matter, and process that Aminah shares with legendary masters Jacob Lawrence, Romare Bearden, and Faith Ringgold. Lisa Farrington's essay places Robinson squarely in the academy among sophisticated, politically and socially engaged contemporary artists such as Xaviera Simmons, Kerry James Marshall, and Kara Walker; and she compares Robinson's exalting tributes to women to the sensitive portrayals by feminist artist Emma Amos. Music scholar William "Ted" McDaniel asserts Aminah's seemingly unusual departure into music is anything but that. Rather, he considers her the architect of another new art form:

OPPOSITE: Carole Genshaft and Deidre Hamlar Co-Curators of *Raggin' On*

multilayered music compositions intended to create art with music through her own notational system.

Ramona Austin presents a final, thoughtful essay that sets the stage for future scholarship about Aminah and her contribution to African American cultural expression. Austin explores the spiritual aspect of Aminah's work and her ability to find inspiration in sources ranging from the drawings of Leonardo da Vinci to African ancestral tales.

## Portfolio

Based on work from her house and related art from the Museum's collection, the portfolio plates reflect the sections of the exhibition:

- "Home as Sanctuary" captures the sacredness of Robinson's home in the Shepard neighborhood of Columbus, Ohio.

- "Beginnings" presents the remarkable work Robinson created as a child, an art student, and young adult.

- "Street Cries" documents both the lively spirit and the nagging poverty of the neighborhoods where Robinson lived.

- "Ancestral Voices: From Bondage to Freedom" is Robinson's depiction of African and African American history based on extensive reading, research, and the narratives of her elders.

- "Raggin' On" showcases Robinson's ongoing series: proud, strong "no-nonsense" women; the integrated world of the Sellsville Circus; and her travels to South America, the Middle East, and Europe.

- "Journals, Texts, and Music" featuring pages of Robinson's writings, often illustrated with pen and ink drawings and watercolors, provide insight into the artist's motivations and creative process.

- "Material Matters" celebrates Robinson's ingenious use of natural substances and manufactured objects in two- and three-dimensional work.

## Acknowledgments

This exhibition marks important milestones in the larger Aminah Robinson Legacy Project that the Museum has undertaken and is the result of five years of demanding work by dedicated staff and volunteers. We have many people to thank. At the helm is the Museum's executive director Nannette V. Maciejunes, whose enthusiastic leadership and professional support led the way. Deputy Director of Operations and Chief Registrar Rod Bouc did much of the heavy lifting—literally—and the organization and packing of materials in the house, as well as their transport to storage. Interns Luke Hester and Max Strauss served as able assistants. Photographers Heather Maciejunes, Alan Geho, and museum staff captured pictures of the house as Aminah left it in 2015, and Geho and Kara Gut photographed Aminah's art for this publication.

Exhibition Designer Greg Jones, Design and Production Assistant Tess Webster, and Preparators David Holm and Cameron Sharp worked tirelessly to achieve the goal of creating the ambiance of Robinson's home in the galleries and spotlighting each work of art. Their artistry is evident in every facet of the exhibition's design: signage and text, lighting, framing, and casework. Associate Registrar of Exhibitions Nicole Rome was instrumental in developing the database to insure documentation of the art, in arranging photography for publication, and in insuring the storage and care of each object. Elizabeth Hopkin brought her skills as a thoughtful editor to shepherding this catalogue and meeting deadlines for essays and illustrations throughout the process. Curatorial assistant Jordan Spencer assisted with publication details. The Seattle firm of Lucia|Marquand partnered with us to design and print this publication; Director Stephanie Williams of Ohio University Press arranged distribution of the book. We are grateful to the National Endowment for the Arts for supporting the exhibition. Registrar of Exhibitions Jennifer Seeds kept track of the budget. Pam Edwards, director of retail operations, worked with her team to create Aminah Robinson treasures for the Museum Store.

Creative Producer Jeff Sims's videotaping of those who knew Robinson well is the basis of the Conversations section of the exhibition. We appreciate the time and

willingness of those we interviewed to contribute a wide variety of recollections and perspectives about Robinson and her work: Loann Crane, Carol Wilkerson, Bing Davis, Gisela Josenhans, Robert Hawkins, Diedre Herd, Debbie Ubamadu, Baba Shongo, Bettye Stull, Barbara Nicholson, Wayne Lawson, Michael Rosen, Robert and Maureen Black, Ron and Cynthia Thompson, Sue Cooper, Carol James, Elwood and Jean Rayford, Ricki Rosen, Queen Brooks, Suzy Saxbe, Judy Garel, Vesta Daniel, Annette Tucker, Angela Tucker McCaleb, Mim Chenfeld, Toni Smith, Marlana Keynes, and Annegreth Nill. Nill's essay in the 2002 *Symphonic Poem* catalogue provided solid foundational research for each of the writers in this book. DeLynn MacQueen shared her memories and photographs of her trip to Peru with Robinson in 2006. Dr. Kellie Jones, professor in art history and archaeology at the Institute for Research in African American Studies (IRAAS) at Columbia University, shared her insights and helped steer us toward contributors to the catalogue. We value our warm and collegial relationship with Marlana Keynes, Laura Savage, Chet Domitz, and Nicolette Swift of Hammond Harkins Galleries (Columbus); and Dorian Bergen, Jeffrey Bergen, and Mikaela Lamarche of ACA Galleries (New York). All of these individuals care deeply about Robinson and her legacy and have been helpful to us in documenting her work.

Cindy Foley, Hannah Mason-Macklin, and the Learning Team worked to provide visitor activities and text that bring together visitors and the art. Lucy Ackley and her development team of Maureen Carroll, Betsy Meacham, Tiffany Duncan, and their assistants helped raise funding for the exhibition and arrange a variety of openings and events for members. Manager for Community Engagement Lauren Emond partnered with citywide organizations to plan a "Block Party." Docents under the direction of Stephanie Samera provided discussions and tours for hundreds of visitors. Our Marketing and Communications team of Melissa Ferguson, Jennifer Poleon, and Jenny Fong were responsible for communicating the excitement and importance of the exhibition. Since Robinson's home became the Museum's responsibility, Dave Leach, Director of Facilities, helped maintain the property.

We are indebted to Gallery Associates under the leadership of Mindy Galik: Bryan Moss, Amber Nagy, Kaycee Moore, Nicholas Schukay, Lauren Jones, Okell Lee, and Alison Kennedy. This team helped photograph and document the work from the house. Also essential were interns Jenina Brown, Katrina Arndt, Alayna Smith, Asia Adomanis, Sharbreon Plummer, and Amanda Grace Finkel. CCAD student Grace Oller began as an intern and then joined the project as an exhibition assistant.

In 2016, the Museum organized a community committee to discuss the future of Robinson's home. This committee, along with the Museum's Board of Trustees, voted unanimously to create an artist residency based in the house. Members of the committee chaired by Barbara Nicholson and Bettye Stull included David Barker, Queen Brooks, Sue Cooper, Carol James, Tom Katzenmeyer, Wayne Lawson, Michael Martz, Gene Smith, Toni Smith, and Carol Wilkerson. In partnership with the Greater Columbus Arts Council under the guidance of Tom Katzenmeyer, the Aminah Robinson Residency was established. We thank Wayne Lawson for connecting us with the Alliance of Artist Communities, a national organization of artist residencies, and for bringing its director, Lisa Hoffman, to consult with the committee. With leadership from Larry James and the Columbus Foundation, public and private funds to renovate and maintain the house were raised, and the Columbus Association for the Performing Arts agreed to help manage the property. Aaron McDaniel of Blueprint Investments was responsible for the renovations with Mark and Mindy Corna as consultants for the project. Brenda Parker of The Columbus Architectural Studio served as architect. Architectural fees were underwritten by Moody Nolan, Columbus. Lindsay Jones and her team at Blind Eye Restoration expertly restored the mosaic Robinson had created in the kitchen. The residency, funded in part by Loann Crane, welcomed its first artist in 2021.

We thank all those who have made the exhibition and catalogue possible. In her work and her life, Robinson constantly acknowledged the importance of family and community. We cannot stress enough gratitude to our Museum family and the extensive community who together have brought this project to fruition.

# Aminah and the Museum

Nannette V. Maciejunes

Executive Director and CEO, Columbus Museum of Art

. . . and somehow we manage to know that truth speakers are timeless.
Timeless beginnings. Timeless endings. The presence, knocking at the door.
Take my hand.

—Aminah Brenda Lynn Robinson

THE Columbus Museum of Art and I were most fortunate to have enjoyed a continuous relationship with Aminah Robinson over several decades. She was an intelligent, talented, observant, and caring artist—and knowing her was a singular and extraordinary experience. Such relationships provide an unparalleled depth of knowledge, understanding, and insight into an artist's practice. Such relationships can also prove daunting, particularly for an artist's hometown museum. Long-term relationships, by their nature, are complex. Artists and their work evolve over time, as do museums. An alliance that seemed quite natural early on may become strained. On the other hand, what began as a relationship of convenience may deepen into a remarkable bond; and this is what developed between Aminah Robinson and the Columbus Museum of Art.

Aminah was born and raised on Columbus's east side, not far from what was then the Columbus Gallery of Fine Arts (today the Columbus Museum of Art). We do not know when Aminah first walked through the Museum's doors, but she proudly remembered that a poster she had created as an East High School student was included in a group show at the Museum. While still in high school, she also took art classes just steps from the Museum, at the Saturday School of the Columbus Art School (now the Columbus College of Art and Design). After high school, she became a full-time student there. At the time Aminah attended, the Museum and the Art School were a single organization; the Museum's galleries were part of students' education. I wish we could take credit for introducing Aminah to her first artist-heroes, such as Leonardo da Vinci, of whom she recounted, "I love him. His work talks to my soul. Always has." Another hero was Rembrandt. Although the Museum's collection includes Rembrandt prints, Aminah's association with the two Old Masters must have come through books. She recalled, "I lived in art and books, and it was at this time something seemed to click."[1]

In 1964, Aminah married a serviceman, and for several years they lived the peripatetic life of a military family. In 1971, Aminah returned permanently to Columbus and in 1980, was legally divorced. Once again, the neighborhood surrounding the art school and the Museum drew her attention. This time, however, the allure included Elijah Pierce's barbershop, which was located on East Long Street, only one block from the Museum. As her friendship with Mr. Pierce deepened, she would spend countless hours at his barbershop talking with him and drawing, sometimes drawing images for his folk-art carvings at his request. A kindred friendship between the two would leave a profound impression on Aminah's perspective as an artist and chart a course for her future work (fig. 1). "Not only was Mr. Pierce my friend and mentor," she

OPPOSITE: Aminah Robinson in Derby Court at the Columbus Museum of Art, 2000s

recalled, "but he was also my spiritual counselor. Our friendship was a very special friendship . . . the barbershop became a meeting place. A praise house. A holy place."[2] But it wasn't just the barbershop that made the neighborhood special to Aminah:

> At Broad Street and Washington Avenue is the Columbus Museum of Art. . . . Behind the Museum is the art school of 113 years. Across the street, at 90 North Washington Avenue, was the Kojo Photo Art Studio. . . . Kojo Kamau, owner and manager, began to give African-American artists an opportunity to exhibit their art and give poetry readings. But most of all, the studio assisted artists to go to Africa to study. During the four years of the art studio, Kojo Kamau kept a permanent exhibit space of Mr. Pierce's carvings (fig. 2).[3]

During these same years, Elijah Pierce began to receive attention in the broader folk-art world beyond Columbus, and the Museum began to acquire his work. In 1973, we held the first of many exhibitions of his carvings. Our relationship with Mr. Pierce—he always was Mr. Pierce to me—drew us ever closer to Aminah. To accompany a 1993 retrospective, the Museum published a major, multi-authored monograph, a watershed moment in scholarship on the artist. Aminah was one of the authors. She wrote a warm personal tribute to her friend and mentor.

As a long-time art instructor who held a deep commitment to nurturing young students, Aminah also helped the Museum design *Create-An-Ark,* an original school program about Mr. Pierce. School classes, whose projects were showcased at the Museum during the retrospective, received a visit from Aminah to discuss the works that they had created, as well as to learn more about Elijah Pierce (fig. 3). Although Aminah and the Museum no doubt would have found one another regardless, I always have believed that our relationship with Aminah was fostered by our journey with Elijah Pierce.

By the time of this Pierce retrospective, the Museum had already acquired its first works by Aminah. These were gifts, some from Aminah herself, including a series

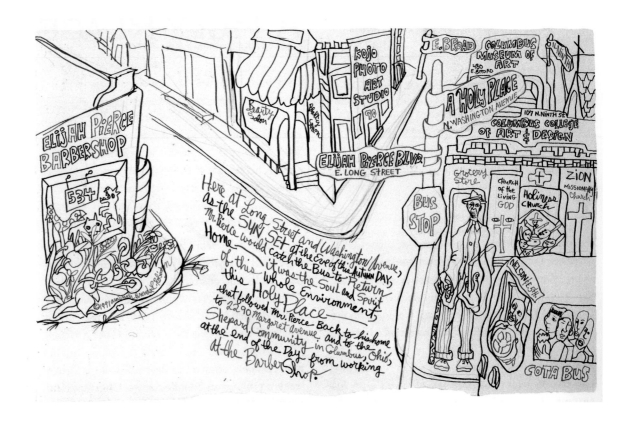

FIG. 1: Aminah Brenda Lynn Robinson, *A Holy Place,* detail, 1991, pen and ink on paper, 8½ × 11 in., Columbus Museum of Art, Estate of the Artist

FIG. 2: Aminah Brenda Lynn Robinson, *A Holy Place,* detail, 1991, pen and ink on paper, 8½ × 11 in., Columbus Museum of Art, Estate of the Artist

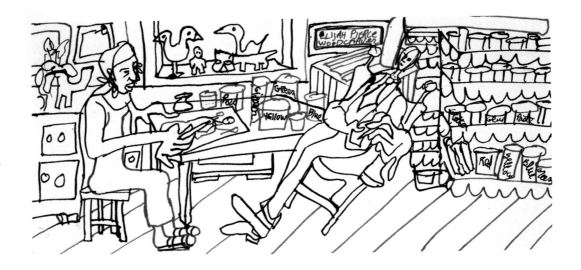

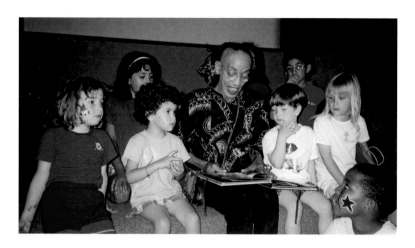

FIG. 3: Aminah and a group of schoolchildren, 1990s

of drawings of her travels in Africa. A few years later, we acquired our first RagGonNon, *A Holy Place*, which she donated in memory of her late son, Sydney. Our first purchase came in 1997: the original artwork for her newly published book *A Street Called Home*. These formed the beginning of a collection of Aminah's work that now numbers in the hundreds and continues to grow.

We organized our first exhibition of her work—*Pages in History: The Art of Aminah Robinson*—in the spring of 1990, accompanied by a modest, thirty-six-page catalogue. We were far from the first to show Aminah's work, however. Gallery and museum audiences in New York City, Chicago, San Francisco, Baltimore, Cincinnati, and Akron, among other cities, had discovered her in group and solo shows beginning in the early 1980s. The Central Ohio community had encountered her work at Otterbein College, Franklin University, and even in the Museum's own Beaux Arts sales gallery. By 1990, Aminah already had received the Ohio Governor's Award in the Visual Arts along with two Ohio Arts Council Individual Artist Fellowships. She was well on her way to widespread recognition.

Although we may have arrived on the scene a bit late, we came with the intention of staying engaged. *Pages in History* was followed by five additional solo exhibitions that were held at the Museum prior to Aminah's death in 2015. Most notable was *Symphonic Poem: The Art of Aminah Brenda Lynn Robinson* (2002), which toured to the Brooklyn Museum, Tacoma Art Museum, and Toledo Museum of Art. A major book accompanied the show. The current exhibition is the fourth project that we have undertaken since the artist's death, including a memorial show

FIG. 4 (RIGHT): Aminah in *Eye Spy: Adventures in Art*, Columbus Museum of Art, 1998

and the debut of *Presidential Suite,* which Aminah created in honor of the election of Barack Obama.

The most unconventional project that Aminah embraced was *Eye Spy: Adventures in Art*, a highly innovative interactive Museum space, which opened in 1998. Visitors engaged with actual works of art while exploring what it means to be an artist and how artists create art. Featured artists included hometown favorites George Bellows, Elijah Pierce, and, of course, Aminah Robinson, who brought *A Street Called Home* to life in the installation (fig. 4).

Being close to a working artist can be challenging. One distinct—and favorite—memory of mine from the last years of Aminah's life came with a call from her in the first few months of Columbus200—the city's 2012 bicentennial celebration. She asked me directly when the Museum was planning to exhibit the body of work that she had created specifically in honor of the anniversary. No matter that I was unaware that she had done this; I should have known that, of course. Aminah would never fail to add her voice to this important event in our community's history. We installed *Songs for a New Millennium, 1812–2012: Works by Aminah Robinson Celebrating Columbus200* not in a traditional Museum gallery, but instead in the more informal Loann W. Crane Forum. Aminah enthusiastically approved. As she always did, she used the history and stories of her neighborhood, friends, and

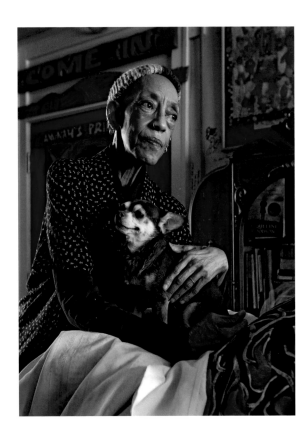

family to create work that transcended and emerged universal.

Aminah was generous to a fault. When her community requested her participation, especially when young people were involved, she was there. She loved teaching and encouraging young artists, no doubt recalling her own childhood. Involvement with community events and joining with neighbors were constant and not to be denied. As the pull of time became stronger, however, Aminah felt overwhelming pressure to complete work that was still inside her. An artist, and this especially applied to Aminah, needs solitude to plan and work, blocks of time to create, and freedom to escape, however briefly, the world outside her door. As Aminah began to feel this and talk about it with close friends, we also strove to assist her to navigate her calendar.

She also contemplated her legacy, and how best to help future generations. Given Aminah's oeuvre, this is easily understood. She came to see me several times to talk

about what she was considering. When Aminah suggested that the Columbus Museum of Art assume responsibility for her estate, I was honored, humbled . . . and fearful. The obligation was beyond enormous. When I asked her about her choice, Aminah reflected upon her long history with the Museum. Her memories stretched from the time when she was a child to the present—more than seven decades. Perhaps even more importantly, she believed that her journey and the Museum's were intertwined; and very rarely was her art not present on the Museum's walls.

Regardless, when Aminah left us on May 22, 2015, the Museum family was staggered to find that she had left her entire estate—a vast trove of her work, her Shepard neighborhood home, all of her personal possessions, and even Baby, her last beloved dog—to the Columbus Museum of Art. Aware of the enormity of this, we knew that we must seek advice, assistance, and partners in order to fulfill our responsibility and to honor Aminah's generosity (fig. 5).

We convened a special committee to help us. Under the leadership of co-chairs Barbara Nicholson, executive director emeritus of the King Arts Complex, and Bettye Stull, longtime curator of the King Arts Complex, the committee included Museum staff and trustees, Aminah's fellow Shepard neighborhood residents, and other community members. Together we crafted a vision of her home as the focus of a residency supporting African-American artists selected from a nationwide pool. Living in Aminah's home during the residency, the recipient would be surrounded by Aminah's art and, indeed, create art in her studio. In that way, Aminah's life as an artist would be perpetuated (fig. 6).

Critical to inspiring the community around the vision of the Aminah Robinson Legacy Project, including the preservation of the house and this exhibition, was Larry James, who spearheaded Columbus' Harlem Renaissance celebration in 2018. Historic preservation and residency programs are not the expertise of most art museums. The Greater Columbus Arts Council had worked with Aminah for years and, under Tom Katzenmeyer's leadership, the organization stepped to the front to assist in implementing this vision. Under their auspices, the Aminah Robinson Artist Residency began in 2020.

FIG. 5: Aminah and her dog, Baby
© *The Columbus Dispatch*

Prior to the residency, we first needed to refurbish the house. The extraordinary generosity of the Columbus Foundation under the leadership of Doug Kridler provided the support for renovations of the house and established additional funding for future capital needs. We also needed to undertake a comprehensive inventory of Aminah's home—a formidable task that required almost five years to complete. In most homes, for example, a stack of books on a shelf is just a pile. For Aminah, to whom association and context were vital, placement could be meaningful. To be certain that we missed nothing, not only did we list what the house contained, we also recorded where it was located. When a group of us from the Museum first visited her home following her death, as we entered a space still permeated with Aminah's presence, our eyes fell upon a work table where her

glasses rested. The home was as when she had left for the hospital, and it seemed that it was awaiting her return.

I have been asked myriad times by numerous people what instructions Aminah gave me regarding her estate and her wishes. I asked her the same question . . . several times. Aminah, with a knowing and trusting expression, responded, "You'll know what to do. You'll do the right thing." The absolute trust that she held for me combined with the enormity of the responsibility that it compelled crashed in upon me. Ours is a unique opportunity, bestowed upon us by a wonderful, prophetic woman. At the same time is a covenant to "do it right." I am confident that Aminah would be proud.

In this exhibition, *Raggin' On: The Art of Aminah Brenda Lynn Robinson's House and Journals,* visitors will experience her amazing house and peruse her journals. In them, as was so often the case, Aminah succinctly defined the importance of art in general and of her relationship with the Columbus Museum of Art. Hers is the final word:

> Art matters—because what is held in [trust for] the public [at] the Columbus Museum of Art is transcendent of art, which becomes functional, instructive, inspiring and which is passed on to future generations, [and] their voices, too, will be added. CMA gives us hope for the humanity of our future. It awakens, enlightens, and uplifts our souls to the consciousness of indifference—wherever it is to be found—key to preservation, growth, and [a] vision to the life of future generations.[4]

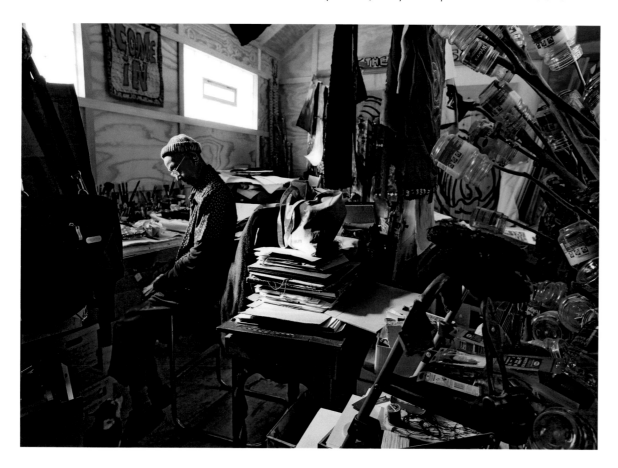

FIG. 6: At work in her studio
© *The Columbus Dispatch*

### Epigraph

Aminah Robinson, "A Holy Place: A Tribute to Elijah Pierce," in *Elijah Pierce, Woodcarver,* ed. Norma Roberts (Columbus, OH: Columbus Museum of Art; Seattle: Distributed by University of Washington Press, 1992), 68.

### Notes

1. Carole Miller Genshaft, "A Different Walk," in *Symphonic Poem: The Art of Aminah Brenda Lynn Robinson,* ed. Judith Sacks (New York: Harry N. Abrams, Inc.), 18.

2. Aminah Robinson, "A Holy Place: A Tribute to Elijah Pierce," in *Elijah Pierce, Woodcarver,* ed. Norma Roberts (Columbus, OH: Columbus Museum of Art; Seattle: Distributed by University of Washington Press, 1992), 67.

3. Robinson, "A Holy Place," 67.

4. ABLR 19-85, Journal, *Aminah 3,* 2006.

# AMINAH'S HOUSE

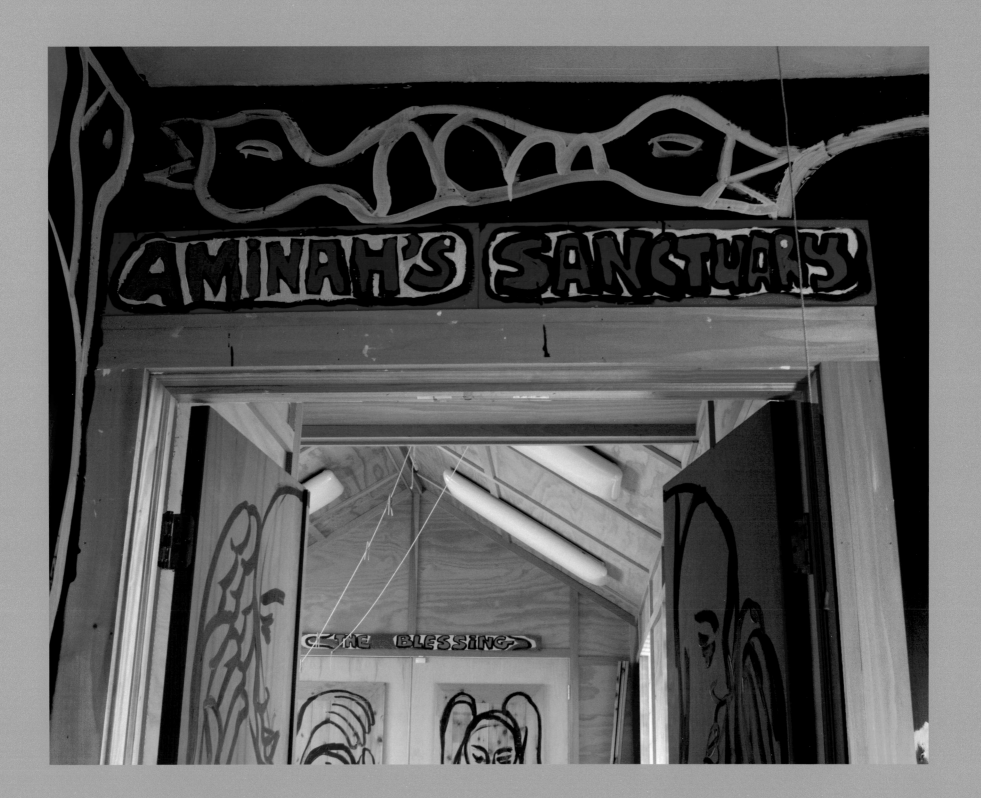

# Sacred Sanctuary

Deidre Hamlar

She spoke the language of art.

Her lines connected stories across communities and continents with

Stitches and paint, mud and leaves, leather and wood, words and books.

She lived in color and testified in pictures of prayer and triumph.

And the music . . . oh, the music soothed her as she spoke.

She lived in harmony with the world as her soul sought solace in sacred spaces,

Where her heart mind, body and spirit were free, and her creativity flowed.

At home, at peace with her art—in Aminah's Sanctuary.

FIG. 2: Aminah Robinson's front walk with *Sankofa* symbol, 2019

FIG. 5 (OPPOSITE): Robinson's Sanctuary Studio, 2015

THE front view of Aminah Robinson's property (plate 1) could be mistaken for a home in North America's Deep South, perhaps Georgia, Mississippi, or the Carolinas, where bottle trees are commonly seen. Aminah was astutely aware that bottle trees in ancient African tradition were used to ward off evil spirits; her brick-paved bottle garden was likely influenced by her research and visits to her ancestral home in Sapelo, Georgia, as well as seeing bottle gardens in her family's backyard in Poindexter Village. The bottles and bricks of her garden meant there was less grass to cut—which pleased her as well. When asked to contribute to a published anthology about gardens, Aminah drew *Bottle Garden Study* for the book and within it wrote:

> My parents planted bottles and flowers in our backyard. . . . People from our community would come to see our beautiful walkway, and they'd look at each other bewildered, in awe. And we never took the bottles up, so every season our garden grew, making rainbows that glistened in the midday sun, singing in the rain or the snow (fig. 1).[1]

Alongside the bottle garden, a concrete walkway adorned with *Adinkra*[2] symbols meaningful to Aminah leads to the front door (fig. 2). The *Denkym*—crocodile—represents adaptability, since it lives in the water and yet breathes the air; the *Nserewa*—cowrie shells—represent wealth, abundance, and affluence; and the symbol near Aminah's door, *Sankofa*—a bird turning its head to look back—represents the retrieval of knowledge from the past and is the proverbial wisdom that inspired her throughout her career.

One enters Aminah's home studio through her dramatic hand-carved, painted front doors and crosses a portal to her soul (plate 2). "Home studio" is the most descriptive terminology for this two-story house in Columbus's Shepard neighborhood, because she turned every square foot of her house into an artmaking space. To gain more space for her art, Aminah slept on the living room couch instead of in a bedroom upstairs. A sculpture titled *A Tree Grows in Brooklyn* overwhelmed the kitchen. Its tentacles culminated in *hogmawg*[3] faces that nearly touched the ceiling and walls of the room (plate 6a). Aminah's work was her life, and every inch of her home studio was carefully curated to reflect that effort. Treasured objects, books, and works of art displayed her abiding pride and respect for homespun stories, natural materials, music, history, geography, community, family, animals, spirituality, and social responsibility. Everything that surrounded her supported her drive to create.

Aminah was a great collector. Every nook and cranny of her space revealed something special, such as a small rock display balanced delicately on the studio windowsill (fig. 3) and a row of antique flat irons placed

symmetrically on a kitchen shelf (fig. 4). These irons also served the useful function of ensuring that paper, fabrics, straw, and found objects adhered to surfaces Aminah prepared for her collage compositions.

Volumes of art books, files of clippings and correspondence, and stacks of periodicals filled shelves, closets, and drawers throughout the house. With the same attention to detail Aminah demonstrated in signing, dating, and annotating her art, she maintained logs of sales and exhibitions, her own cataloging system, and notebooks with photos and slides documenting her work. She filled boxes with labeled manila folders and transparent protective sleeves holding source materials including newspaper clippings, magazine articles, maps, and ephemera. Layers of colorful museum and gallery exhibition announcements covered the surface of a cabinet near her living room work space.

Over the years, every room of Aminah's home studio grew to be stocked with hundreds of books that she annotated and mentally catalogued. Visitors to her library were astonished at her ability to easily locate any book among the many volumes. This talent is likely attributed to a technique she learned from her father called "penetration"—remembering places, faces, and events to recall later (plate 95b). She utilized this technique in her art and to keep the sense and memory of "home" with her wherever she traveled.

Memory was an essential part of her work, and Aminah wrote about the importance of retaining ancestral memories, carrying the spirit of one's home in memory, and passing on memories to future generations. She observed:

My actions are always caused by Memory. It is the energy of the ancestors. You don't search for something you already have. One must remember. Remembering means the passing on of that invisible spirit—the passing of knowledge, wisdom, and cultural traditions. Where memory dwells deep in the timelessness of Home. . . . Whenever I leave my home to visit in another place—I carry in my soul the spirit of Home—it moves me wherever I go. If a person does not carry home with them, then he

FIG. 3: Rock arrangement on Robinson's windowsill

or she leaves a great portion of that Soul in another place when he or she returns.[4]

The concept of passing on ancestral spirits undergirds much of Aminah's work and can be seen particularly in the complex mixed media works she named RagGonNons. These complex tapestries were a constant presence in the artist's living room. Overhanging an eight-foot table, punctuated by dangling needles and embroidery thread, this mountain of fabric, buttons, beads, cowrie shells, and found objects dominated the space. Aminah might work on a RagGonNon for months—or even years. She defined the concept of a RagGonNon:

In my Home Studio, my life is spent with God, In Solitude, in Prayer, and in the workings of a RagGonNon. . . . RagGonNons are sacred works. The unfolding of a RagGonNon takes on its own spirituality—where it speaks out of a Divine Spirit through the people of a Community . . . RagGonNons teach our future the past life of a community, its myths, its legends—that the works were made especially for them, illuminating Hope, Justice, Equality, and above all, Love.[5]

Aminah's spirit had no boundaries, her heart was an open door for people, and she communicated love seamlessly through her art. She appreciated community, all aspects of the characters that make up a

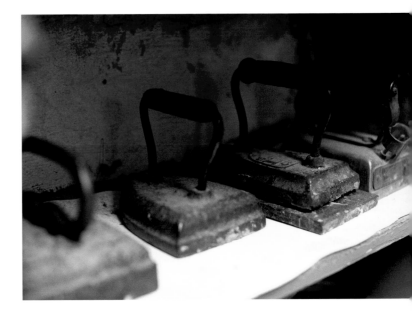

FIG. 4: Robinson's collection of flat irons

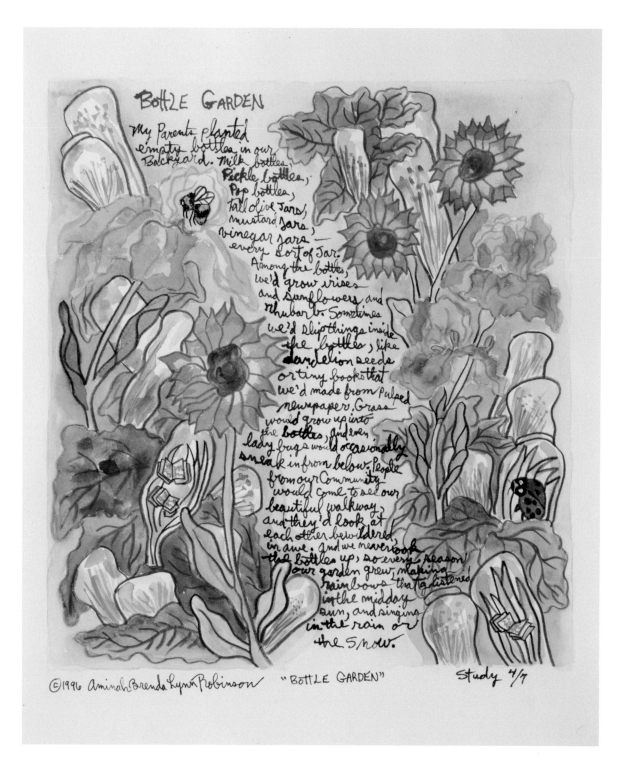

Inside the image (artwork text):

BOTTLE GARDEN

My Parents planted empty bottles in our Backyard. Milk bottles, Pickle bottles, Pop bottles, Tall olive Jars, mustard Jars, vinegar Jars — every sort of Jar. Among the bottles, we'd grow irises and Sunflowers and rhubarb. Sometimes we'd slip things inside the bottles, like dandelion seeds or tiny books that we'd made from pulped newspaper. Grass would grow up into the bottles, and even lady bugs would occasionally sneak in from below. People from our Community would come to see our beautiful walkway, and they'd look at each other bewildered, in awe. And we never took the bottles up, so every season our garden grew, making rainbows that glistened in the midday sun, and singing in the rain or the Snow.

©1996 Aminah Brenda Lynn Robinson "BOTTLE GARDEN" Study 4/7

FIG. 1: Aminah Brenda Lynn Robinson, *Bottle Garden Study*, 1996, pen and ink with watercolor on paper, 16 × 14 in., Columbus Museum of Art, Estate of the Artist

community—particularly those from Poindexter Village and Mount Vernon Avenue in Columbus, Ohio—and she had a sensitive spot in her heart for homeless people. Perhaps because her own home meant so much to her, she felt the devastation of those who had none. When she traveled, she often focused on those who appeared to be homeless and, in many cases, invisible to others (plate 85).

While her connections to people and communities were boundless, Aminah cherished time alone. Her physical space at home, insulated with windowless doors and dense glass block windows, reflected her need for privacy. This is where Aminah sought solitude with her thoughts and with her work, to protect her soul and her work process. To maintain a state of high productivity and a sense of control and peace, Aminah created spaces within her home—inner rooms that she referred to as "sanctuaries." One of these private spaces was the new studio she had built in 2004 after she received a MacArthur Fellowship and its accompanying monetary award. Aminah placed a painted sign reading "Aminah's Sanctuary" above the studio doors that were always closed to visitors (fig. 5). The Writing Room, a small space on the second floor, was also off-limits to visitors. Here Aminah wrote in her journals and corresponded with friends surrounded by treasured books, photographs, and a collection of art she had acquired by trading with other artists.

When Aminah's son Sydney died in 1994, her need for a sanctuary was greater than ever. While she may have appeared strong to friends and family, she struggled to find her artistic voice while grieving the loss of her son. Nevertheless, she persisted. By making art and writing in her journals, Aminah reclaimed her voice and healed her heart. In addition to dedicating much of her art to Sydney (fig. 6), his toys, schoolwork, photographs, artwork, awards, and letters to her were loving mementos scattered throughout the home studio.

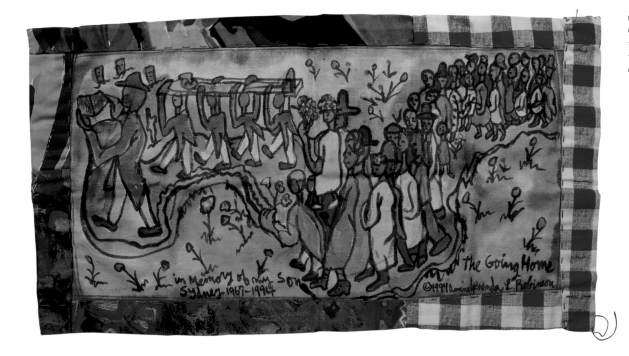

FIG. 6: Aminah Brenda Lynn Robinson, *The Going Home in Memory of My Son Sydney, 1967–1994*, 1994, cloth painting with thread, 18 × 32 in., Columbus Museum of Art, Estate of the Artist

For Aminah, there was no separation between home and studio, just as there was no separation between Aminah the individual and Aminah the artist. All that was within her surroundings she wove into webs of meaning that enveloped, inspired, and protected her and her process. "The way an artist arranges the objects around him is as revealing as his artworks," observed Picasso, ". . . it's not enough to know an artist's works. One must also know when he made them, why, how, under what circumstances."[6]

Aminah's home studio reveals a vivid portrait of her circumstances. Her works are her progeny, born of her history and delivered by her spirit; they are creative forces to move us to see life through new eyes. By means of strong and repetitive themes, Aminah helps us see the significance of history, community, ancestry, memory, home, homelessness, comin' home, going home, leaving home, and remembering home. Even while she traveled to residencies in New York City; Santiago, Chile; and Herzliya, Israel, Aminah created series of works about Columbus, Ohio. In this sense, she never left home.

Art historian Wanda M. Corn effectively asserts that artists' homes and studios are important art historical evidence:

Artists' studios—from the highly decorated formal room to the plain white box—tell different stories from diaries or photographs. Like any genre of architecture, they can be classified into definable styles that change over time. Their locations relative to the artists' living quarters change, as do their sizes, ceiling heights, fenestration, wall finishes, and décor. Some have windows that look out on views, while others are closed hermetic boxes providing physical and mental privacy. Some provide chairs, displays and amenities for visitors; others are utilitarian workshops. By reading these work sites as material artifacts and comparing one against another, we gain insights into the history of artistic culture as well as the art and aesthetic allegiances of the artists who created and worked in these spaces.[7]

When Aminah died in 2015, her paintings, drawings, an enormous RagGonNon, life-size sculptures, stacks of watercolors and woodcut prints, collections of books and dolls, tools, traded art, and art she received from family and friends filled every room. Art supplies consisting of buttons, beads, ties, clothespins, music boxes, coins, leather, fabric, and paints remained, ready for her next mixed media project. Aminah's carved furniture, painted doors, autographed walls, and mosaic floors turned ordinary rooms into charmed settings, and each room, including the basement and backyard studio, which she called her Doll House, were the artist's sacred artmaking spaces (fig. 7). To investigate Aminah's home studio is to appreciate the fullness of her life, the omnipresence of her work, and the sacredness of her space.[8]

## Epigraph
Deidre Hamlar

## Notes

1. Michael J. Rosen, ed, *Down to Earth* (Harcourt Brace & Company, 1998).

2. *Adinkra* symbols relate to the history, beliefs and philosophies of the Akan Asante people of Ghana. These symbols, which now appear on cloth, wooden prestige objects, jewelry, brass weights, and architecture, were reserved historically for Asante kings and printed on mourning cloth. *Adinkra* translates to *goodbye* or *farewell* in the Akan Twi language. https://africa.si.edu/exhibits/inscribing/adinkra.html.

Aminah's friend, Barbara Nicholson, Emeritus Director, King Arts Complex, Columbus, Ohio, painted the symbols on the walk.

3. *Hogmawg* is Aminah's word for a mixture of mud, pig grease, dyes, sticks, glue, and lime that she used in both two- and three-dimensional work.

4. ABLR 19-78, Journal, March 12, 2004.

5. ABLR, *The Art of The RagGonNon,* April 14, 2007 in artist's file, *Writings Notes,* 2007.

6. Brassaï, *Conversations with Picasso,* (Chicago: University of Chicago Press, 1999), 133.

7. Wanda M. Corn, "Introduction and Overview," *American Art* 19, no. 1 (Spring 2005): 2–11. University of Chicago Press Journals. https://www.journals.uchicago.edu/doi/10.1086/429967.

8. Robinson's home has become the base for an artist's residency in Columbus, Ohio. Every effort was made to preserve Aminah's spirit and, at the same time, make the house a comfortable temporary home for artists.

FIG. 7: Floor plan of Robinson's home, 2015

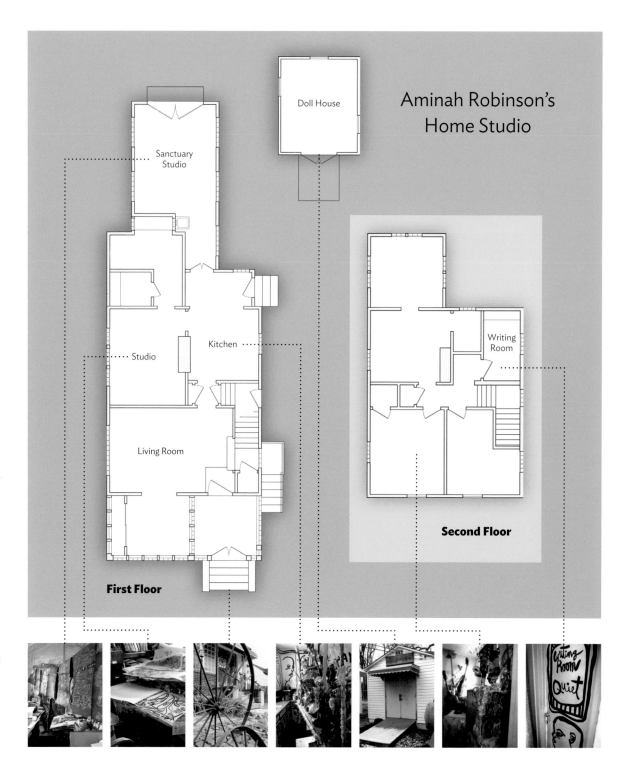

Aminah Robinson's
Home Studio

Doll House

Sanctuary
Studio

Writing
Room

Studio

Kitchen

Living Room

**Second Floor**

**First Floor**

# Stay on the Path

Debra Priestly

DWARFED by the Columbus Museum of Art's Derby Court, Aminah Brenda Lynn Robinson asked my mother if she could "adopt" me. The moment was surprising and intense. After all, it was 1989, I was twenty-eight years old, and Aminah and I had only known each other for a few months. We had planned to meet that day to view my exhibition at the Museum. Aminah had asked me several times if she could speak to my mother about "adopting" me, but I was unaware of how serious she was. Of course my mother agreed to the arrangement. For the rest of the day, my momma and my new mom, Aminah, strolled arm in arm through the galleries in a very private conversation, while Aminah's son Sydney and I tagged along behind.

Earlier that year, Aminah had received a fellowship from the National Endowment for the Arts to work with master printmaker Robert Blackburn at his printmaking workshop in New York City. I had moved to New York City from Columbus to attend the Pratt Institute a few years earlier and had also received a fellowship for the Blackburn workshop. Bob called me and said, "There is someone here from your home. Aminah Brenda Lynn Robinson is making prints and she wants you to call her tomorrow." Bob possessed a gift for knitting a community of artists. I immediately called Aminah and started to introduce myself.

"I'm—"

"I know who you are!" she belted. "And I know everything you have been doing since you left Columbus. . . . When are you coming over here?"

I met Aminah, and her Chihuahua, Boo Boo, early the next morning at her apartment in Queens. While at Blackburn's, she also had a residency at PS1 Contempo-

rary Art Center in Long Island City and planned to spend the whole summer in the city. Meanwhile, I had the luxury of time; I had just returned from a Visiting Artist position in New Zealand and was poised to begin working at the Studio Museum in Harlem and the Schomburg Center for Research in Black Culture in the fall. That summer, Aminah and I, with Boo Boo tucked securely inside her handmade bag, made a routine of museum visits, sketching, beading, and searching for art materials.

We visited Harlem often. Aminah loved this kinetic hub of African American culture, particularly 125th Street, lined with vendors who offered colorful textural beads and African fabrics. We also frequented Materials for the Arts (MFTA) in Long Island City and carted several loads of donated supplies back to her studio at PS1. She consumed materials at a rapid pace and she was resourceful. When she ran out of paper, she steamed open plain envelopes and flattened them to make her *Unwritten Love Letters* series (fig. 1). These mixed media, winged-shaped drawings pay homage to African American history and culture.

Once, at MFTA, Aminah found a stack of large, leather floor tiles. We moved them to her studio with considerable effort. One side of the tiles had a rich, reddish-brown patina dotted with fading high-heel shoe impressions. The other side had glue residue she sanded away. Aminah soaked the tiles in water for days before transforming them into carved book covers and accessories such as small personalized satchels and beaded pen sheaths she gave as parting gifts. Incised into my satchel is a portrait of me pointing to the doors of The Studio Museum in Harlem, the Schomburg Center for Research in Black

OPPOSITE: Debra Priestly and Robinson at Hammond Harkins Gallery, Columbus, OH, 2010

Culture, and the Apollo Theater (fig. 2). She also gave me several tiles with instructions on how to form them.

Aminah was a keen observer, an avid researcher, an archivist, and a *griot*—a storyteller and a keeper of oral history in the West African tradition. She found inspiration all around her. She was engrossed in projects that lasted decades, during which the concept of time meant nothing. Sometimes she felt a sense of urgency to record an event and would drop everything else to focus on this special task. For example, one day, Aminah appeared outside my apartment building on 136th and Lennox Avenue in Harlem, screaming my name in what sounded like sheer panic. I scurried down five flights of steps to find her in a fit of laughter. She had forgotten my apartment number, but she wasn't concerned. She said she knew I would hear her sooner or later. Aminah was giddy from the journey from her studio to my apartment.

"You will never believe what I saw . . . a birthing on the C Train . . . and I gave the mother water from my bag . . . I am going to make a piece about it!" she declared, then promptly revealed the sketches she already made on the train and said she had committed the rest to memory. She was extremely amused by my look of terror and the fact that she managed to alarm and embarrass me. She was mischievous and she loved to tease and to laugh.

A few days later, visiting her at her studio at PS1, we unfurled *Birthing on the C-Train* (fig. 3). We placed one end of the weighty, mixed media painting on the floor by the farthest wall in her studio. Then Aminah and I rolled it out through the studio door and into the wide hallway of the old, repurposed school building, proving that neither limited materials nor limited space can come between an artist and her work.

Our last stop that summer was the Fountain Pen Hospital in lower Manhattan. We delivered Aminah's black

Signature fountain pen, with the ornate silver sleeve, to be cleaned. I admired her reverence for fine tools and discovered there actually *is* a hospital for pens! Afterward, I helped her into a taxi bound for LaGuardia Airport. She was carrying a small, mustard-colored suitcase almost too heavy to lift. The suitcase contained her "field box" (her portable studio) and a button book in progress. She had shipped everything else home to Columbus, leaving only a box of materials for my studio, which contained a spool of pale green string painstakingly dyed red, small jars of ink, assorted brushes, and a handmade glass quill pen. I hated to see her go, but I knew this was only the beginning of a lasting friendship. She left me with words she would come to repeat often:

"I love you.

"Stay on the path.

"Never, never, never forget you are an Ohioan."

Although our friendship began in New York City, I first learned about the work of Aminah Brenda Lynn Robinson in 1981 during my sophomore year at The Ohio State University (OSU). As a work study student for the Logan Elm Print Press and Paper Mill, my first assignment was to finish binding an edition of books from her *Pages in History* series. It was my great fortune to inherit the task left by another work study student whose term had expired. I carefully folded each long, skinny strip of hand-printed

FIG. 1: Aminah Brenda Lynn Robinson, *An Old Custom from the Blackberry Patch Unwritten Love Letter* (from *Unwritten Love Letters* series), 1988, pen and ink, dyes, and watercolor on envelope, 9 × 15¾ in., Columbus Museum of Art, Estate of the Artist

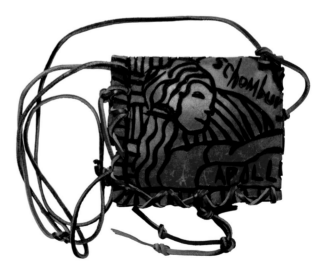

FIG. 2: Aminah Brenda Lynn Robinson, *Satchel for Debra Priestly*, 1989, carved leather, 5¼ × 6 in., Collection of Debra Priestly

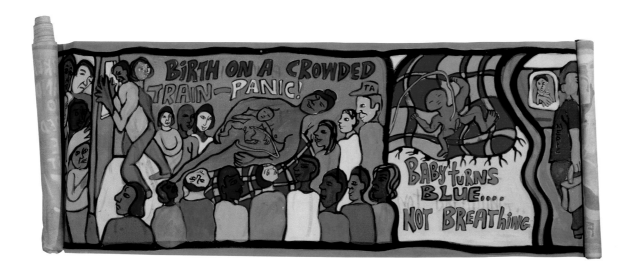

FIG. 3: Aminah Brenda Lynn Robinson, *Birthing on the C Train,* detail, 1989–91, paint on cloth, 37 × 572 in., Private Collection

dear friend and mentor, Elijah Pierce, speak about their work. Another time, I trekked downtown to Franklin University Gallery to view a suite of her drawings. I was struck by her presence and her work, and I felt a palpable kindred bond. I grew up in Springfield, Ohio, just forty-five miles west of Columbus and, in seeing her work, I saw new possibilities in mine. Aminah was an African American artist from my home, telling her own story with such joy and passion. I was developing my own visual vocabulary, making paintings infused with images from my family's photo archive. They were my "memory maps," as Aminah would later call them (fig. 5).

Over the years, I remained Aminah's "adopted daughter." She and my mother pretended to be sisters. She quickly "adopted" my sisters Lee and Tressia, and the rest of my family. She kept track of important dates—birthdays and anniversaries—and she was wholly invested in our creativity. She would send unique materials for each of our practices. For patoka rivers, the family art and craft business, she offered drawings we translated into stained-glass panels.

I visited Aminah's home often. I enjoyed walking through the front gate, over the button encrusted walkway, past the bottle garden with two iron wagon wheels (fig. 6), up to the porch, and finally through the hand-carved front door (plate 3). Inside, the modestly furnished home gradually filled with more books, papers, art, and materials until it became a maze with narrow passages that only she could maneuver with ease. Additional tables and desks appeared, providing more work stations. A large sculpture that contained tree

paper back and forth into a neat square, adhered the top and bottom cover with archival glue, and then placed it under a weight until it cured. This edition chronicled the life of John T. Ward, who transported runaway slaves in Columbus, Ohio. It also paid tribute to her Columbus neighborhood, Poindexter Village. As I worked, I considered the accordion style format a fitting choice. This book, which contained a multicolored panoramic woodcut and letterpress text, unfolded a magical world unique to Aminah (fig. 4).

Impressed and curious about Aminah and her work, I seized any opportunity I could to hear her speak or visit her exhibitions during my studies at OSU. Breaking out of the orbit of campus life, I hopped onto a city bus bound for a public library across town to hear Aminah and her

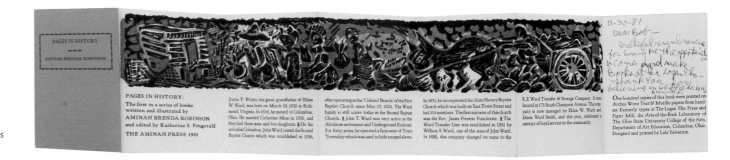

FIG. 4: Aminah Brenda Lynn Robinson, *Pages in History, John T. Ward,* 1981, woodcut with letterpress text, 3⅞ × 3 in. (folded), Columbus Museum of Art, Gift of Logan Elm Press, 2009.042.001

FIG. 5: Debra Priestly, *mattoon 5*, detail, 2002, acrylic, photo transfer, ink, and resin on wood panel, 80 × 24 in., Courtesy of Debra Priestly and June Kelly Gallery, New York, NY

branches and upcycled amber medicine bottles jutted from the center of the kitchen table in all directions. I often brought small gifts of miniature clothespins and buttons from craft stores, "Indian bead" stones from the Wabash River, "devil claw pods" from the Hudson River, and blocks of asafetida from an East Indian grocer in New York City's East Village. With a wall of bookshelves at our backs, we spent most of our time in the living room on an overstuffed sofa that doubled as a huge pin cushion, especially when she was creating one of her massive textiles she called RagGonNons (plate 4). The upper edge and arm rests were teeming with needles strung with an embroidery thread palette of crimson, canary yellow, and light blue. I kept one eye on the baseboard, hoping to get a glimpse of a pet lizard, which was expected to eat unwanted insects. One or more canine companions would also join us. We admired new works, such as her intricate handmade dress that contained compartments for a pen, a sketchbook, and her dog, Boo Boo. As we had done at PS1, we rolled out works along the floor. Here, we started from under the kitchen table and extended into the living room.

The Writing Room upstairs was off limits. The stoop outside her studio, "the Doll House," was a good spot for tea in any season. On rare occasions, we descended to the basement, where rows of eight-foot tables supported large watercolors in progress. Along one wall, a curtain concealed her son's toys, with which she could not part. She tried to entice me to make "hogmawg," her sculptural "mud" that included pig grease. Because I was a vegan, she knew I couldn't get past the ingredients, and she found humor in the offers. In later years, she greeted me with a short to-do list; I was delighted to oblige. I shuffled heavy carved doors, shifted several feet of huge textile works, and moved boxes of supplies (purchased and donated) from her front porch into the house so she could continue to work.

Between New York City and Columbus, we enjoyed long phone conversations. "Got your tea?" she'd say in a very serious tone, without a hello. My answer was always yes because what she was really asking was, "Do you have time?" While we talked, she made *gupas* (plate 104),

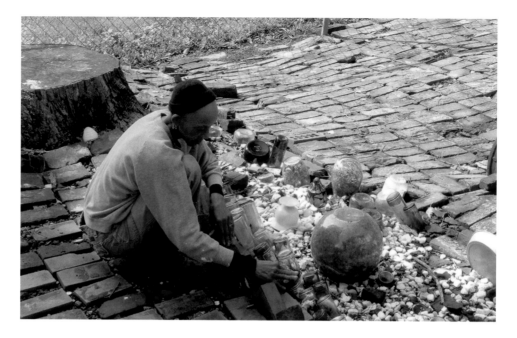

doodles she made during phone calls on scraps of parchment. I dropped whatever I was doing and made one of my own daily drawings. She talked about how she compartmentalized her day by making a schedule for writing, printmaking, drawing, carving, and so on. She described what she was working on then, and she asked about each member of my family, my ongoing series, and my genealogy research. She was always enthusiastic when one of my exhibition invitations arrived in the mail or she saw a reproduction of my work, and she would call to tell me I made a "masterpiece." I was amused but deeply grateful for the encouragement. Before we hung up, she asked if I needed anything and then closed with the usual:

"I love you.

"Stay on the path.

"Never, never, never, never . . . *never* forget you are an Ohioan."

Presenting an unflinching view of birth, life, and death in the wake of the African Diaspora, Aminah stayed on the path. Never doubting she was making important work, she made sure her art came first and she stayed true to herself. She whole-heartedly embodied the concept of *Sankofa,* the idea held by the Akan of Ghana:

we must know our past to ensure our future. She also believed memory must be kept and knowledge must be shared. Borrowing a term from Christine Sharpe's *In the Wake: On Blackness and Being,* I believe Aminah made "wake work." It is work that keeps watch over the dead, work that is born of consequence, and work intended to awaken consciousness. Today, Aminah's work is relevant and continues to inspire.

## Bibliography

Sharpe, Christina. *In the Wake: on Blackness and Being.* Durham: Duke University Press, 2016.

# AMINAH'S JOURNALS

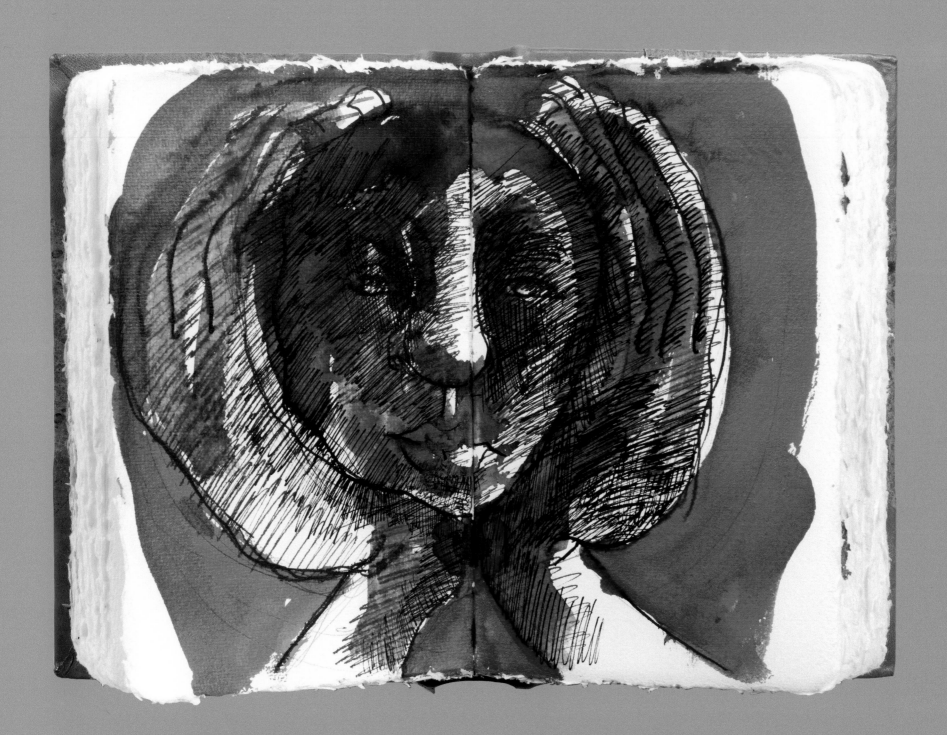

# Songs from the Ocean
## *The Journals and Memoirs*
Carole M. Genshaft

ENTERING Aminah Brenda Lynn Robinson's house and probing her journals invites us to enter her mind. It necessitates crossing a threshold into a mystical land inhabited by ancestral spirits and signified by interconnected sacred waters. Robinson is a conduit to the stories of her elders and to historical data, but foremost she is an inventor whose visual art and written constructions strive to make sense of a complex world. At the beginning of the nineteenth century, William Wordsworth described poets as those who are affected by "absent things as if they were present."[1] Like the poets Wordsworth describes, Robinson was constantly in the presence of the ancestral past.

In a memoir from 2010, Robinson writes of being admonished by ancestral spirits in the form of birds to protest the impending demolition of Poindexter Village, the apartment complex on the east side of Columbus where she lived for the first seventeen years of her life. Walking down the street in front of the complex, she thought at first she was seeing families of pigeons "nesting and going about their day to day lives." Quickly she realized they were "ancestral spirits moving slowly about and within the world of the present." "Their voices," Robinson cautions, "scream out to the world of the living. . . . The ancestors are always living among us. They watch us. They continue to teach us. They judge us in our everyday living."[2]

Writing in the last decade of her life, Robinson indicated that she herself had become an amalgam of the ancestral stories, historic research, and lived experiences she had absorbed during her lifetime (fig. 1):

I grew up in this beloved Columbus, Ohio community where I was born between a small village of Luanda, Angola, and the ancestral lands of Kemet, Kush, and the Songhai Kingdoms where Imhotep, the father of medicine, Askia the emperor of Songhai, Ahknaton, philosopher and first ruler of Egypt to believe in ONE GOD, and the land of Punt, which is today present day Ethiopia. My work was born between the deep bloody waters of the Atlantic Ocean swallowing the horrors of the Middle Passage, where many of my ancestors were branded with "Destination USA"—my work is born out of the slave communities of Georgia, Mississippi, Alabama, and Kentucky and in the far reaches throughout Amerika. I found my VOICE deep in the Ohio valley that was hemmed-in by overgrown trees and the thicket of the forest and of the Scioto River along Water Street. Migrating eastward of the Scioto to the near eastside of Columbus, Ohio around the 1200s—even to this day in 2006 the Migration continues. Steeped in the dense forest was Chipo Village. A Settlement established in 1200s by the Afrikan seaman and traders. The transformation of Chipo Village 600 years later became the FARMLANDS, evolving into the Blackberry Patch which is today Poindexter Village—I was born of All these voices—a life that inspires reverence.[3]

Robinson's identity as an artist merged inextricably with the stories of her elders and her intensely felt life experiences. "I love deeply and I hurt deeply," she

FIG. 1 (OPPOSITE): Aminah Brenda Lynn Robinson, *Offerings* (from an untitled journal), 2006–12, 7⅜ × 5 in., ABLR 19-83, Columbus Museum of Art, Estate of the Artist

reflected, "Everything I do, I do deeply."[4] In the early 1970s, Robinson found herself a single mother forced to resort to the welfare system to survive (fig. 2). This experience, which sensitized her to the predicament of those living in poverty, and the homeless individuals she encountered in Columbus and in the places she visited throughout the world, became an ongoing theme in her work.

Her journals reveal her love of humanity and her belief in human integrity, but at the same time, Robinson was cognizant of the insidious racism and immorality that permeated society. As a consequence, African life before slavery, the horrors of the Middle Passage, enslavement in the Americas, emancipation, migration, discrimination, the civil rights movement, and unrelenting poverty were a very real part of her psyche as much as the innate code of the genetic makeup in her body. This continual tug between humanity's most uplifting aspects and its most treacherous was a part of her soul, her art, her writing, and her interactions with others. She observed,

> From way back deep there is a simple song, a
> people that echoes through me and my work. This
> echo, this simple song is the spirit and soul of my
> people. . . . It is this song that must be appreciated.
> One must feel its beauty, its love. And its sadness.
> And it must continue to live.[5]

Robinson typifies folklorist scholar William R. Ferris's observations about the intense bonds between black art and memory: "Through story, song, and visual image, black art forms embody and state the history of a culture. Like the *griot,* they preserve memory with their voice and hands, and tend ancestral fires with their creative gifts."[6]

In one of numerous books from her personal library on African and African American art, Robinson underlined and repeated in a notation the words of sculptor and educator Edward Wilson: "To discover the universal in the specific, to transform the black experience into 'universally understood terms.'"[7] These words capture Robinson's lifelong efforts to mine the particular details of African American life in Columbus, and the journeys of her ancestors, for materials to use as a template for the much larger account of black history and culture.

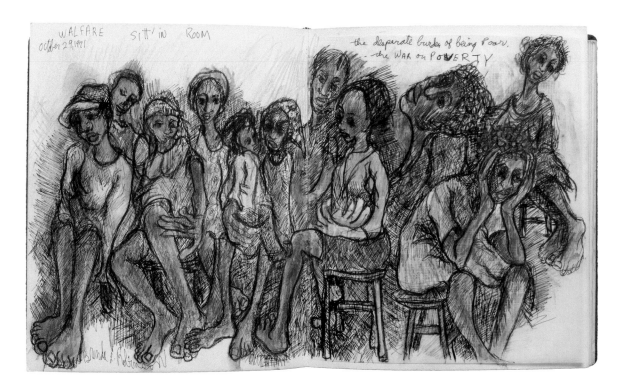

### Journals, Memoirs, and Manuscript Pages

When Robinson died in 2015, she left her estate, including the home where she had lived for more than forty years in Columbus, Ohio, to the Columbus Museum of Art. Every inch of the 1,660-square-foot house was layered with art, artmaking materials, ephemera, newspaper clippings, and correspondence. Among the artist's possessions were books in every conceivable form: an extensive library of art, fiction, nonfiction, poetry, and pop-up books; journals, handwritten diaries, memoirs, illustrated texts; and one-of-a-kind handmade books. Books were an intrinsic part of Robinson's life and a format for her work; they were a part of the way Robinson "walked." As a young child, her father, Leroy Robinson, taught her to make homemade paper by forming a pulp of discarded mail and empty cardboard boxes. After spreading the pulp on a wire mesh to dry in the sun, they used the paper to construct small books. By the time she was eight years old, she routinely carried a sketch book and filled it with drawings detailing her surroundings (fig. 3).

FIG. 2: Aminah Brenda Lynn Robinson, *Welfare Drawings (Puerto Rico)* (from an untitled journal), 1971, pen and ink with watercolor, 9¾ × 16 in., ABLR 19-31, Columbus Museum of Art, Estate of the Artist

Robinson was twelve years old when her father gave her a book about the notebooks of Leonardo da Vinci. Robinson recalled: "This was the beginning and inspiration for my great love for the drawings and manuscript pages of Leonardo. I have tried through the years to expand, invent, and innovate the art of creating 'Manuscript Pages.'"[8] On blank pages carefully removed from the end pages of published books and on irregular pieces of vellum, Robinson combined text with drawings and called them "Sacred Manuscript Pages." While in art school, she referred to her journals as "constant companions" and, like Leonardo's manuscript pages, they were filled with a combination of text and illustrations.

During her years in art school and while working at the main library in downtown Columbus, the notebooks became diaries filled with serious reflections on self-identity, racism, and her relationship with God; poetry and prose about the beauty of nature; hopes and fears about the future; and her complex interactions with family members, teachers, and friends. Entries describe her feelings of complete despair, loneliness, and personal failure: "Hello, I'm lost . . . in many things man cannot understand, but we must trust God's judgment—sometimes we must give up our dreams of happiness."[9] Other entries record her absolute love of nature and all humanity: "The New Year will be beautiful—I know it will be because the sun shines and the flowers grow, and—I'm in love with it all."[10]

For the rest of her life, Robinson continued to keep dozens of journals and notebooks. Handwritten, in most cases, the contents attest to the passionate artist and deep and complex person Robinson was. These texts, which number more than 125, were often illustrated with pen, ink, and graphite drawings; watercolors; and paintings on cloth. They provide fascinating insight into the artist's thought processes and creative endeavors as well as her views of the world and her place in it. In addition to the journals and memoirs, Robinson wrote extensively in books from her personal library. These underlined passages and notations constitute another type of insight into her life and work. This essay offers an overview of the journals and reveals patterns in Robinson's voluminous writings, but the vast amount of material beckons future researchers to continue the investigation.

## Recurring Refrains: Music, Symphonic Poem, Drawing

The journals and memoirs demonstrate Robinson's growth personally and artistically, but they also attest to the consistency of themes that concerned her from the time she was in art school to the last decade of her life. For example, music became a "place" where Robinson gravitated for meditation and peace. As a three-year-old, Robinson crossed the street from her Poindexter Village apartment and entered the world of the Beatty Recreation Center, where she reveled in the artmaking possibilities available to her in an array of art materials, bric-a-brac, and fabric scraps. Mrs. Bray, a frequent instructor, played 33 1/3 rpm records of classical music and African American spirituals and told her young charges stories about the composers and performers.[11] As she matured, music became a salve to Robinson's raw feelings of frustration and anger in the face of racism

FIG. 3: Aminah Brenda Lynn Robinson, *Untitled (Lamp)* (from *Flying Squadron Pencil Tablet* sketchbook), 1948, charcoal on paper, 11½ × 8¼ in., ABLR 19-IA, Columbus Museum of Art, Estate of the Artist

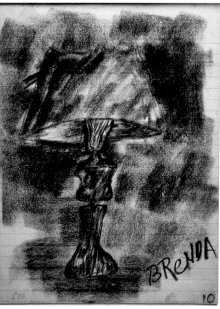

and personal disappointments, and a celebration of her brightest moments. Music became a part of her "walk" and it gave direction to her art. "I love music," she wrote. "I am deeply engaged in it. Music has so much to say—most times I can't quite capture the meaning, perhaps there is none. Music to me is sometimes like a child listening to poetry of words, not quite understanding—but feeling it all."[12] Music is a constant reference in the journals:

> I am listening to Shostakovich's *Symphony #6*. How beautiful it is! It is a juxtaposition of the past and present, the past belonging to the world of foment and struggle for liberation of the human spirit—the present is sheer exaltation in victory and lends the music its airy, carefree character. The past, then, is the sorrowful first movement, while the remaining two symbolize the present.[13]

Robinson transferred this far-reaching view of the depths of classical music to her own concept of a symphony, in which visual art, music, poetry, and performance merge:

> What is important is the moral character of our Nation, and the people in it. What is more important is each individual who breathes the life of his inner-most soul. I am going to make statements about all of these people; I am going to tell all about them—I am going to paint them, write about them and sing the songs that they know and understand and perhaps, someday might love. I am going to whisper to each of them telling each a song. A dream. A multitude of songs. I am going to tell about the whole world—A Symphony.[14]

Eventually Robinson considered this concept of "symphony" as a structure she called "symphonic poem" to encompass all her work. Her first painting titled *Symphonic Poem* was a four-panel screen she assembled herself (fig. 4). Filled with haunting pen and ink drawings of female figures and expressive text, this screen was a response to the devastation she endured when she was denied a scholarship for her last year of art school. "This first experience of injustice in my personal life,"

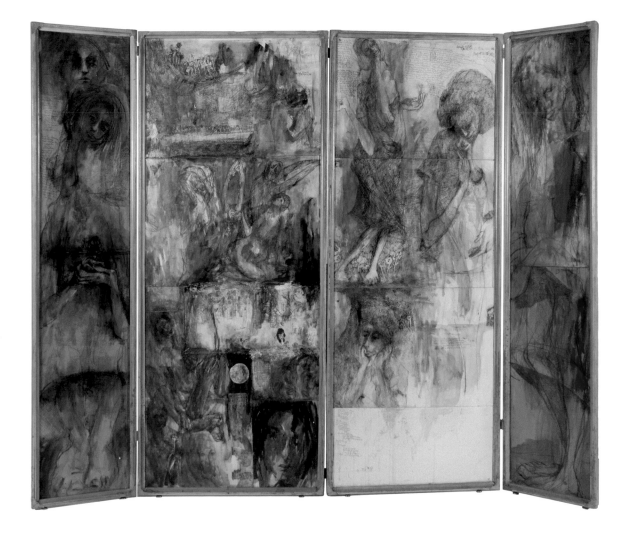

she wrote, "was the beginning of my journey to dedicate a level of each work of art I produce over my lifetime to Human Rights—not just for myself, but for everyone!"[15] Gradually the idea of "symphonic poem" swelled from one object into a conceptual plan for a comprehensive staging of visual art, writing, performance, and music.[16] All her work, including the journals, memoirs, and texts, is a part of this total vision.

> *Symphonic Poem* is a work that will manifest itself throughout my life. A *Symphonic Poem* is my struggle to impart unity and structure to the chaos

FIG. 4: Aminah Brenda Lynn Robinson, *Symphonic Poem*, 1959–60, ink, crayon, oil, and paper on board on four-panel screen, 71½ × 89 in., Columbus Museum of Art, Estate of the Artist

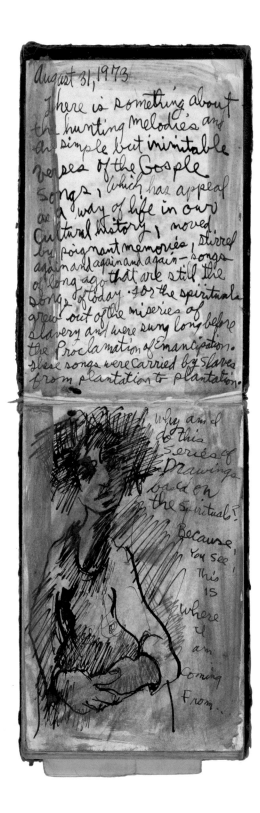

and confusion of my visual experience in a work that exists in its own right and for the sake of a message.[17]

This concept evolved into an obsession to remember, record, and pass on her story and those of her elders: "*Symphonic Poem* is no longer a song but a total record of experiences derived from everyday life."[18]

In addition to hearing African American spirituals at the Beatty Recreation Center when she was a preschooler, Robinson absorbed the melodies and lyrics of gospels wafting from the neighborhood Baptist churches during her childhood. Later she used the songs as a basis for *The Teachings,* an entire book in which each gospel song was represented by the powerful face and hands of a woman (plate 69). She believed these songs captured the essence of black cultural history and, at the same time, her private struggles with racism and poverty. The gospel songs served as a memorial to all those who suffered enslavement. "Songs of long ago," she noted in the inside front cover of a small, pocket-size notebook (fig. 5) "that are still the songs of today."[19]

Throughout her life, music was a constant, and she applied its vocabulary and notational systems to her art. With exuberance, she created visually stunning musical notation, seemingly not intended to be played but rather to reflect her innermost thoughts and moods. In *Music Score, Book of Revelations,* for example, Robinson expressed her joy in the election of President Barack Obama (plate 100b). The notes rise and fall in visual homage and, at one point, give way to figures of women who lift their voices and hands in praise. Like sacred, illuminated medieval music, much of this notation is executed on parchment.

Drawing, like music, was foundational to Robinson's methodology. Even though she explored an inexhaustible array of media, drawing was constant and akin to breathing for Robinson. "Drawing," she explained, "is to the artist what language is to the writer—basic, not so much a tool or a technique as the natural means of remembering, visualizing, defining, and projecting—of thinking in short."[20] Her journals filled with graphite, pen and ink, and watercolor drawings and a houseful of folders, files, and envelopes bursting with finished and unfinished drawings attest to her belief in the power of this medium. Drawing was the foundation for developing ideas for large- and small-scale projects ranging from rag paintings[21] and button-beaded book illustrations, to hogmawg[22] sculptures, life-size puppets, and monumental tapestries she called "RagGonNons." For example, figures in the position of the *Strawberry Picker* (fig. 6) from one of her journals appear in many other examples

FIG. 5: Aminah Brenda Lynn Robinson, *August 31, 1973* (inner front cover from *In this Field* journal), pen and ink with watercolor, 4¼ × 12 in., ABLR 19-39, Columbus Museum of Art, Estate of the Artist

FIG. 6: Aminah Brenda Lynn Robinson, *Strawberry Picker* (from the *Quilt of Humanity* journal), 1984–85, graphite and colored pencil, 9¾ × 7¾ in., ABLR 19-65, Columbus Museum of Art, Estate of the Artist

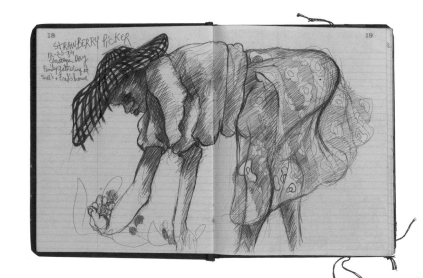

of Robinson's paintings and prints. For her, drawing, like music, was a means to communicate innermost thoughts. "How difficult," she observed, "it sometimes is to write or even talk about those things which are so close to your heart! For me, such feelings are most successfully realized when they are translated into drawing."[23] Drawing was an end in itself: "I love pen and ink, but not as a means of reproduction, but as an original, creative medium."[24] She considered the drawings to be, like prehistoric cave art, "visual records of existence."[25]

## Recurring Refrains: Civil Rights, Artistic Freedom

Each of the journals, memoirs, and daily diaries dating from the early 1960s to her death in 2015 spans time periods of a year or a range of several years. More than a dozen journals from 1963 are the exception and reveal this was a momentous year in Robinson's life. She records in great detail her tumultuous, long-distance relation-ship with her future husband Clarence Robinson, who was stationed at an Air Force base in Spain. During that summer, racial tensions were at a peak in America and Robinson was actively involved in meetings, marches, and demonstrations organized by the National Association for the Advancement of Colored People (NAACP) and the Congress for Racial Equality (CORE) in Columbus. Numerous entries in her journals reflect the emotions she experienced, which ranged from frustration and anger in regard to racial inequality to hopefulness that the struggle for justice and freedom would prevail. She was incensed by personal affronts and by the injustices she witnessed that were being suffered by other African Americans: inadequate housing and discrimination in education and job opportunities. "This long struggle for freedom is in my midst, in my time,"[26] she observed. She proclaimed that as an African American, a woman and an artist she was no longer "a stand-by" but was committed to the struggle (fig. 7).[27]

In the following poem, she detailed incidents of civil unrest throughout the country and joined the ground-swell to end racial injustice. The last line of the poem, about the need for a new image of the Negro, foretells the subject that would dominate her work for the rest of her life—to remember, honor, and preserve the African and African American past.

*The Mood of the Negro*
The mood speaks in angry eyes and anguished hearts.
It says now!
It says All.
The words, the angry eyes and the heavy hearts are
Reflections of a vast and potentially explosive emotional
    upheaval of America.
The upheaval expresses itself on one level in a growing
    mood
Of defiance and despair;
In go-for-broke demonstrations in Mississippi
And Alabama
And spasmodic protests in the North.
On another level,
The upheaval takes the form of massive disaffection
And a growing
Mood for blackness.
The mood and its manifestations
Are moving Negro Americans
To fateful eyeball to eyeball
Confrontation with Jim Crow.

There will be no racial peace in the nation,
In the South or the North,
Until segregation and
Inequality are gone . . .
The Negro no longer shrinks back
He will assert himself
And if violence comes so be it.

There is a growing feeling in the Black Ghetto,
What is white is not Right.
Negroes are rejecting American's image of the Negro.
This rejection expresses itself in a conscious identifica-
    tion with the symbols of the Negro past.[28]

On August 28, 1963, Robinson boarded an over-crowded church bus in Columbus—away from home for the first time—to participate in the March on Wash-

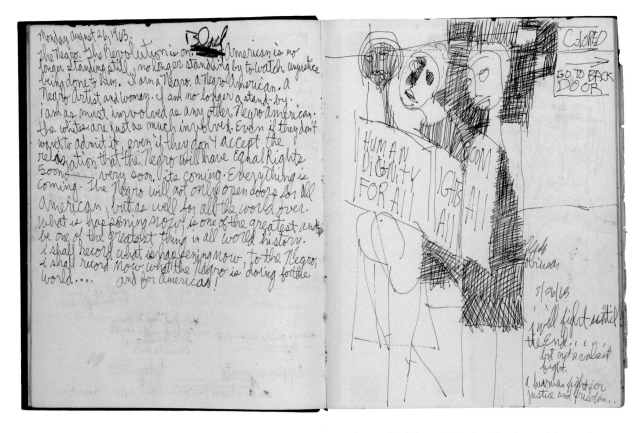

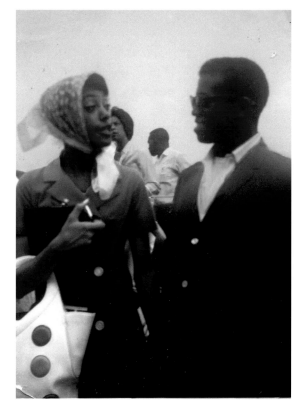

FIG. 7: Aminah Brenda Lynn Robinson, *March on Washington*, 1963, pen and ink in journal, 11 × 8½ in., ABLR 19-11, Columbus Museum of Art, Estate of the Artist

FIG. 8: Robinson in the "dignitary section" at the March on Washington, August 28, 1963. Photograph by Barbara Jemison

ington for Jobs and Freedom. In a journal devoted to the march, Robinson detailed the trip in a hand-written letter[29] addressed "To my Children and their children's children" (plate 93). She typed this letter and sent it to close family and friends. As the bus sped along the Ohio and Pennsylvania turnpikes, Robinson described how she and her childhood friend Barbara Jemison excitedly joined in singing freedom songs until they arrived at the National Mall in Washington. As the day wore on, the temperature increased and Robinson fainted. After visiting the restroom, Robinson and her friend were directed to a special area reserved for dignitaries. With Mahalia Jackson singing in the background, they were stunned to find themselves seated among James and David Baldwin, Ruby Dee, her husband Ossie Davis, Lena Horne, and Harry Belafonte. While waiting for Martin Luther King, Jr. to address the crowd, the two young women spoke at length with these civil rights leaders (fig. 8). "We were so

over-joyed that I had fainted," Robinson wrote. "We were *there*! Sitting with everyone we had never dreamed of seeing and meeting."[30]

While the March on Washington ultimately led to the passage of the Civil Rights Act of 1964, the speeches and songs of hope, freedom, and unity were in sharp contrast to the continuing acts of outrageous racist terrorism in the months following the march. Robinson deplored the September 15, 1963 bombing of a church in Birmingham, where four young girls were murdered. She wrote:

> I believe the white people are sick. How could they—haven't they any conscience about them at all? I do not know. I simply do not know about world peace and integration here in America—the land of freedom? The land of liberty and justice for all? No! There is no such 'America'—there is no

such freedom or liberty and justice for all! There is no such land. . . . The Black man is alone in this world, exile in his own country! But we will fight and we will win! Now is the time! [31]

The civil rights movement was a defining experience in Robinson's life and it solidified her determination to make art devoted to filling in the blank spaces of African American history and culture. Robinson believed that the experiences of black people could be the basis for a new society that truly respects human dignity. She cautioned, "a work of celebration must be created—not a celebration of oppression."[32] Robinson often referred to slavery in her work, but her emphasis was the celebration of those who survived and flourished—be it on Sapelo Island, Georgia, or on Mount Vernon Avenue in Columbus, Ohio.

In addition to her outrage against widespread racism and inequality, Robinson addressed the closely related issue of personal artistic freedom. She observed that the white art world was embarrassed by art reflecting black art and culture. She asked, "Why is the pressure on the creative Black artist to deny his roots?" And she answered her own question:

Because—the Black experience in this country is the most fundamental criticism of the American way of life. This reality—America refuses to face. It always was and always will be, so long as Black remains the symbol of human dispossession. . . . The Black man's sojourn in America is the universal story of man's inhumanity to man, capable of being understood in any language in any nation on earth.[33]

Depicting the black experience became her obsession, whether or not it was fashionable. "No one can," she believed, "no one should, define or dictate in art what is the right or wrong way to create a work of art." [34] Thirty years later, she continued to rail against anyone or any institution that attempted to control her work: "The most important factor to creativity is Freedom—the power to decide what to do and how to do it—a sense of control

over one's own ideas and work. Just leave a creative artist alone!"[35]

## Recurring Refrains: Ancestral stories, Solitude, Timelessness

For Robinson, retelling ancestral stories in art and in writing served the noble purpose of healing the remnants of slavery:

I continue to grow and cling to these traditions of my ancestors. Over time, one realizes the profound importance of these sacred mysteries in relationship to the world and universe, and especially the Divine with great hopes that future generations will keep alive the Torch that has been handed forward to them. It is a sacred life. A responsibility of trust. A life dedicated to endless waters of life force. This journey ultimately focuses on the transformative— slowly healing the legacy of slavery in Amerika and throughout the world.[36]

Four community elders—Leroy Robinson,[37] Robinson's father; Alvin Zimmerman,[38] her Uncle Alvin; Cornelia Johnson,[39] her Great-Aunt Cornelia; and woodcarver Elijah Pierce[40] had a crucial impact on her life and her art. Their stories are the subject matter of numerous examples of Robinson's art in a variety of media and they occur on page after page in her journals and memoirs. Of these four influential mentors, she credits her father with teaching her artmaking skills and with encouraging her to visit her elders and listen attentively to their stories. He instructed her in memory exercises that he called "the art of penetration." As a result, Robinson was able to scan a scene or study an individual and retain detailed information to use in a drawing or painting, long after the subject was no longer in view (fig. 9).

In addition to sharing with Robinson light-hearted fables and legends, Uncle Alvin (plate 98a) recounted bygone days of Columbus's historic black neighborhoods. By combining factual information she researched at the library with her uncle's stories, Robinson brought to life the energy of the lively city streets that had been marginalized by urban renewal projects. From Uncle

FIG. 9: Aminah Brenda Lynn Robinson, *Untitled (Penetration)* (from *Afrikan Pilgrimage: The Extended Family* journal), 1979, pen and ink with watercolor, 18 × 7 in., pp. 232–3, ABLR 19-56, Columbus Museum of Art, Estate of the Artist

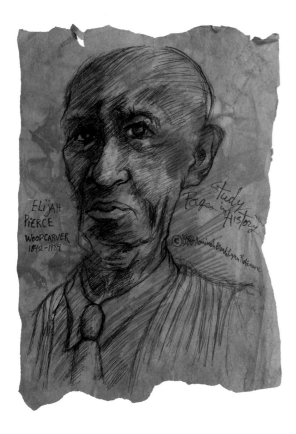

FIG. 10: Aminah Brenda Lynn Robinson, *Elijah Pierce Woodcarver*, 1988, pen and ink with colored pencil, 15 × 10 in., Columbus Museum of Art, Estate of the Artist

Alvin, Robinson developed a healthy skepticism of traditional history with its omissions and distortions of black history. She noted, "Uncle Alvin says that [the history of] Black people in the Americas prior to the slave-trade and slavery is met with tremendous resistance—it upsets the 'status quo.'"[41] The "status quo" represented those who continued to define Africans as slaves, incapable of having been navigators, explorers, and those adventurers looking for a better way of life in the Americas. Her uncle's stories of African traders and seafarers settling in the Ohio Valley as early as the 1200s became the subject for several series of Robinson's work, including *Life Along Water Street* and *Songs for a New Millennium*.

Crystallized in a 2001–06 memoir are the handed-down oral stories Robinson absorbed as a young girl from her Great-Aunt Cornelia (plates 40, 95c). Robinson's father regularly took his young daughter to visit Cornelia on Hosack Street on Columbus's south side. In her small house, where she lived with her sister Bertha, Cornelia used asafetida roots and peach leaves to cure fevers and stomach ailments of family and neighbors.

Robinson became immersed in her great-aunt's stories about Africa and of slavery on Sapelo Island, Georgia. She visited the island in search of ancestral history and created hundreds of Sapelo drawings, paintings, and sculptures (plates 56–63). In Robinson's art and writing, Cornelia was known by the African name of Themba. She was a mythic figure who symbolized every African ancestor who had been kidnapped, made to endure the horrific Middle Passage, and forced into slavery in the Americas and elsewhere. Most significantly, her great-aunt represented all the heroic survivors of slavery who were the progenitors of proud, strong, resilient descendants here in the United States and around the world. Cornelia/Themba succeeded in living a life of dignity and was beloved by her family and community. Robinson had great respect for her great-aunt and considered her a shaman endowed with the power to heal the sick and the ability to see the future. The last major series of rag paintings that Robinson worked on before her death was *Themba: A Life of Grace and Hope* (plates 43–46). Robinson thought of herself as heir to Themba's healing and divining powers with the grave responsibility to tell this story and keep her great-aunt's legacy alive:

> Cornelia (Themba) Johnson was one of those Voices who escaped the ocean waters—but her voice speaks through me. She told me her 'story' week after week for 14 years up to the time of her death in 1957.[42] I will never allow the horror of her life story to be forgotten. Her story is sacred and one that must be told and passed on to future generations. So I wish to dedicate "Themba's" story to all people throughout the world that they should be always vigilant, and to never allow indifference, hate, or cruelty to intrude upon their lives or the lives of others.[43]

In the early 1970s, Robinson became friends with Columbus folk artist Elijah Pierce (fig. 10). The friendship paralleled a particularly difficult time in Robinson's life, when her marriage to Clarence Robinson was failing and she found herself a single mother raising her young son, Sydney. She and Pierce were neighbors, and the long walks they took together brought Robinson peace and solace. She considered Pierce her spiritual mentor who encouraged her to "stay on the path" and to continue making art. As a "disciple" of Pierce, Robinson credited him with teaching her to "see with her ears" beyond that which is visible and be attuned to voices from God in her head.[44]

As a mature artist, Robinson relished working in periods of solitude when she sometimes refused to answer the telephone or open her door to visitors. She was encouraged in this "path" by Pierce, a soft-spoken man who valued silence. Her relationship with Pierce strengthened her belief in the importance of solitude. "I love being ALONE. Being alone with myself, and to work, has become an obsession with me. I love the serenity and tranquility. I want to work and grow and I do it best when I am alone."[45] She described the healing nature of their relationship:

> The Discipleship under the care of Elijah Pierce lasted for 13 years. Training under Elijah Pierce

was always in the seclusion and secrecy of his Barbershop and WALKS we took together in our neighborhood. The mysteries of life, his knowledge, wisdom that he imparted to me, now flow through the work that I do today. . . . The world of solitude is also a part of this Path.[46]

Although Robinson loved being with people, she treasured her solitude as a means of communicating with God and with ancestral spirits in a trance-like state she called "timelessness." "In the solitude of my work," she explained,

> I have been able to evolve as an artist. To achieve my own voice in the "Telling" of my own stories—visions God gave to me—it is like moving to music that is inside of me, but not yet written. The daily path never ends . . . one's creativity demands time which consumes one's life—to study community life, families who come and go from these communities and to their cultural traditions—a careful working out of creative investigations. Sowing of seeds, gathering of blossoms which must be carried on through long periods of time. All life then becomes timeless.[47]

For Robinson, the stories and relationships with her father, Uncle Alvin, Great-Aunt Cornelia, and Elijah Pierce are connected to each other because they link the past with the present and future, Africa and America, and the earthly and the spiritual. The stories of these elders and her interaction with them created a timeless state in the "ancestral waters of memory."[48] "We must remember, . . ." she explained, " . . . the beginnings of one's life never begins with oneself."[49]

## Raggin' On—Journeys Abroad

Whenever she traveled, Robinson prepared for the journey by reading extensively to better understand the land and people she would encounter. She studied the language of each destination through written and oral tutorials and, in some cases, lessons with fluent speakers. For each destination, Robinson delved into its history and

searched for information about the presence of Africans. She referred to this as her "ongoing documentation of a Global Afrikan Presence."[50] For each journey, she prepared and organized art supplies and packed a variety of papers, parchments, pencils, and pens. She chronicled her daily experiences in journals with detailed descriptions and drawings sometimes layered with fabric and found or purchased objects. Her handwritten accounts of trips to Africa, Israel, Sapelo Island, Chile, Italy, and Peru capture her responses to each environment and to the people she interacted with (fig. 11). Some of these books are embellished with covers of carved leather or button beaded fabric cases (plates 90, 91).

In the months prior to her trip to Africa, in the summer of 1979, Robinson wrote about her upcoming trip and her concept of the Extended Family:

> This is a study taken through my life and the lives of my family and friends and all Black people, around the globe. The consciousness of the Extended Family has now grown into a spiritual

FIG. 11: Aminah Brenda Lynn Robinson, *Looking Back into the Future* (from *Afrikan Pilgrimage: The Extended Family* journal), 1979, pen and ink with watercolor, 10 × 14¼ in., inner cover and p. 1, ABLR 19-56, Columbus Museum of Art, Estate of the Artist

pilgrimage with its beginnings in the Life of Poindexter Village—the place of my birth and growing years. To spend time with my brothers and sisters in Afrika means to see and understand the realities of the invisible lineage which is always a part of the THROB—the inner workings of all Black people— the awakening of Spiritual consciousness—the total love commitment we have for each other/the Extended Family.[51]

In a letter thanking the American Forum for International Study for arranging the trip, Robinson wrote, "For me, this Afrikan Pilgrimage was the beginning of a new day."[52] In Egypt she was given the name "Aminah," which means trustworthy in Arabic. She was even more pleased with this name after discovering from her father that "Aminah" was her grandmother's middle name. She legally changed her name in 1981.

Wherever she traveled, Robinson sought evidence of both the historical and contemporary presence of Africans. In the summer of 1998, Robinson received an Ohio Arts Council Visual Arts travel fellowship to spend five weeks at an artist's residence in Herzliya, Israel. For years, she had read about the small group of Christian Ethiopians who trace their Jerusalem lineage to the Queen of Sheba and her relationship with King Solomon. Robinson found their enclave above the Church of the Holy Sepulcher in the Old City and spent time there with the nuns and monks (fig. 12; plate 80). Their cell-like homes reminded her of the small living quarters she had observed in villages in Africa. Absorbing the ancient history that surrounded her, she observed, "Walking through the streets of Jerusalem forms a bridge from present to the past. Biblical chronicles are no longer to me merely ancient religious history. They are the records of a life of a people."[53]

In trips to Chile, Italy, and Peru, Robinson specifically asked her hosts and guides about the history of slavery in these countries. "All civilized nations of the world at some time during their history," she observed, "tolerated some form of slavery."[54] In Italy, she hoped to answer a recurring question about Leonardo da Vinci:

As an African-American artist, I am also deeply interested in how the beginnings of slave trade to America affected the life of Leonardo around 1492? . . . Were they Afrikans who lived in Italy long before the slave trade began? Or were the Afrikans there because of the slave trade?[55]

In Peru, she looked for similar information about enslaved ancestors:

Ten days living in Peru, has been a swelling of the earth as I move through its light. Even though Afrikan and indigenous people are not chained to the horrors of slavery, the silver mines and sugarcane plantations are still in use all over Peru. These voices from the ocean waters still scream and speak to my soul and to my life—to never forget what happened to my great aunt Themba and to millions of Afrikan people throughout the Global world . . . the aftermath is deeply rooted in mankind.[56]

## Writing Room—Writings from the 2000s

On the second floor of her house on Sunbury Road in Columbus, Robinson converted a small bathroom into a space she called the Writing Room (plates 11a, 11b). This room, like the studio she had built on the first floor after she received a MacArthur Fellowship in 2004, became a sanctuary. Filled with collections of brushes, pens, canes, photographs, record albums, and keepsakes, the writing room was a private retreat where she listened to music and penned letters to a multitude of friends and acquaintances.

Stored in boxes and metal file cabinets in other rooms in Robinson's house, the early journals are diaries that intersperse shopping lists, telephone contacts, and art inventories with poetry, private musings, and historical research. The memoirs she composed in the Writing Room in the last decade of her life are carefully penned and are often accompanied by fully rendered illustrations. In a number of cases, the stories are repeated with exactly the same wording in other journals or in the text

FIG. 12: Aminah Brenda Lynn Robinson, *Untitled (Ethiopian Village Priest)* (from the *Journey to the Holyland* journal), 1998, watercolor and paper collage, 16½ × 14 in., ABLR 19-70C, Columbus Museum of Art, Estate of the Artist

of separate Manuscript Pages. Their polish and completeness suggest their importance to Robinson and her desire to share these stories with others. In a memoir entitled *Poindexter Village As I Walk …* (2001–06), Robinson revisits her childhood when her first studio was under her bed in the room she shared with her sisters. "Here underneath this bed," she recalled, "I lived out my early years as an artist. I could not have been any closer to God than being here, drawing and painting."[57]

Robinson's "walk," as she referred to her life and work, was buffeted with opposing forces as evidenced in the complexity of the writing in the journals and reflections in the later memoirs. Her "walk" was grounded in the belief in an abiding love of humanity and, at the same time, a keen awareness of the racism that permeated daily life in America. She voiced hope for the future and gratitude to the black community and the general community for her own opportunities and triumphs. But at the same time and often on the same page, she wrote about persistent worldwide racism and personal mistrust of people's motives when they interacted with her. Childhood and young adult memories of rejection by family and later by art school and those she felt did not understand her art appear throughout the journals. "For 61 years," she wrote in a preface to autobiographical observations in the *Poindexter Village* memoir,

> I have given my life to celebrating Afrikan People, I also disclose the racial and discriminatory practices that have haunted Black people to this day—not FAR have we come. The injustices, even today as I pen this Memoir, are still present in our daily life.[58]

In an entry entitled "A Quiet Revolution," on one of the last pages of the *Poindexter Village* memoir, Robinson encapsulates the past, comments on the present, and states her abiding confidence in the future:

> The Civil Rights struggles of the late 1950s and the 1960s in Columbus, Ohio as well as throughout Amerika, was truly a time of change—changes demanded by the people—to open up public facilities and equal opportunities for all people.

> We marched, we had sit-ins, we had boycotts and I am left today with the first Afrikan Amerikan President—our 44th President to give a new world order to Amerika and to its people. This will not eradicate bigotry, racism, prejudice or injustices committed throughout the world but it does give a base for a better tomorrow and hope for our young people today and for all those yet to come.[59]

Robinson's journals and memoirs attest to her resolve as an artist and how that sense of purpose dictated the way she lived and defined who she was. She was completely intentional about her art, what it meant, and what it might accomplish. "It is my hope that the art I produce," she wrote, "bridges all generations, giving meaning and perhaps giving a sense of who we all are. This is my hope for today and tomorrow" (fig. 13).[60] Robinson's reason for being was to remember and record ancestral voices. She is now one of these voices that begs to be heard.

FIG. 13: Aminah Brenda Lynn Robinson, *Untitled* (from the *Poindexter Village As I Walk* journal), 2001–06, pen and ink with watercolor, 11¾ × 9 in., pp. 10–11, ABLR 19–73, Columbus Museum of Art, Estate of the Artist

# Notes

1. *Prefaces and Prologues,* ed. Charles W. Eliot, vol. 39, The Harvard Classics (New York: P.F. Collier & Son, 1909-14), Online edition, Bartleby.com 2001. www.bartleby.com/39/. Retrieved June 10, 2019.

2 . Aminah Brenda Lynn Robinson (ABLR) 19-89, Journal, *Uncle Alvin Stories, A Memoir,* 2010.

3. ABLR 19-83, Journal, *Offerings,* 2006. Robinson repeated this passage and expanded on it in ABLR 19-73, *Poindexter Village As I Walk. . . .,* 2001–06, pp. 81–84.

4. ABLR 19-12, *Untitled Journal,* September 1963.

5. ABLR 19-5, Journal, *January 1963,* 1963.

6. William R. Ferris, *Black art ancestral legacy: the African impulse in African-American Art* (Dallas, Texas: Dallas Museum of Art, 1989), 78–9.

7. Inscription on pages 8–9 by Robinson in her copy of *The Afro-American Artist: A Search for Identity* (New York: Holt, Rinehart and Winston, Inc., 1973) by Elsa Honig Fine.

8. ABLR 19- 89, Journal, *Uncle Alvin Stories, A Memoir, 2010.*

9. ABLR 19-4, *Untitled Journal,* September 4, 1962.

10. ABLR 19-4, *Untitled Journal,* December 12, 1962.

11. ABLR 19-73, Journal, *Poindexter Village As I Walk. . . .,* 2001–06, p. 15.

12. ABLR 19-4, *Untitled Journal,* September 16, 1962.

13. ABLR 19-11, *Untitled Sketchpad,* July 29, 1963.

14. ABLR 19-23, *Untitled Journal,* 1968.

15. ABLR 19-73, Journal, *Poindexter Village As I Walk. . . .,* 2001–06, p. 196.

16. For a thorough discussion of *Symphonic Poem,* see Annegreth Taylor Nill, "My Life Is Lived from Within," in *Symphonic Poem: The Art of Aminah Brenda Lynn Robinson* (New York: Harry N. Abrams, in association with the Columbus Museum of Art, 2003), 33–43.

17 . ABLR 19-24, Journal, *Notes on a Symphonic Poem,* 1968.

18. ABLR 19-28, Journal, *Symphonic Poem Vol. I,* 1970–1973–1978.

19. ABLR 19-39, Journal, *In this Field, A Series of Studies for 100 Drawings,* 1973.

20. ABLR 19-16, Journal, *For not yet my very soul cries out in need of passion,* January 1964.

21. Collage-like pictures in which Robinson uses fabric scraps in the same way other artists use paint.

22. Robinson's word for a mixture of mud, pig grease, dyes, sticks, glue, and lime used in both two- and three-dimensional work.

23. ABLR 19-5, *Untitled Journal,* 1963.

24. ABLR 19-10, *Untitled Journal,* July 1963.

25. ABLR 19-6, *Untitled Journal,* February 4, 1963.

26. ABLR 19-9, Journal, *Symphonic Poem Panels,* July 1963.

27. ABLR 19-11, Journal, *March on Washington,* August 26, 1963.

28. ABLR 19-9, Journal, *Symphonic Poem Panels,* 1963.

29. ABLR 19-11, Journal, *March on Washington,* August 28, 1963.

30. ABLR 19-11, Journal, August 28, 1963.

31. ABLR 19-12, *Untitled Journal,* September 16, 1963.

32. ABLR 19-45, Journal, *Etching and Lithography: Notes Studies,* 1975.

33. ABLR 19-30, Journal, *Notes on Symphonic Poem,* 1971.

34. ABLR 19-11, Journal, *March on Washington,* 1963.

35. ABLR 19-7, Journal, *My Community is for me . . .,* 1999.

36 . ABLR 19-73, p. 52.

37. Leroy Robinson, 1918–1979.

38. Alvin Fitzgerald Zimmerman—Robinson's mother's oldest sibling and only brother.

39. Cordelia Johnson, 1875(?)–1963, also Cornelia, Big Annie, and Themba—Robinson's great-aunt, her paternal grandmother's oldest sister.

40. Elijah Pierce, 1892–1984.

41. ABLR 19-85, *Untitled Journal,* 2006.

42. Robinson often noted that Cornelia/Themba lived to be 105 and died in 1957. However, the date on Johnson's death certificate is 1963. I thank Michael B. Hays for his research on the dating of Cornelia's life and death. The discrepancies he pointed out attest to Robinson's goal of creating a mythic figure based on Cornelia's stories and a wide range of African American historical experience.

43. ABLR 19-73, Journal, *Poindexter Village As I Walk. . . .,* 2001–06, p. 115.

44. ABLR 19-73, pp. 22–35.

45. ABLR 19-31, Journal, *Welfare Drawings,* 1971.

46. ABLR 19-73, p. 29.

47. ABLR 19-73, p. 16.

48. ABLR 19-73, p. 59.

49. ABLR 19-78, Journal, *Bridges of Passion, Chilean Suite,* 2004.

50. ABLR 19-84, Journal, *Constant Companion Walks,* 2006.

51. ABLR 19-56, Journal, *Afrikan Pilgrimage: The Extended Family,* 1979.

52. ABLR 19-57, Journal, *Outline Studies for Afrikan Pilgrimage; The Extended Family,* 1979.

53. ABLR 19-70 B, Journal, *Sacred Pages Israel Journey,* July 20, 1998, separate handwritten note tucked in.

54. ABLR 19-58, Journal, *Pages in History Journal, Timelessness of Life, Vol. 1,* 1981, p. 171.

55. ABLR 19-73, Journal, *Poindexter Village As I Walk. . . ,* 2001–06, pp. 122–23.

56. ABLR 19-84, Journal, *Constant Companion Walks,* 2006.

57. ABLR 19-73, p. 12.

58. ABLR 19-73, pp. 8–9.

59. ABLR 19-73, pp. 10–11.

60. ABLR 19-73, pp. 10–11.

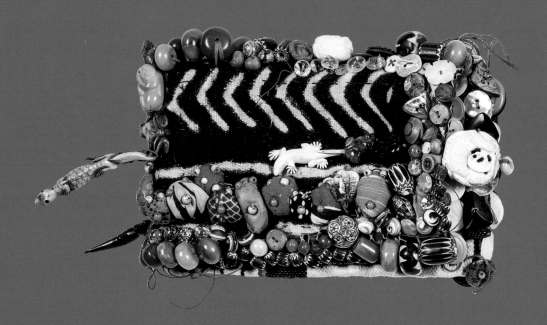

# AMINAH'S ART

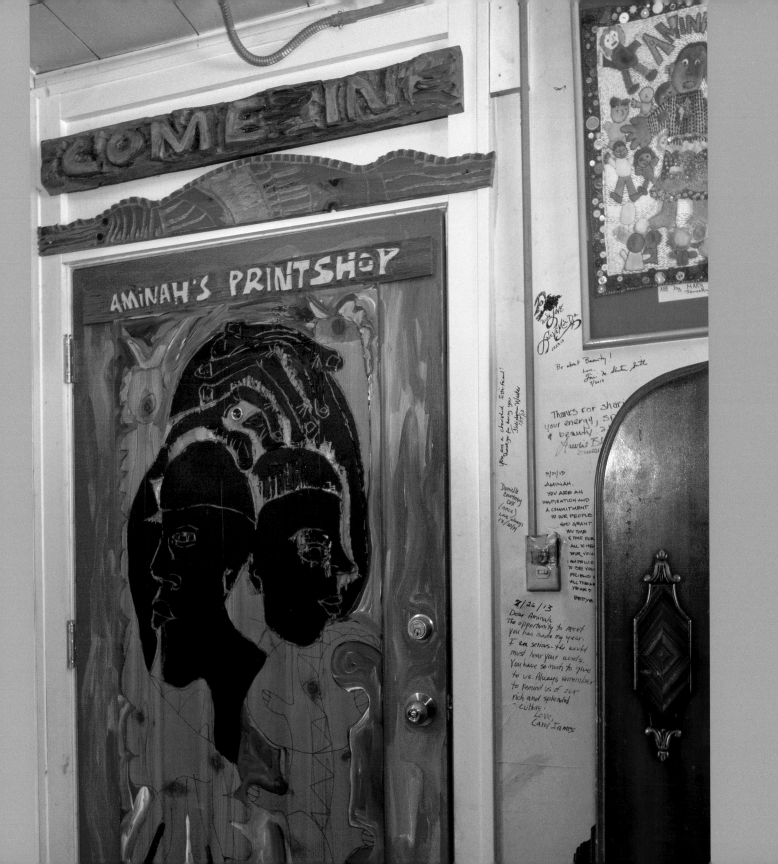

# Passing On What Was Handed Down
## *The Gifts of Aminah Brenda Lynn Robinson*
Lisa Gail Collins

Memories, woven together like the threads of treasured family cloths, are protected and loved through generations; the sharing of memories becomes the story of all of our lives. Over time, memories become our history, telling us who we have been and who we are becoming.

—Aminah Brenda Lynn Robinson, *The Teachings*

IN crossing the threshold of Aminah Brenda Lynn Robinson's house, it was eminently clear to me: I was entering a temple. The inside of her front door made this plain—hand-carved and painted, with its two black faces encircled by strong and expressive hands, it is a striking and summoning work of art (fig. 1). Surrounding the entryway are the proud signatures of visitors to her home, marking their sojourns, and paying their respects to the extraordinary artist seeker, and keeper of the word who lived her life here. "The world must hear your words. . . . Always remember to remind us of our rich and splendid culture," wrote one honored, first-time guest. "You are a cherished Sista-Friend! Thank you for being you," wrote another.

The late artist's Columbus, Ohio, house is a sacred sanctuary for contemplation, connection, and creation. Modest in size, her hallowed home is a mighty testament to the search for truth, the quest for justice, and the will to create. Art, books, materials for making, and works in progress are everywhere. The two-story house has been transformed into small studios, or designated areas,

for creating work in two and three dimensions, preparing recipes (such as the distinctive *hogmawg* material she learned to make from her father), stowing supplies, storing art, and displaying the artist's many collections of found and repurposed objects. At the top of the stairs, there's a cozy room for writing that includes books by Toni Morrison and a photograph of the artist with Faith Ringgold (plate 11b). Befitting a lover—and a maker—of books (and a former library assistant whose art often integrates text), the whole house resembles a special collections archive; tables and shelves brim with treasured books devoted to African American history and culture, Africa and its diasporas, world languages (Korean, Spanish, Hebrew, Swahili, Mandarin, and so on), and art from across the ages and around the globe (fig. 2).

Outside her home, there's a bottle tree and garden in the front yard, a clothesline hanging out back, steel utility tubs on the side fence ready for use, and a small shed converted into additional studio space (plate 9). House and yard feel like a potent—and protected and beloved—place for honoring ancestors and elders, holding history, carrying memory, and sharing stories by way of making art: a place for passing on what has been handed down.

Fully resonant with her home, Aminah Brenda Lynn Robinson's magnificent body of work cares for and carries forward an essential and expansive inheritance. A living legacy—staggering in its struggles and striking in its creativity—that she, in life and art, devotedly holds space for and gives voice to. Through her lush, layered, life-affirming creations, she tenderly draws all of us close to pass on what has been handed down to her—the things she carries. Gathering us 'round, she offers these precious

FIG. 1 (OPPOSITE): Front door, Robinson home

William Edward Robinson, had passed along his considerable drawing skills (fig. 3). Employed as a custodian for the Columbus Public Schools, he had also shared his broad knowledge of how to make handmade books from scratch, teaching her how to make paper, natural dyes, charcoal, glue, and tanned leather.

Within the opening pages of Aminah Robinson's 2001–06 journal *Poindexter Village as I Walk . . .* is a self-portrait of the artist as a young girl, showing some of the drawing, bookmaking, and needlework skills she learned from her parents. This start to her story, this luminous two-page spread, depicts what she recalled of her "First Art Studio," which was conveniently located under her bed (plate 95a). At the center of these multimedia pages, the elementary school-aged artist sits cross-legged on her bed surrounded by various art projects and supplies, including a paint palette on the floor. Leaning forward, the girl is fully immersed in creating a colorful work on paper. As viewers, we are invited to witness this scene by using our own hands and lifting the floral fabric—the small quilt—that covers the working artist and her bed. Upon pulling back the sewn cloth cover, we can see she has already absorbed her family's legacy of creativity.

Aminah Robinson not only praised her parents for being fabulous first art teachers, but she also understood their teachings as profound blessings that had shaped and enabled her life's path as a creator. Speaking with Faith Ringgold about her strong embrace of two materials closely associated with her mother, cloth ("rags") and buttons, she stated with gratitude and grace: "Those are the gifts that were passed down to me."[3] And in speaking of her father's role in living her life as an artist, she explained: "My father, he was the one . . . to give me this joyous life of creating. He, too, was an artist."[4]

Aminah Robinson drew strength and inspiration from her family and her community. One quality they both shared—and that she celebrates in her art—was resilience or self-sufficiency. As a child, her parents showed her that she could make art without relying on store-bought supplies. "Most of the time I didn't have paint," she recalled, so "my father and my mother taught me how to use the land."[5] Her wise, resourceful parents taught

FIG. 3: Leroy Robinson, *Untitled,* 1934, graphite on paper, 14 × 11 in., Columbus Museum of Art, Estate of Aminah Brenda Lynn Robinson

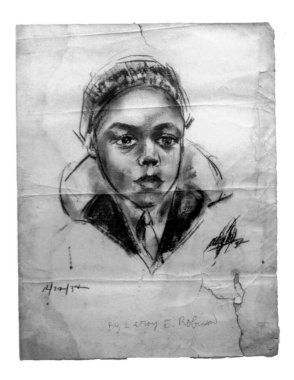

gifts as vital resources for the present. And so the future will remember.

Time and time again, when asked about the sources and forces behind her work, the artist shared she was carrying forward a familial and community legacy. That she was "simply" a conduit, *griot,* a holder of history. Responding to the recurrent question regarding the origins of her art, she characteristically explained, "Well, it doesn't come out of me, it comes through me from a community, from a family, and from my immediate family who shaped my memory, and I just continue the work."[1]

The artist consistently gave credit and praise to her mother and father for enabling her lifelong artistic journey by sharing their creative talents with her, starting when she was a very young child. "Everything started at three," she recalled.[2] Her mother, Helen Elizabeth Zimmerman Robinson, had handed down her special skills with needle, thread, cloth, and buttons. Her father, Leroy

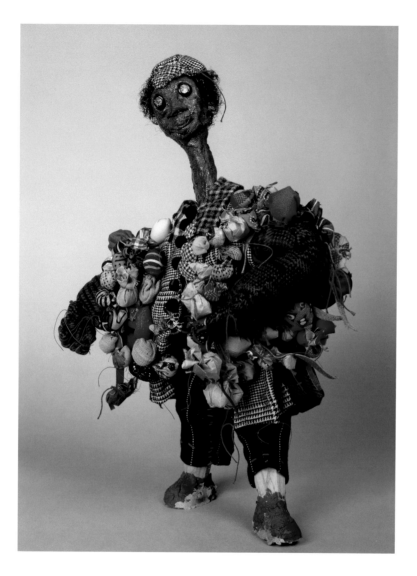

FIG. 4: Aminah Brenda Lynn Robinson, *Brownyskin Man*, 1997, mixed media, 18 in. (height), Columbus Museum of Art, Museum Purchase with funds donated by Wolfe Associates, Inc., 1997.010

their daughter how to make her own colors by using the seeds, bark, leaves, stems, roots, flowers, and fruit of plants.[6]

Born of necessity, both making and making do were integral to the life of her urban African American community during the era of Jim Crow. Describing the main street in Poindexter Village, the public housing development in Columbus, Ohio, where she was raised in the 1940s, she recalled with pride: "That was a self-sufficient street; it knew how to survive."[7]

In her dynamic work *A Street Called Home,* Aminah Robinson recalls and pays tribute to this time and place by recreating her community's vibrant thoroughfare Mount Vernon Avenue during the 1940s. Her lively streetscape features some of the determined and enterprising individuals—the Iceman, Ragman, Cameraman, Vegetableman, Sockman, and Chickenfoot woman—who embodied the struggling and loving community's heart and soul (fig. 4).

In addition to her familial and community training in artmaking, resilience, and creative utility, Aminah Robinson also attended art school, taking classes at the Columbus Art School (now the Columbus College of Art and Design) from 1957 to 1960 and later taking additional classes at Ohio State University. Although she repeatedly points to her parents and her African American community—and their histories, stories, and legacies—as the sources for her skills and subject matter, she stated that "art school was the place where I began my work ethic."[8]

In part, this seems to be related to the nature of her commute to the Columbus Art School. The artist shared how she had routinely walked from her east side home to the downtown school with her art materials in tow. And that she had transformed this mundane experience, walking to and from school, into a ripe opportunity to further deepen the keen observational skills her father had taught her—to closely and carefully study the world around her (plate 95b). Building on his rigorous lessons, she used her treks on foot to make what she called "observational penetrations," taking in not only the form and shape of what she saw, but also listening to, and being present for, its pulse. Drawing precisely

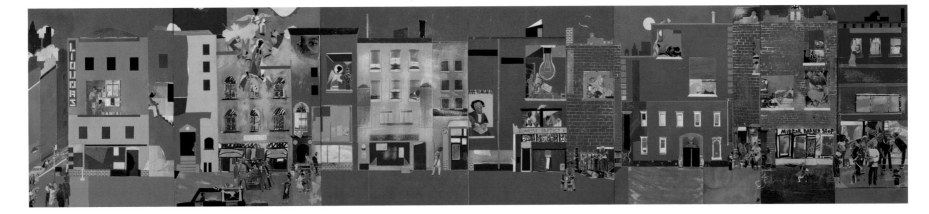

and passionately was the goal because, as she explained, "sight is seeing in the soul."[9]

Beginning with her generative working walks to and from art school in the late 1950s, and continuing over the next five decades, walking the streets of Ohio's capital city—and making studies and sketches based on her observations, insights, and encounters—was an integral aspect of Aminah Robinson's artistic practice. Concerning the city of her birth and its impact on her art and life, the lifelong resident exclaimed in 2010: "This is my open-air sketchbook. And my one jewel. It's my soul. I love it. But I also love leaving. They send me out. . . . And I bring it home."[10]

Having made several trips overseas including to Egypt (where, in 1979, she received the Arabic name "Aminah," meaning trustworthy), Nigeria, Senegal, Israel, Kenya, Italy, Chile, and Peru, Aminah Robinson was an enthusiastic international traveler. In cities and villages across the globe she walked—like she did in her hometown—making friends, making connections, making observations, and making art. And always with her art supplies (plate 79). "You got to have your sketchbook. You must have your sketchbook," she declared.[11]

Drawing on sketches and stories, history and memory, research and intuition, Aminah Robinson's art is attentive and responsive to both external worlds and her own inner landscape. Her process for creating her extensive body of work—an oeuvre that includes drawings, paintings, quilts, sculptures, leatherwork, prints, dolls, furniture, music

boxes, jewelry, journals, handmade books, and illustrated children's books—seems to have involved working simultaneously on various projects at varying stages. Frequently involving a variety of media, her richly layered and thickly textured projects were often years (and, in many cases, decades) in the making. And sometimes her projects, especially her RagGonNons, were intentionally conceived as never-ending and meant to continue "on and on." Her preferred way of working might best be described as immersive, iterative, and cumulative. She once explained that her continually evolving, resounding work became conspicuously "connective through the years."[12]

Aminah Robinson was an extraordinarily productive and prolific artist. She possessed both an experienced hand and an established practice. A daily, devotional art-making practice was a key component of her strong work ethic. Typically, she started her workday at four o'clock in the morning. Characteristically, when named a 2004 MacArthur Foundation Fellow, she barely stopped working long enough to take the call, at eight o'clock at night, officially announcing her award of the coveted "genius grant."[13]

With her immense gifts for gathering and assembling various materials in colorful compositions to convey and deepen meaning—consistent with the method and medium of collage—and her passion for history, memory, and myth, Aminah Robinson's work is in rich conversation with the work of Romare Bearden. Her monumental mixed media work of 1997, *A Street Called Home,* evokes

FIG. 5: Romare Bearden, *The Block*, 1971, cut and pasted printed, colored and metallic papers, photostats, graphite, ink marker, gouache, watercolor, and ink on Masonite. The Metropolitan Museum of Art, New York. Gift of Mr. and Mrs. Samuel Shore, 1978. © Romare Bearden Foundation / Licensed by VAGA at Artists Rights Society (ARS), NY Image copyright © The Metropolitan Museum of Art. Image source: Art Resource, NY

Bearden's *The Block,* his epic collage of 1971 (fig. 5). With its bright colors, dense composition, heroic scale, loving tone, and affirmative sensibility, her exuberant streetscape of Columbus's Mount Vernon Avenue, the heart of the city's African American community in the 1940s, warmly recalls his contemporaneous streetscape celebrating everyday life in the Harlem neighborhood of Manhattan.

*A Street Called Home,* Aminah Robinson's "rag painting," is also reminiscent of *Tar Beach,* Faith Ringgold's 1988 "story quilt" celebrating a summer night on a Harlem rooftop that was also later published as a children's book (fig. 6; plate 29a). Transforming childhood memories onto cloth, both beloved projects, Robinson's *A Street Called Home* at the Columbus Museum of Art and Ringgold's *Tar Beach* at the Guggenheim Museum—like Bearden's *The Block* at the Metropolitan Museum— lovingly depict urban African America during the 1930s and 1940s.

Aminah Robinson and Faith Ringgold are part of a small but influential group of women of African descent who drew insight and energy from the struggles for both black liberation and women's liberation at a time—the 1970s and 1980s— when these catalytic sociocultural movements were not always viewed as intersecting. Both women made strikingly original art that creatively combined the narrative art forms (stories, legends, and tales) celebrated by Black Arts Movement cultural workers and the domestic art forms (sewing, quilting, and needlepoint) heralded by artists during the overlapping feminist art movement.

The two artists also share an ingenious, fluid approach to artmaking. They are inclusive and imaginative in their use of a wide array of

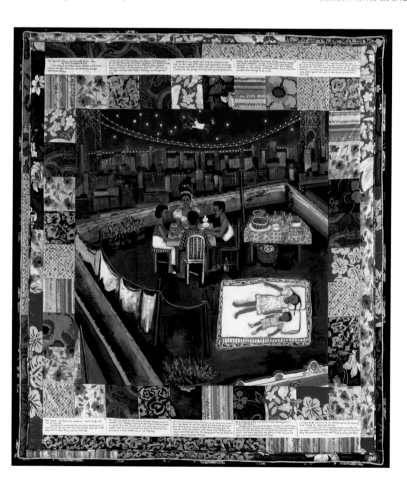

art forms and techniques: sewing, beadwork, handwriting, soft sculpture—including puppets and dolls—painting, printmaking, storytelling, performance; and book making, writing, and illustrating. Both, too, are inventive and imaginative in their creation of new forms of art: Robinson's hogmawg (a clay-like material made of sticks, leaves, mud, glue, grease, and lime) sculpture and Ringgold's story quilts.

Aminah Robinson's house is full of treasured books, including many illustrated art books. On the heavy shelves of her home library are several books devoted to the art and life of Jacob Lawrence. And here, too, there are many fruitful points of comparison. Both artists consistently gave credit and praise to their urban African American communities for shaping and enabling their lifelong artistic journeys. Both sketched neighborhood scenes, frequented local libraries, and conducted extensive research to inform their art. Through their work, both artists recorded and illuminated the movements and struggles that define black lives. Using their own expressive tools, both artists produced—and passed on for the future—monumental bodies of work that creatively visualize black history and life and affirm the innate dignity and humanity of their lovingly chosen subjects.

Both also shared an abiding interest in tools. Jacob Lawrence collected old woodworking tools, while Aminah Robinson collected old flat irons, clothespins, thimbles, and buttons. Lawrence once explained that he saw tools as extensions of hands.[14] And on this subject the two artists are also aligned, as expressive, oversize hands are recurrent in their bodies of work. In Lawrence's 1945 painting *The Shoemaker,* for example, the cobbler's strength and sense of purpose are suggested by his deep concentration, broad shoulders, and, most tellingly, by his large, capable hands (fig. 7).

Strong, expressive, eloquent hands are a consistent presence in Aminah Robinson's artwork (fig. 8). They can be found everywhere: encircling the black faces on her front door; gracing the artwork in her book on African American spirituals, *The Teachings*; playing central roles in her illustrated children's books; and so on. Through these wise and tender hands, the artist reaches for our own:

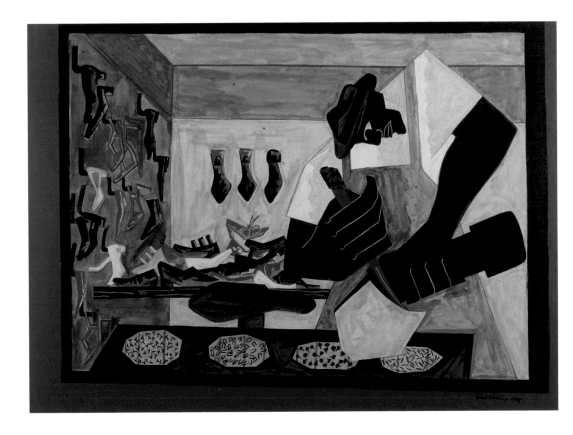

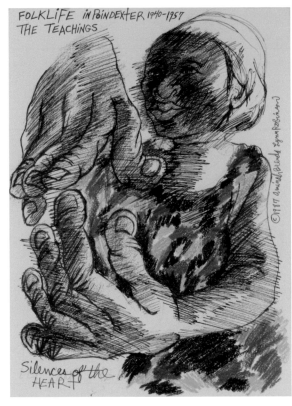

drawing us close to pass on what was handed down to her, and what she held, sustained, and enriched; offering us the precious gifts she lovingly cared for and carried forward before being carried home.

## Notes

1. Aminah Brenda Lynn Robinson, "Along Water Street at the Akron Museum of Art," directed by Dave Kuhar and hosted by Jody Miller, Western Reserve Public Media, 2009, video, 28:12, https://www.youtube.com/watch?v=7Ke7oRlz_-4&t=189s.

2. Aminah Brenda Lynn Robinson, "Conversation with Aminah Robinson and Faith Ringgold." Columbus Museum of Art, October 21, 2010, video, 41:15, https://www.youtube.com/watch?v=9eDTkNecO6E&t=777s.

3. "Conversation with Aminah Robinson and Faith Ringgold."

4. Aminah Brenda Lynn Robinson, "Aminah Robinson Turns 75," produced by Joe Blundo and Scot Kirk, *The Columbus Dispatch*, February 15, 2015, video, 2:03, https://www.youtube.com/watch?v=w2vk_K-PVU4.

5. "Conversation with Aminah Robinson and Faith Ringgold."

6. Decades later, her son, Sydney, recalled his mother's inventive use of these skills: "I remember several years ago, on an early Saturday morning we went to the dam to collect leaves, bark, rocks and twigs for her art. 'Everything can be used' she would say... Taking the leaves, she would first

dry them out, then prepare them in a way so they'd be nearly transparent. Then she would paint on them, and stitch beads on them . . . It was amazing." Sydney Robinson, quoted in Dennison W. Griffith, "Aminah Robinson," in *Gumbo Ya Ya: Anthology of Contemporary African-American Women Artists* (New York: Midmarch Arts Press, 1995), 232.

7. Aminah Brenda Lynn Robinson, *A Street Called Home* (San Diego: Harcourt Brace & Company, 1997), inner cover.

8. Aminah Brenda Lynn Robinson, "Aminah Robinson and Faith Ringgold," recorded by Grace Matthews, June 27, 2010, video, 4:17, https://www.youtube.com/watch?v=vWt9kCVQ1fc&t=97s.

9. "Conversation with Aminah Robinson and Faith Ringgold."

10. "Conversation with Aminah Robinson and Faith Ringgold."

11. "Conversation with Aminah Robinson and Faith Ringgold."

12. "Conversation with Aminah Robinson and Faith Ringgold."

13. "Conversation with Aminah Robinson and Faith Ringgold."

14. Patricia Hills and Peter T. Nesbett, *Jacob Lawrence: Thirty Years of Prints (1963–1993): A Catalogue Raisonné* (Seattle: Francine Seders Gallery, in association with the University of Washington Press, 1994), 36.

FIG. 7: Jacob Lawrence, *The Shoemaker*, 1945, watercolor and gouache on paper, The Metropolitan Museum of Art, New York. George A. Hearn Fund, 1946 © 2019 The Jacob and Gwendolyn Lawrence Foundation, Seattle / Artists Rights Society (ARS), New York Image copyright © The Metropolitan Museum of Art. Image source: Art Resource, NY

FIG. 8: Aminah Brenda Lynn Robinson, *Silences of the Heart* (from *Folklife in Poindexter Village* series), 1987, pen and ink with pastels on paper, 15 × 11 in., Columbus Museum of Art, Estate of the Artist

OPPOSITE: *The Teachings* (cover), detail of plate 69

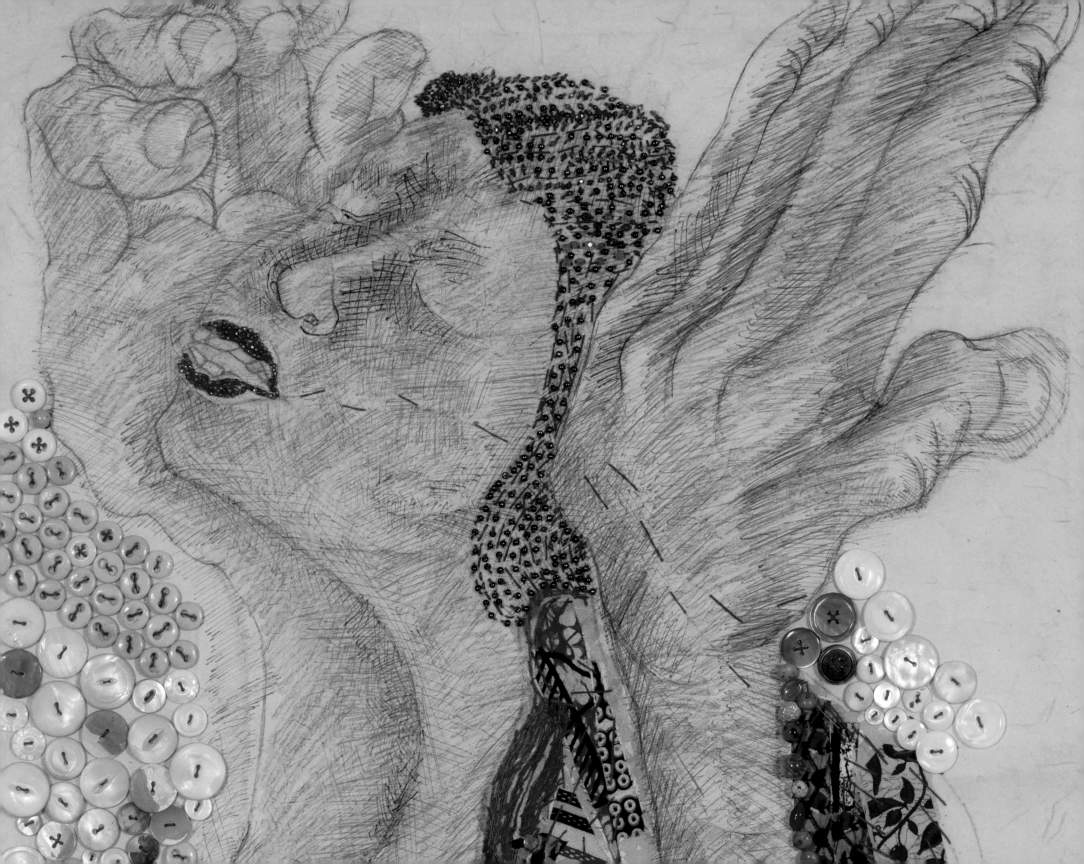

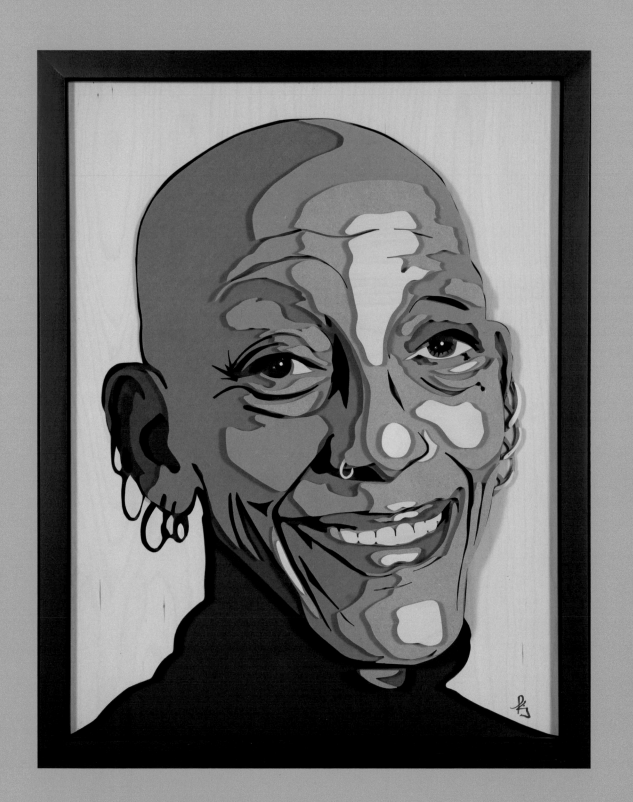

# *Sankofa* and Contemporary Art

Lisa Farrington

TOWARD the end of her life, Aminah Brenda Lynn Robinson presented an arresting figure—lithe, tall, bald, and clear-eyed. Her gaunt face and high cheekbones were equally striking, giving her the appearance of an East African queen or ethereal ancestor (fig. 1). Perhaps she was just such an avatar, given her unique take on art, which was, in both form and content, the embodiment of the concept of *Sankofa.* A word from the Twi language of southern Ghana, *Sankofa* literally translates as "return, go, fetch, seek, take" or "to go back and get."[1] Conceptually, the word refers to the practice of studying the past in order to navigate the present and plan for the future. Robinson employed this philosophy throughout her art by way of certain preferred iconographical themes—slavery, civil rights, women elders, ancestors, and family of both the near and distant past. For Robinson, community began with the family in all its iterations—blood relatives, "fictive" kin or chosen family, and forbears.[2]

Robinson's adherence to the concept of *Sankofa* is evident in most of her oeuvre, particularly the Memory Maps of her home community in Columbus, Ohio; her handmade historical books; and her monumental, multimedia RagGonNons,[3] which recount everything from Robinson's world travels to her family histories and the history of Africa. The artist's dedication to "looking back" is something she shares with any number of African American artists. Noteworthy among these is multimedia and performance artist Xaviera Simmons (born 1974). Simmons documents her performances in her capacity as a photographer and, like Robinson, routinely makes use of found objects. In the spirit of *Sankofa,* Simmons's 2007 performance *One Day and Back Then* (fig. 2) references

in its title the black past and future. Separate moments in time are merged in a lush field of golden reeds that alludes to the African motherland before imperialism, colonialism, and the slave trade. In Simmons's fantasy world, a nude woman (the artist) in blackface (indeed, covered entirely in black pigment) with brightly painted red lips and an afro wig, sits solemnly in a stylized African throne staring at the viewer. She is both minstrel and goddess; African and African American; the butt of a racist joke and having the last laugh. Simmons's art deconstructs rather than instructs, questions rather than documents. In using this methodology, she differs from Robinson, whose love and reverence for community precluded such sardonic portrayals as of those of Simmons.

## Civil Rights: The Dignity of the Working Class
Throughout her life, Robinson was surrounded by communities of both the familial and the "fictive kin" variety.

FIG. 1 (OPPOSITE): Percy C. King, *Aminah Robinson,* 2019, birch plywood, Masonite, and compressed particle board, 31⅞ × 25⅜ × 2¼ in., Columbus Museum of Art, Museum Purchase, Derby Fund, 2019.005

FIG. 2 (ABOVE RIGHT): Xaviera Simmons, *One Day and Back Then (Sitting),* 2007, Chromira C-print, ed. 3/7, 30 × 40 in., Rubell Family Collection, Miami. © Xaviera Simmons. Courtesy the artist and David Castillo Gallery.

From them she learned of her ancestors, who were taken from Angola and had been slaves in Sapelo, Georgia. She also learned about African history more broadly, particularly the Middle Passage[4]—the deadly slave ship voyage across the Atlantic, whose victims were also Robinson's ancestors. For instance, Robinson's paternal Great-Aunt Cornelia (aka "Themba") Johnson's family lived on Sapelo Island until after the Civil War. Cornelia made a point of sharing accounts of her past with her grandniece, who chronicled what she learned in words and images. A dizzying aggregation of thread, yarn, fabric, and buttons, *Sapelo Island, Hog Hammock Community Quilt* (plate 56) documents, in epic fashion, the faces, figures, history, and lives of Robinson's Sapelo family.[5]

Accessible only by plane or boat, Sapelo is a remote island where, during the eighteenth and nineteenth centuries, slaves taken from West Africa were brought to work the cotton and sugarcane fields. Due to its isolation as a barrier island, the slaves worked primarily under their own supervision, creating a uniquely African-centered community. Today, only a single populated neighborhood remains on Sapelo—Hog Hammock—hosting less than

fifty residents. When Robinson visited there for the first time in 1983, there were seventy residents. The artist felt an urgency to document the fast-ebbing community, and did so in a number of works such as *A Way of Life is Slowly Passing Away* of 1983 (fig. 3), which delicately portrays a quiet, almost otherworldly scene of women hulling rice (in the Mali, West Africa, fashion) and feeding pigs and chickens. A grave cross and the haunting faces of the dead complete the vignette. As much as anything, Robinson documented here the dying of African traditions in America. Robinson's *A Way of Life* shares much in common with works by artists Kerry James Marshall (born 1955) and Romare Bearden (1911–1988).[6]

Best known for his kaleidoscopic collages of urban life, Bearden, too, was a chronicler of the African American experience. Impossible to pigeonhole, Bearden worked in styles that ranged from social realism to postmodernism. Born in Charlotte, North Carolina, Bearden spent much of his life in the urban North—Pittsburgh and Harlem. The black communities that touched his life in the South, North, and the Caribbean were central themes in Bearden's art. His monochromatic collage *Watching*

FIG. 3 (LEFT): Aminah Brenda Lynn Robinson, *A Way of Life is Slowly Passing Away*, 1983, pen and ink with pastel on paper, 5¼ × 8¼ in., Columbus Museum of Art, Estate of the Artist

FIG. 4 (RIGHT): Romare Bearden, *Watching the Good Trains Go By*, 1964, collage, 13¾ × 16⅞ in., Columbus Museum of Art, Museum purchase, Derby Fund, from the Philip J. and Suzanne Schiller Collection of American Social Commentary Art, 1930-1970. © Romare Bearden Foundation / Licensed by VAGA at Artists Rights Society (ARS), NY

*the Good Trains Go By* (fig. 4), for example, depicts church buildings and a gathering of black folks standing in a field with patchwork clothing and bare feet. The scene also features a chicken and tin pails, alluding to the artist's memories of North Carolina. The eyes of Bearden's figures stare outward at a moving train—a reference to the Great Migration, which brought both Bearden's and Robinson's families (and 1.5 million other blacks) from the rural South to the urban North between 1910 and 1930 in an effort to escape Jim Crow racism.

Neo-Expressionist[7] Kerry James Marshall is likewise known for his visual narratives about African American history and society, populated by black-pigmented figures in urban settings. He also often utilizes collage; and like Bearden, was born in the South (Birmingham, Alabama). By age eight, however, Marshall had moved to a Watts housing project in Los Angeles, which was not unlike the Poindexter Village housing project in Columbus where Robinson once lived and which was the subject of so much of her work. Marshall's *Watts, 1963* (fig. 5) bears comparison to both the style of Robinson's art as well as to her Poindexter Village subject matter. Part of Marshall's *Garden Project* series, this monumental canvas portrays well-dressed black children tending to the gardens in

their housing project. In crisp white shirt and dress, the boy, the girl, and a sleeping man portray dignity amidst poverty. The scene is filled with flora, fauna, a romantic sunset, and heraldic banners printed with pleasant phrases such as "Better Homes Better Gardens" and "There's More of Everything"—an ironic foil to the actual poverty-ridden conditions of public housing.

Robinson's work *A Street Called Home* (plate 29a) is analogous to Marshall's in several ways. Although more epic in scope, Robinson's piece depicts the urban black existence of her lower-income community with equal dignity and panache. There are both somber and light-hearted moments in Robinson's frieze-like work, which features dozens of figures, neighborhood storefronts and signage, professionals going to work, hawkers of all types, sleeping dogs, and artists painting *en plein air*. As frank chroniclers of the palimpsest nature of African American city life, Robinson, Marshall, and Bearden are true kindred spirits.

Having lived on the edge of poverty herself for many years, Robinson was always concerned with the socioeconomic conditions of African Americans, as evinced by her choice of subject matter—such as a series of drawings of homeless people inspired by a 1989 trip to New York City (fig. 6). She paid more than artistic lip service to her concerns. As a young woman, Robinson participated in the 1963 March on Washington to demand civil rights for blacks. She was an active member of the civil rights groups CORE (the Congress of Racial Equality) and the NAACP, participating in numerous demonstrations against racism as early as 1958.[8] In the words of scholar and curator Annegreth Taylor Nill, "One must see Robinson's work in light of the struggle of African Americans for freedom and recognition or, at the very least, for visibility."[9] Visibility was Robinson's goal as much as anything, and her lifelong dedication to depictions of the black poor and working class is the proof of this commitment.

In the pastel and acrylic painting *Field Hand—Hands of an Artist* (plate 74), for example, Robinson clearly identifies herself (and artists in general) with the archetypal "worker," as first defined by Karl Marx and Friedrich Engels in their theory of art. Essentially, they posited that

FIG. 5 (LEFT): Kerry James Marshall, *Watts, 1963*, 1995, acrylic and collage on canvas, 114 × 135 in., ©Kerry James Marshall, courtesy of the artist and Jack Shainman Gallery, New York, NY

FIG. 6 (RIGHT): Aminah Brenda Lynn Robinson. *New York Homeless Woman (Study)*, 1989, pen and ink with pastels on color paper, 11½ × 8¾ in., Columbus Museum of Art, Estate of the Artist

one's socioeconomic condition shaped one's life; and that it was the calling of the visual artist to depict these conditions with as much fidelity as possible, and with an aim toward educating viewers and thus improving worker conditions.[10] Robinson's art fits firmly within this socialist tradition. It is concerned throughout with the rights of the poor to have access to the same socioeconomic bounty as the middle and upper classes. Her imagery not only chronicles black life and history honestly, but it enlightens, teaches, and educates viewers about African Americans, from the microcosm of her Poindexter Village housing project to the macrocosms of the Middle Passage and the Great Migration. In fact, Robinson was a bibliophile who began her career in the late 1950s working as a library assistant in the history department of the main branch of the city's public library. She maintained an extensive home library on African and African American history throughout her life.[11] She believed that awareness of the Middle Passage, specifically, had the capacity to promote spiritual growth in African Americans. In her words, "As horrendous as it was, there is something good that has come out of it."[12]

*Field Hand* portrays a seated woman working, not in the fields as the title suggests, but with needle and yarn, creating the very fabric art for which Robinson herself is so well known. In this picture, a slave is transformed from the myth of the cotton-picking dullard into a fabric artist. For most enslaved women, creativity had few outlets beyond those of the seamstress, tatter, basket-weaver, or quilt-maker. The beauty and innovation seen in so many of these historical objects points to the fact that their makers were fine artists as much as they were crafts-women. From this feminist vantage point, one can read *Field Hand* as a work that raises alleged "women's work" (working with fabric) to the level of high art. In this, Robinson shares much in common with contemporary artists such as Faith Ringgold (born 1930).

While Simmons, Bearden, and Marshall share elements of iconography and form with Robinson, Ringgold shares much more, including the use of fabric in her art, doll-making (soft sculpture), an interest in civil rights, feminist and women's themes, and African American

history. Typical of Ringgold's paintings are their fabric borders, which began as a way to "soft-stretch" her paintings (eliminating the rigid wooden stretcher) so that she—a diminutive mother living in a Harlem apartment building—could fold her paintings and thus easily and economically transport and store them. Over time, Ringgold added batting and backing to her paintings, which subsequently became known as "story quilts" because, like Robinson, Ringgold often wrote extensive narratives directly onto her work. Nearly twenty of these quilted stories—which range from feminist-oriented fiction to accounts of notable African Americans and historic events in black history—have been published as children's books. Ringgold's interest in books is yet another commonality shared with Robinson, who was a prolific writer and maker of both published and one-of-a-kind handmade books, such as one about Columbus abolitionist James Preston Poindexter (fig. 7).

## Slavery: Making the Invisible Visible

A topic that riveted both Ringgold and Robinson was slavery. An examination of their unique takes on the subject highlights both differences and similarities. During a 1979 trip to Senegal, Robinson visited Gorée Island, located two miles off the coast of Dakar. It is the site of La Maison des Esclaves (the House of Slaves). An erstwhile way station for Africans about to embark on the Middle Passage, the Maison was constructed in the 1770s and incorporates the infamous Door of No Return—so named because, once slaves passed through it, Africa was forever lost to them. In red, black, and sand-colored tones—suggestive of black skin, the sands of Africa, and the blood of enslaved Africans—Robinson's 1980 *Roots Begin with Gorée Island* (plates 47, 48) depicts multiple views of the Maison's interior curving staircase, leading to the Door of No Return. Oversized chains and shackles emerge from a dark archway, tellingly painted white as the instrument of torture and imprisonment used by the white Portuguese, French, Dutch, and British slavers whom Robinson identifies with graffiti-like writing on the walls of the Maison. Indeed, a lengthy narrative detailing the history of the Maison covers the walls of Robinson's haunting structure.

FIG. 7: Aminah Brenda Lynn Robinson, *James Preston Poindexter 1819–1907*, 1989, cloth and found objects on paper, 13 × 10 in., Columbus Museum of Art, Estate of the Artist

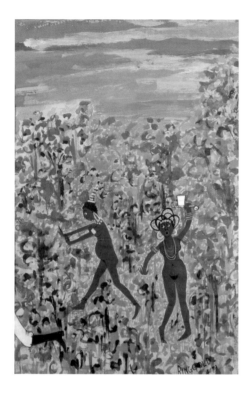

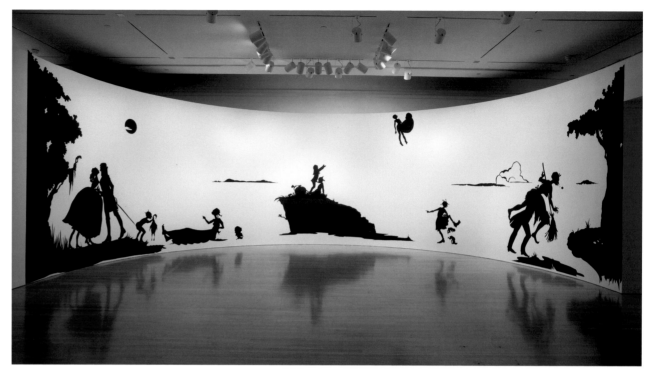

FIG. 8 (LEFT): Faith Ringgold, *Help: Slave Rape Series #16*, 1973, acrylic on canvas, 58 × 32 in., Private Collection, © Faith Ringgold / Artists Rights Society (ARS), New York, Courtesy ACA Galleries, New York

FIG. 9 (RIGHT): Kara Walker, *Gone: An Historical Romance of a Civil War as It Occurred b'tween the Dusky Thighs of One Young Negress and Her Heart*, 1994–97, cut paper on wall, Overall 13 × 50 ft., Museum of Modern Art, New York, Gift of The Speyer Family Foundation in honor of Marie-Josée Kravis, © Kara Walker, Courtesy of Sikkema Jenkins & Co., New York

After visiting the Maison, Robinson remarked, "I heard my ancestors, I could feel them, I could smell them, and I wanted to bring that to this piece."[13] In *Roots Begin at Gorée Island* she surely has achieved that aim.

Ringgold's slave imagery focuses on an empowered fantasy rather than a wretched reality. Beginning in the 1970s and continuing into the twenty-first century, Ringgold created numerous painting series about slavery, wherein she virtually rewrites the history of the period, invariably with a more positive outcome. Most fascinating among these is Ringgold's first foray into the motif—her *Slave Rape Series* (fig. 8), which portrays surprisingly active (vs. traditionally passive) female nudes in lush tropical settings. Using an illustrative vernacular much like Robinson's, Ringgold painted her women running, leaping, and pregnant! The figures share in common with Xaviera Simmons's nude (fig. 2) a disturbingly comical quality in their resemblance to black minstrels—large, staring white eyes and bright red lips. Described by historian Moira Roth as a "Trojan Horse" delivery of a deeply somber message,

whimsy ends at the work's surface.[14] Articulating her particular understanding of *Sankofa*, Ringgold stated, "*Slave Rape* . . . was like going back and trying to understand the roots of black women . . . what were we like before we got here? I wanted to be in touch with that."[15]

Another contemporary African American artist who has turned to themes of slave rape in her work is the controversial MacArthur "genius award" winner Kara Walker (born 1969). One can detect in Walker's art a like-minded penchant for Ringgold's Trojan Horse-style delivery and for reconfiguring slave history. Her large-format, lyrical, and vintage-style black silhouettes at first beguile with their Victorian-era charm and then horrify with their brutality. Inspired by the 1936 Pulitzer Prize-winning Margaret Mitchell novel and the 1939 Oscar Award-winning film *Gone with the Wind*, Walker's panorama *Gone* (fig. 9) depicts a dozen scenes of rape and inhumanity. While many read her work as obscene reinforcements of stereotypes, Walker acolytes applaud her double-edged pageants of beauty and horror.

As absorbed with shedding light on the slave experience as Ringgold and Walker, Robinson devoted many works of art to the theme of slavery. Robinson's goal differed, however. She was less intent on rewriting history than on illuminating its horrors. This aim becomes evident in her works on the topic that serve as unerring teaching tools. Among these is Robinson's *1804 Ohio Legislature Enacted the First Black Laws* (fig. 10). It documents the statutes that were put in place from 1804 to 1849 to curb the rights of free blacks and allow for the repatriation of runaways to slave-holding states. As a foil, Robinson includes in the same drawing, images and text that detail a mass meeting held in Columbus several years after the repeal of the Black Laws to celebrate the Emancipation Proclamation. Although a non-slave state, Ohio made it nearly impossible for out-of-state blacks to relocate there.

Robinson's epic RagGonNon *Dad's Journey* (plate 39) documents African history from past to present and from eastern to western hemispheres. It incorporates an accordion book entitled *Nightmare of Horrors: The Atlantic Slave Trade* (plate 38), on one page of which the artist painted a scene of naked African men and women leaping overboard during the Middle Passage to commit suicide by drowning. Rather than endure the passage—spending up to twenty hours daily in squatting positions below decks, quite literally suffocating from the toxic fumes of their own feces and urine—they chose drowning. For them, the sea offered a pathway home or to the next life, where their forebears awaited them.[16] Here, as always, Robinson remains loyal to truth-telling and revelation by highlighting and personalizing experiences that contemporary culture tends to obscure. The Middle Passage was such a critical event to Robinson (who repeatedly referenced it in her oeuvre) because she understood it as an arc or a bridge—a bridge between living African Americans and their deceased African ancestors.[17]

### Feminism: Exalting Women

*She is my sister. She is my friend. She is my teacher and mentor.*

—Aminah Robinson, *Symphonic Poem*

Robinson's art not only combines disparate materials but often fuses several themes within a single work, in particular the motifs of slavery and powerful women. Underground Railroad heroine Harriet Tubman (1822–1913) is an ideal example of the two motifs and has inspired Robinson and any number of contemporary artists for precisely that reason. As an escaped slave, Civil War spy, and Underground Railroad conductor who risked her life and freedom more than a dozen times to lead some seventy escapees to freedom, Tubman embodies the concept of female empowerment.[18] Among several works devoted to Tubman, Robinson's 1988 three-quarter life-size puppet of her (plate 53) pays understated homage to the freedom fighter, fashioning her as she actually was—frail, slender, and dignified.

Contemporary artist Alison Saar (born 1956) was less faithful to Tubman's physical appearance than Robinson

FIG. 10: Aminah Brenda Lynn Robinson, *1804 Ohio Legislature Enacted the First Black Laws*, date unknown, pen and ink on parchment, 15 × 14 in., Columbus Museum of Art, Estate of the Artist

when she created *Nocturne Navigator* (fig. 11). A powerfully monumental sculpture, it exemplifies Tubman's character more so than her physiognomy. The title of the piece identifies Tubman's activities navigating the secret Underground Railroad trails under cover of night. A shimmering indigo patina coats the double life-size figure whose face looks up to the heavens and whose hands are outstretched as if in prayer. A relatively small torso of Tubman is perched above a massive hooped skirt suggestive in its size and pyramidal shape of the authority of Tubman's spirit and determination.

Tubman was hardly the only powerful black woman who captured Robinson's attention. She also created a portrait of Pulitzer Prize-winning poet Maya Angelou (1928–2014) (plate 108). Her drawing of Angelou is delicately articulated on a sepia-toned envelope flap, and utilizes text to describe the poet. If we compare these somber and relatively monochromatic works with portraits of famous African American women by multimedia artist Mickalene Thomas (born 1971), it becomes evident that Robinson, who lived so much of her own professional life in quiet obscurity, understood women's power as an inner rather than outer strength. Thomas, on the other

hand, gives us rhinestone-studded portraits of celebrities such as Oprah Winfrey (fig. 12) using a Neo-Pop[19] vernacular that correctly frames popular culture in all its brashness and superficiality.

Robinson was equally captivated by the women of her own extended family, whom she came to know as centerpieces of her community—as keepers of traditions, as *griots,* teachers, and the glue that held families and communities together against all odds. In Robinson's words, women are

> the ones who pass [traditions] on. During slavery, women were the ones who kept things together . . . we were all separated and somehow the enslaved women tried to keep the family together. Even after slavery it was the women who tried to keep the family intact.[20]

Through learning about and interacting with these extraordinary women, over many decades Robinson created a substantial body of work to honor and remember them. A particularly influential woman in the artist's circle was her beloved Great-Aunt Cornelia. Robinson dedicated a number of pieces to Cornelia, chronicling her life. Robinson titled these works *Themba*—the Xhosa (Bantu, South African) word for "hope."

Striking among the *Themba* pieces is the monumental *Themba: Incantations,* completed over sixteen years between 1996 and 2012 (plate 44). Almost nine feet long, *Incantations* depicts four powerful women on a brilliant orange ground, separated by vertical rows of buttons, creating the effect of animation cels and, thus, of time passing. With energized bodies and arms raised, three of the figures wear ritual masks; and additional masks populate the composition, suggesting African religious ceremonies. The fourth and last figure is unmasked and wearing a floral print dress, likely reminiscent of Aunt Cornelia herself. Viewers are treated to a timeline of life, beginning in Africa and ending in America, and to the idea that, by praying to the ancestral gods, Cornelia was able to live "a life of grace and hope"— words that Robinson etched in the lower right corner of this epic piece.

FIG. 11: Alison Saar, *Nocturne Navigator,* 1998, copper, wood, neon, 144 in. (height), Columbus Museum of Art, Museum Purchase with partial funds donated by the Columbus Chapter of Links, Inc., 1998.005a-d. © Alison Saar. Courtesy of the artist.

FIG. 12: Mickalene Thomas, *When Ends Meet (Oprah Winfrey),* 2008, left panel of diptych, screen print with hand-applied rhinestones on four-ply museum board, 20 × 23⅞ in., Columbus Museum of Art, Museum Purchase, Westwater Fund, 2012.030a&b. © 2019 Mickalene Thomas / Artists Rights Society (ARS), New York

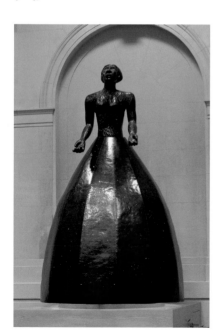

In the 1990 series, *A Clutch of Blossoms,* Robinson uses portraiture to pay homage to the influential women in her life, from her mother and her mother's circle of friends to celebrated women of color. The series includes a portrait of Ursel White Lewis (fig. 13), an arts patron and milliner who founded the Columbus State Library's permanent art collection.[21] Lewis, who was one of Robinson's earliest and staunchest supporters, is represented wearing one of her own hats. The artist's palette is a dazzling combination of jewel tones—ruby, gold, amethyst—giving the correct impression of Lewis as a fashionista known for wearing glittering earrings and brooches. Robinson also gave Lewis oversized hands, indicative of a life of giving to the artistic community of Columbus. In Robinson's words,

> *A Clutch of Blossoms* is a body of work about women I have known and women whom I have admired through the years. It's mothers and daughters—it's a celebration of womanhood. The women are the ones who clutch their families and the families are the blossoms. The series involves my mother, my friends, mothers, and daughters— the women who gather together the blossoms.[22]

*A Clutch of Blossoms* was not Robinson's first foray into this arena. A decade before, she completed a suite of portraits for a miniature loose-leaf book titled, *Afrikan-Amerikan Women: Life and History* (plate 64). Historic in scope, as the title suggests, these portraits are devoted to such outstanding African American women as eighteenth-century enslaved poet Phillis Wheatley; civil rights activists and educators Mary McLeod Bethune, Mary Church Terrell, Septima Poinsette Clark, and Daisy Bates; Robinson's mother; and others.

*A Clutch of Blossoms* and *Afrikan-Amerikan Women* correspond to the work of feminist fabric artist Emma Amos. Amos's collection of portraits of women entitled *The Gift* (fig. 14) also consists of portraits of women artists, friends, and colleagues who exerted significant and positive influences on her life. As its title suggests, *The Gift* is precisely that—a bequest given by Amos to her daughter, India, for her twentieth birthday. *The Gift* and *A Clutch of Blossoms* share a reverence for the friendship

and support given to these two artists by the women who were the driving forces in their lives.

## Conclusion

Although this discussion undertook three themes in Robinson's art—civil rights, slavery, and feminism—the artist has more in common with contemporary artists than these leitmotifs. In many works by Robinson there exists a nexus of formal elements that situate her firmly within several postmodern and contemporary genres. For instance, the text-based work of conceptual artists such as Howardena Pindell (born 1943), Pat Ward Williams (born 1948), and Glenn Ligon (born 1960); the intermedia performances and installations of Houston Conwill (born 1947), Terry Adkins (1953–2014), Adrian Piper (born 1948), and Renée Green (born 1959); and the assemblage art of Alison Saar and Willi Cole (born 1956) all dovetail with Robinson's aesthetics. Finally, in drawing style, Robinson is closely linked to the black Neo-Expressionists such as Kara Walker and Kerry James Marshall. Paradoxically, although Robinson was as preoccupied with the African past and present as the artists of the Afrofuturist[23] movement, she was not interested in this group's use of science fiction and fantasy to reconfigure history; rather she undertook to set down African American history as accurately as possible.

In the past, Robinson has been mistaken for a vernacular or folk artist, despite her extensive arts education. She shares this in common with Alison Saar, whose early found object assemblages sometimes had a raw, unfinished quality that appeared naive to the untrained eye. In all truthfulness, the "folk" designation is classist at best; racist at worst. It marginalizes artists due to their economic status or inability to afford art training. Robinson's art is hardly the product of any deficiency, financial or otherwise. On the contrary, it is as current, sophisticated, politically and socially engaged as any contemporary art one might name. One simply needs to look—and learn— without preconceptions and with the same inquisitiveness that dominated Robinson's life journey.

FIG. 13: Aminah Brenda Lynn Robinson, *Ursel White Lewis—A Clutch of Blossoms,* 1990, pen and ink with pastel on Pellon ™, 60¼ × 22 in., Columbus Museum of Art, Gift of the Artist, 2014.050.030

FIG. 14: Emma Amos, *The Gift*, 1990–94,
48 watercolor portraits, 19¾ × 26 in. each,
9 × 21 ft. total © 2019 Emma Amos / Licensed
by VAGA at Artists Rights Society (ARS), NY;
Courtesy of the artist and RYAN LEE Gallery,
New York, photo by Becket Logan

## Notes

1. *Akuapem-Twi Language Guide* (Ghana: Akan Language Committee, Ghana, Bureau of Ghana Languages, 1995), 56.

2. Kenneth Goings, "Preface," in *Symphonic Poem: The Art of Aminah Brenda Lynn Robinson* (Columbus, OH: Columbus Museum of Art, 2002), 11.

3. RagGonNon refers to large-scale fabric-based works by Robinson that are complex in form and content. They are created over many years; portray events over long periods; and multi-media, often including layers of buttons, beads, books, music boxes, and other found objects. Carole M. Genshaft, et al., *Aminah's World*, Columbus Museum of Art, accessed July 9, 2010, http://www.aminahsworld.org/meet/bio.php.

4. Middle Passage refers to the second leg of the cyclical Triangular Slave Trade routes of the seventeenth to nineteenth centuries. Textiles, rum, and manufactured goods were shipped to Africa from Europe and traded for slaves in the first passage. Slaves were then shipped to the Americas in the Middle Passage and sold for raw goods. Sugar, tobacco, and cotton were shipped to Europe for refinement in the final passage. An estimated two million (some estimates are as high as eleven million) Africans lost their lives during the grueling three- to twelve-week journey, due to murder, starvation, disease, drowning, suicide, and suffocation in the near airless cargo holds. See Herbert S. Klein, *The Atlantic Slave Trade* (Cambridge University Press, 2010), chapter 6; Aminah Robinson (2 March 2002), taped interview with Ramona Austin, tape 1, quoted in *Symphonic Poem*, 55; Genshaft, *Symphonic Poem: A Case Study In Museum Education*, PhD dissertation, Columbus: Ohio State University, 2007), 66.

5. Genshaft, *Symphonic Poem: A Case Study In Museum Education*, 15, 144, 190.

6. Melissa L. Cooper, *Making Gullah: A History of Sapelo Islanders, Race, and the American Imagination* (Chapel Hill: University of North Carolina Press, 2017), 304; Genshaft, *Symphonic Poem*, 21, 144.

7. Neo-Expressionism is a style of art originating in the late twentieth century that rejected Minimalism and Conceptualism in favor of strong colors, figurative imagery, and active surface textures.

8. Genshaft, *Symphonic Poem: A Case Study In Museum Education*, 190.

9. Nill, "My Life Is Lived from Within," 34.

10. Gordon Graham, "The Marxist Theory of Art," *The British Journal of Aesthetics* 37, issue 2, April 1997, 109–117; Karl Marx and Friedrich Engels, *Manifesto of The Communist Party* (English version 1888; Project Gutenberg ebook #61, released 2005, unpaginated, http://www.gutenberg.org/cache/epub/61/pg61.html).

11. Genshaft, *Symphonic Poem: A Case Study In Museum Education,* 25, 191.

12. Robinson, *Symphonic Poem,* 68, 136.

13. Robinson, *Symphonic Poem,* 137.

14. Moira Roth, "A Trojan Horse," in *Faith Ringgold: A 25 Year Survey,* ed. Eleanor Flomenhaft (Hempstead, NY: Fine Arts Museum of Long Island, 1990), 49.

15. "Faith Ringgold, Archives of American Art Oral History," interview by Cynthia Nadelman, 6 September to 18 October 1989 (Washington, D.C.: Archives of American Art, 1989), 234.

16. Eric R. Taylor, *If We Must Die: Shipboard Insurrections in the Era of the Atlantic Slave Trade* (Baton Rouge, LA: LSU Press, 2006), 37–38; Antonio T. Bly, "Crossing the Lake of Fire: Slave Resistance during the Middle Passage, 1720–1842," *Journal of Negro History* 83, no. 3 (1998): 178–186; Marcus Rediker, *The Slave Ship: A Human History* (London: Penguin Books, 2007), 40.

17. Ramona Austin, "History, Myth and Memory: Africa in the Art of Aminah Robinson," *Symphonic Poem,* 56; Robinson, *Symphonic Poem,* 136.

18. Milton C. Sernett, *Harriet Tubman: Myth, Memory, and History* (Durham, NC: Duke University Press, 2007), passim.

19. Neo-Pop refers to a 1980s and 1990s art movement inspired by 1960s Pop Art but with emphasis on more contemporary subjects and materials.

20. Robinson, *Symphonic Poem,* 140.

21. Pamela June Anderson, *Lady Lewis: Her Hats, and Her Gloves: The Conversational and Pictorial Memoirs of Ursel White Lewis, the First African American Patron of The Arts In Columbus* (Columbus, Ohio: Kojo Photos, 2007), viii.

22. Robinson, *Symphonic Poem,* 91.

23. Afrofuturism is an art movement that incorporates science fiction and fantasy with themes concerning Africans in the global diaspora.

# Aminah's Music

William "Ted" McDaniel

IT is not uncommon for artists who may have earned their fame or reputation for excellence in one medium to display interest in or demonstrate their love for another. Frankly speaking, we do not have to look very far to find singers, dancers, musicians, and actors who enjoy wearing the hat of the visual artist. Many are familiar with the great jazz trumpeter Miles Davis, who created impressive paintings on canvas. The opposite, the visual artist becoming a composer of music, is rarer; and the idea inspires commentary and analysis. Aminah Brenda Lynn Robinson is known and celebrated in the world of the visual arts for her rich and diverse body of work, which includes paintings, drawings, woodcuts, sculptures, and mixed media constructions of appliquéd cloth panels. Not widely known is that Robinson, in the midst of her vast corpus of art, also created sheet music.

The *Italian Cantos* (figs. 1–3) is a captivating and provocative example of her music, indeed, her musical mind, thoughts, and ideas. I have learned that Robinson did have some formal study of music. In the rec center across the street from her home, she listened to classical music, gospel, and jazz; and she and her two sisters took piano lessons. She absorbed and admired the music of fellow African Americans and of classical European composers. Her musical heroes included Howard Hanson, Edward MacDowell, Ludwig van Beethoven, and Johann Sebastian Bach.[1] When one considers that music must have played an important role in Robinson's life, it becomes plausible that she would write her own music with the same imagination, creativity, meaning, and purpose she gave to her art. Perhaps Aminah Robinson had a more literal understanding of the term "art music,"[2] one that

elicits the figurative interpretations in *Italian Cantos*. Inspired by her 2005 trip to Italy, *Italian Cantos* reflects a particular love for the art and varied interests of Leonardo da Vinci. The landscape of hills and valleys surrounding Vinci, Leonardo's birthplace, is reflected in the music.

For me her work begs the question: "Is this music, or is this art?" As I see it, one can offer support for either side of this argument. Consider that her canvas of parchment has the typical artifacts and characters of the Western music notation system, composed of blackened and black-outlined notes. There are quarter notes, half notes, eighth notes, whole notes, dotted eighth notes and sixteenths, eighth notes that are flagged and beamed, notes that are stemmed, triplet note figures, and eighth and two sixteenth note figures. Additionally, Robinson provides a few articulation marks over notes: slurs, ties, and phrase markings. The inclusion of a musical staff with five lines and four spaces, with often properly placed key signatures using flats and sharps, clearly demonstrates that Robinson was familiar with the traditional Western system of music notation. The choice of pitches, range, and contour of musical lines, contrasting rhythmic note groupings, and the extensive use of chords that appear on the first page of the *Italian Cantos* (fig. 1) all suggest that Robinson was deliberately composing music, and not simply using musical notation for a separate artistic purpose.

Robinson's music manuscript is challenging, just like the music of many composers and the work of many visual artists, especially when we attempt to extract meaning and purpose. One of the most arresting elements of her sheet music manuscript is the absence of specified instrumentation. Is her music playable? And,

FIG. 1 (OPPOSITE): Aminah Brenda Lynn Robinson, *Italian Cantos,* 2005, pen and ink on parchment, 15 × 16 in., Columbus Museum of Art, Estate of the Artist

if so, by whom on what? The combining of two staves written in treble and bass clefs gives a hint that this could be for piano or some kind of keyboard instrument, or for a combination of instruments including voice; however, there is no time signature of 4/4 or 3/4 or any suggestion of meter or metrical structure. This point alone does not make a performance impossible, but typically contemporary composers who avoid metric construction "line up" the notes (they define both pitch and rhythm) so that the "conductor" and "performer" understand which notes to play when and how long to play them. Further challenging is the absence of any rests, which are as important as notes because they regulate when to breathe or when to stop playing or singing. This may indeed be a totally free-form piece where the conductor—or performer—makes the decision when to rest. Perhaps the composer Robinson has created a different notational system from the Western norm, "The Aminah Notational System."

Let's assume that Robinson's composition is playable. There are parts of it that could be rendered on piano or sung, and there are many musical lines that could be assigned to instruments. That suggests some sense of orchestration. With those assumptions, what would the music sound like? The dense, chord-like structures on the first page; the Bach-like four-part harmony; the long florid lines that appear with amazing contours that suggest going up and down the hill; and the hemiola-like "two against three note rhythmic groupings" that appear in another section of her work define so much activity, it is difficult to imagine.

Perhaps an even better question to ask: Is her composition musical? There are people (musicians, artists, aestheticians, philosophers, lay people, and so on) who would fiercely defend the idea that "no sound is unmusical." In the end, those who subscribe to this theory believe that we as human beings ultimately determine which sounds are musical, as we experience the rhythms, sounds, and nuances of life.

Aminah Robinson's music is multidimensional. Her music has so much imagery that reflects movement, energy, depth of expression, and architecture. There is symmetry and asymmetry. There are phrases that are

FIG. 2: Aminah Brenda Lynn Robinson, *Italian Cantos*, 2005, pen and ink on parchment, 15 × 16 in., Columbus Museum of Art, Estate of the Artist

FIG. 3: Aminah Brenda Lynn Robinson, *Italian Cantos*, 2005, pen and ink on parchment, 15 × 16 in., Columbus Museum of Art, Estate of the Artist

parallel and non-parallel; contrapuntal lines that appear both horizontal and vertical; suggestions of tonality with key signatures that dance around implied tonal centers rather than define them; flirtations with strong visual movement that suggest human figures swaying and dancing; flagged notes that remind me of individuals following in a line, like children marching behind one another; and musical phrases that are connected with legato phrase markings and ties. I find her music to be imaginative and inspiring, yet very challenging and even complex. I am not bothered that I cannot explain all that she has done with her music and her work as a composer, just as I cannot explain all the meaning in a painting or drawing. She has generated more questions for me than I have answers for. I can say that her music has inspired me to continue to study this artist, and for that I am enriched and grateful to her.

## Notes

1. ABLR 19-4, *Journal*, 1962.

2. Art music is music composed by the trained musician, as contrasted with folk and popular music. https://www.merriam-webster.com › dictionary.

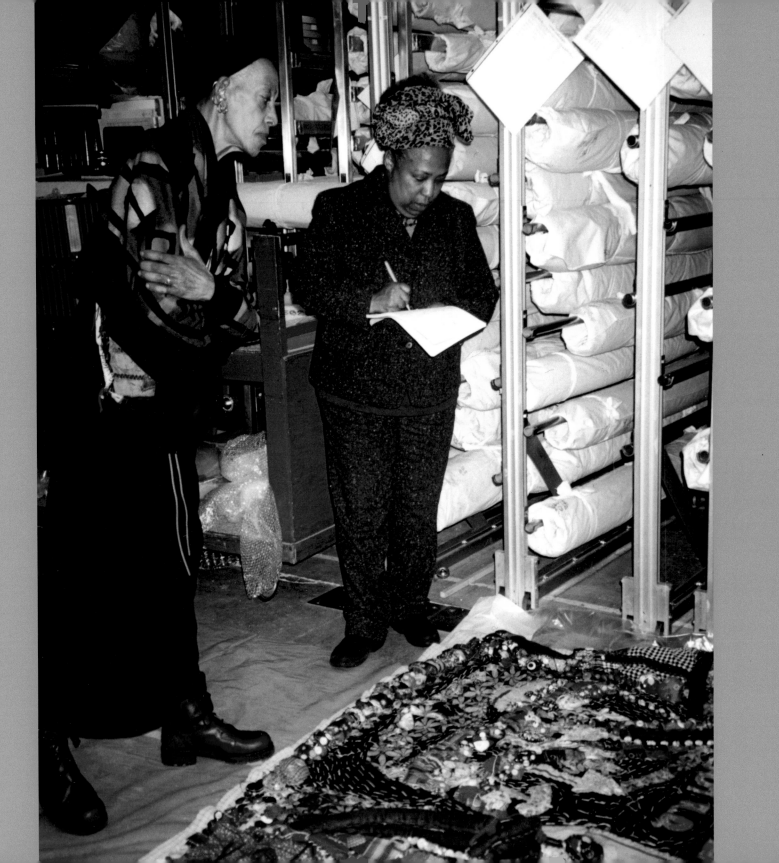

# A Song of Being

*Challenges of the Art of Aminah Robinson*

Ramona Austin

IT is rare to have the access to an artist's life and work that Aminah Robinson has given by way of her complex bequest of art, writings, collections, house, and books to the Columbus Museum of Art. This is important because, as an African American woman born in the heyday of the Great Migration of blacks from the South and privy to stories of those who were born into slavery or shortly thereafter, Robinson was a witness to Africans becoming African Americans and the centrality of African American women to that process. More importantly, she translated that story into her art as an epic of memory and healing, and the triumph of community overcoming affliction. She elevated ordinary men and women to protagonists of a grand story without which the true historic experience of America cannot be told. It is also a story of reclamation of self: of the battle against erasure of the psyche pummeled by racist caricature and propaganda; of the implacable and insistent sustaining of cultural gifts brought from the motherland by ancestors and honored in the deep woods of the South during slavery; and in the cadences of performance and prayer in black churches.

Robinson's art and life present a series of inquiries that are a unique opportunity to investigate, and bring into clarity, the scope of the experience of Africans in the Americas and the making of African American expressive culture. The continuity stretches from slave art to the florescence of African American Art during the Harlem Renaissance in New York in the 1920s to the second Renaissance centered in Chicago at mid-twentieth century; to artists who are working today, making a significant cultural statement within American culture and making liaisons on a global scale with black diaspora cultures and

beyond. The essays and works presented in this catalog open up enormous possibilities for exploring Robinson's accomplishments against the backdrop of the African American experience, and the role expressive culture played in that experience. This work earned her many accolades during her lifetime, including a MacArthur Fellowship as a unique cultural contributor. Explored here are a few of the themes and artistic devices in her work that, through strategic questions and explorations, link her to a worldwide community of peoples of African descent. This is especially true in the Americas, where 250 years of the afflictions of bondage, and the ongoing quest for justice and healing, have forged indelible bonds of experience and memory.

Robinson's work presents specific motifs: the Middle Passage; African historic figures; landscapes and fauna; migration north from the South; scenes of social injustice and protest; cultural transformation through healing; memory (cultural preservation through reclamation); the afflictions imposed upon African Americans' bodies and souls; and the valorization of black culture. Her focus is the indispensable contribution of the strength, resilience, moral action, and mastery of cultural aesthetics of black women as mothers, teachers, guardians, builders, and protectors, as well as the ultimate preservers of black life and spiritual well-being. And finally, Robinson extended her visual vocabulary and sense of community through cultural experiences outside of America in Africa, Chile, Peru, Italy, and Israel. Other black artists of her time were experiencing similar journeys, ones that also included family roots in the Great Migration. Many who entered art academies experienced discouragement from the faculty

OPPOSITE: Ramona Austin and Robinson examining the artist's work in storage at the Columbus Museum of Art, 2002

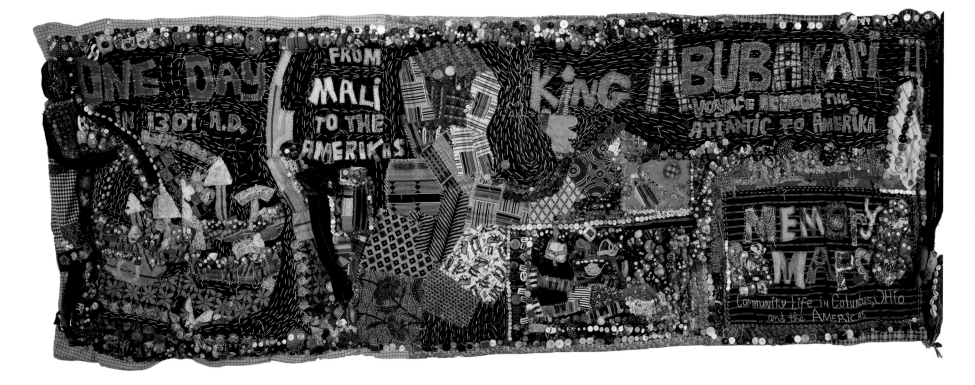

for incorporating the aesthetics of the rural South, of slave culture, and of urban practices born of these influences in their creative explorations and finished works. The continuities and discontinuities of these experiences need charting for a larger picture of the development of American art. Many, like Aminah Robinson, are no longer living. Living artists who do not have oral histories must be interviewed. Archival material of deceased artists must be combed to create the aggregate cultural manifestation of their art practices from their perspectives, upon which communalities among black artists have been formed. Many received little or no recognition during their lifetimes. Robinson's achievement of a remarkably coherent vision is a worthy landscape upon which to frame the visions of African American artists, trained and untrained, and to define salient overarching themes concerning black art in America that are common among them.

African Americans have adopted the term *griot*— found among many parts of northern West Africa, from

whose peoples many African Americans have come—for those artists that seek to preserve the history of the community and of the African homeland. Griots were experts attached to royal personages; they were living depositories for the knowledge of the culture. Praise for cultural heroes is a part of this tradition. The tradition continues today as the need remains to preserve cultural memories and art forms that conserve ancient histories and traditions. As a griot, Robinson created visual praise poems of her community. The role of music in communing with the metaphysical world is part of this tradition. Music is the means to communicate with the otherworld in many cultures. Among many African peoples it is the world of the ancestors.

Many black artists have sought to portray black music visually in their works as a supreme mode of artistry, communication, and healing in black culture. It is so repetitive a theme that these motifs bear studying for their overt and covert symbolism in the works of African

FIG. 1: Aminah Brenda Lynn Robinson, *One Day in 1307 A.D.: King Abubakari II*, 1985-92, Button Beaded RagGonNon Music Box Pop-UP BoOk [sic.]: cloth, thread, buttons, beads, paper, paint, graphite, and music boxes, 55 × 135 in., Columbus Museum of Art, Gift of the Artist, 2002.016.001

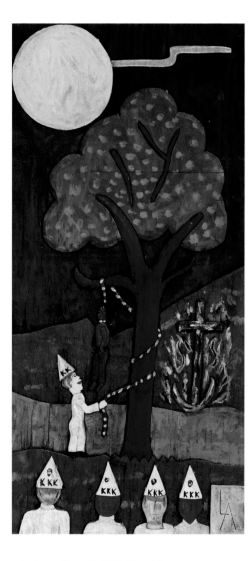

FIG. 2: Leroy Almon, Sr., *KKK*, 1989, painted
bas-relief carving on wood panel © Leroy
Almon, Sr. Courtesy of Baron and Ellin Gordon
Galleries, Old Dominion University, Norfolk, VA

American artists. Like the works of Homer, who recorded the centuries-old oral traditions of the Greeks, music is an ancient aural and oral method of preserving history in Africa; it requires deep cultural knowledge, skilled musicianship, poetic speech, and praise singing. Cognate aspects are found in Robinson's work, such as incorporating music boxes into her textile RagGonNon paneled constructions, and she also filled her journals with musical notations of her own devising (plate 100b).

In her works, Robinson visually preserved her vision of historical events of great import, such as the Middle Passage of captives across the Atlantic from Africa into slavery, which figures so profoundly in African American thought and experience (plate 49). Other works are praise poems of the cultural heroes of her community and of Africa, such as the voyage to the New World by Abubakari II, a *mansa* (ruler) of fourteenth-century Mali (fig. 1). Black American religious culture is steeped in prophetic imagery. This imagery is tied to times of spiritual need, often to the experience of affliction wrought upon the community by forces that they struggle to control. Special personalities come forth who are anointed by others as prophets, or who are self-anointed through a religious experience that is often characterized as hearing a voice, considered divine, that guides the anointed to fulfill his or her prophetic role. The community may also anoint such a person, who often stands out as having special qualities of comportment and speech. That person is considered above the ordinary by way of special gifts that are otherworldly; they unite the past and present, and they lead the community into the future. Robinson found her prophet in Columbus self-taught artist and preacher Elijah Pierce, who, during walks, introduced her to sacred knowledge. Noted African historian Professor Djibril Tamsir Niane, himself descended from griots of Guinea, relates in the introduction to his 1960 translation of the oral epic poem, *Sundiata: An Epic of Old Mali,* words of the griot Mamadou Kouyaté, who opined:

> Other peoples use writing to record the past, but this invention has killed the faculty of memory among them. They do not feel the past anymore,

for writing lacks the warmth of the human voice. With them everybody thinks he knows, whereas learning should be a secret. The prophets did not write and their words have been all the more vivid as a result. What paltry learning is that which is congealed in dumb books![1]

The interdiction of reading and writing for American slaves made books objects of veneration. They are a major art form for Robinson. That reading, writing, or owning books had to be covert activities also kept alive the veneration of the spoken word as African culture became African American culture. Kouyaté's statement is of great import as it thus has implications for black expressive culture in America. Intertwined in America are prophetism's role in addressing affliction; music's role as a means of achieving metaphysical dimensions; and memory's role in preserving history. Analyzing Robinson's body of work points to the great richness in African American culture, one that requires deep, interdisciplinary investigation. Artists like Robinson are especially important to this endeavor.

One of the most important aspects of Robinson's life history, and a fascinating aspect of black culture, is her spiritual discipleship to non-canonical artist Elijah Pierce. That Robinson was a trained artist is immaterial, especially in this context. What dimension of black culture makes this possible? The prophetic tradition within black culture that has been discussed above is tied to the overt experience of oppression during slavery and the continuing overt and covert oppression of blacks after slavery. This explains why the imagery of the deliverance of the Israelites from Egypt's pharaoh by God through Moses is so predominant within black theology, imagery, and music. Within the Christian and non-Christian traditions of black culture is the constant search for, and anointment (or self-anointment) of, leaders with a spiritual aspect—from Nat Turner and Harriet Tubman to Martin Luther King, Jr. and Malcolm X. This is most often seen as part of prophetic declamation in African American culture. The African American prophetic tradition is distinct from the prophetic tradition of Euro-American

Christianity in that the prophetic or biblical voices that are emphasized are those concerned with the poor and oppressed, as seen in the writings of James H. Cone, the esteemed black theologian and founder of black liberation theology. He points to three themes that give black liberation theology its philosophical basis "[the book of] Exodus, prophets, and Jesus."[2] Cone also notes the profound importance of the cross and the hanging tree as two of the most emotionally charged symbols in African American expressive culture (fig. 2; plate 43).[3]

A starting point for charting the textual and visual references in African American art can begin in 1829 with David Walker's *Appeal to the Coloured Citizens of the World*.[4] Walker published one of the most radical documents in American history. His *Appeal* was an unflinching condemnation of the oppression and injustice of slavery created by the evil of American racism, for which he prophesied divine retribution if not remedied. Slave songs set the stage for the profound imagery of the spirituals. The struggle for civil rights led to the black liberation theology of such thinkers as James H. Cone, who is joined by other great black theologians such as the late Howard Thurman.[5] These and other scholars across disciplines helped create important textual foundations and cultural references in essential spheres of expressive culture within the African American experience. These investigations and redresses led to such florescences as the Black Arts Movement empowering self-actualization and cultural validation. The art of Aminah Robinson charts along the continuum of these historical and metaphysical concerns and philosophies in black culture. This has been a rich vein of inquiry that has yet to be exhausted by scholarship, as these movements continue to create influential themes and symbology.

Aminah Robinson not only tells the story. Through her journals she also shows us the process by which she came to these stories as her life's work. She infects us with her passion and the resoluteness of her quest. We are stunned because the spirituality of her work is so potent—she pulls us in like a religious conversion. Her audience is foremost black, but the humanity of her quest takes us all in, enchants, educates, and admonishes

us that we all beat with a common heart. Robinson shows us the power of the black aesthetic, its place in world culture in which she was schooled by her family and community, importantly her Great-Aunt Cordelia Johnson (also known as Cornelia), who inspired her *Themba* series of works; her spiritual mentor, Elijah Pierce; and her black Columbus community. That aesthetic is absorptive of other cultures and open to constant change. It is improvisational and alchemical molding expressions of creative culture that is always more than the sum of its parts yet remains unique to its roots like blues and jazz.

Another example of this cultural absorption in Robinson's work is her use of red cloth charms that heal, protect, or destroy. They are sacred medicines, a retained practice Central Africa's Kongo peoples brought with them in the slave trade across the Atlantic Ocean. They entered the country by way of Haiti through the Gulf of Mexico to New Orleans, Louisiana, and Mobile, Alabama, to become a part of the voodoo/hoodoo conjuring traditions of the South.[6] Similar charms of stuffed cloth are utilized by Robinson in her work to charge them, and the story they tell, with power (fig. 3). Robinson claimed that she was first introduced to the secrets of these charms by her Great-Aunt Cordelia Johnson, an act that recalls the words of griot Mamadou Kouyaté: "learning should be a secret."[7] She would disclose only so much, and she was firm about not revealing what she had been taught as it pertained to the cloth charms she attached to her textiles. She only acquiesced when she understood that others recognized what the pieces meant.

Robinson was introduced to the visual arts by her father and uncle, and through early exposure to many books, such as those about Leonardo da Vinci. She loved his aesthetic, which she rapturously recalled as impactful and exciting to her. There was no contradiction with her great-aunt's aesthetic. Leonardo's magnificent drawings were respected and absorbed. The lesson: greatness and inspiration are found everywhere; do not cast them away. Look, feel, absorb, and then play. Inspiration is grounded in the by-ways of the culture, first from the South and then in the congregation of communities transported, foremost by rail, to the urban North. The world you live in

FIG. 3: Aminah Brenda Lynn Robinson, *Nightmare of Horrors: The Atlantic Slave Trade* (from *Dad's Journey* series), detail, 1995, mixed media, 13½ × 10 × 3½ in., Columbus Museum of Art, Estate of the Artist

will seek to confine you. Use everything you encounter to pry open the bars. Creativity is your path to freedom. Art is life, indestructible. This experience and communication are essential elements of the experience of many black people in the Americas and globally. Aminah Robinson's art poses questions lighting a roadmap to the soul of the black diaspora. A chorus of black creative artists join her in her reflections. What is the score of their song?

## Notes

1 . D. T. Niane, "The Words of the Griot Mamadou Kouyaté," *Sundiate: An Epic of Old Mali,* trans. G. D. Pickett, rev. ed. (Harlow, Essex, England: Pearson Education Ltd, 2006), 1.

2. James H. Cone, "Said I Wasn't Gonna Tell Nobody," *The Making of a Black Theologian* (Maryknoll, New York: Orbis Books, 2018).

3. James H. Cone, Pratt Podcasts, "Discussion of His Book, *The Cross and the Lynching Tree,*" March 1, 2012, https://www.prattlibrary.org /booksmedia/podcasts/index.aspx?id=2275, accessed October 23, 2019.

4. *David Walker's Appeal, In Four Articles: Together With A Preamble To The Coloured Citizens Of The World, But In Particular, And Very Expressly, To Those Of The United States Of America,* introduction by Sean Wilentz, rev. ed. (New York: Hill and Wang, 1995).

5. Howard Thurman, *Jesus and the Disinherited,* reprint ed. (Boston: Beacon Press, 1996). Supposedly, Martin Luther King, Jr. always carried a copy of Thurman's seminal work.

6. Interviews with Aminah Robinson 2002 and 2014 about the RagGonNon, *One Day in 1307 A.D.: King Abubakari II, 1985–92* about the work's red and black cloth figures. See also Maude Wahlman's entries for *Pacquet Kongo* and "Vodun dolls," New World Charms section under "Textiles; African American Quilts, Textiles, and Cloth Charms," in Philip M. Peek, Kwesi Yankah, eds., *African Folklore: An Encyclopedia* (New York, London: Taylor & Francis e-Library, 2005), 413. Wahlman mentions red cloth charms manifesting as appliqués on contemporary quilts from Alabama and that these are adapted practices from the Kongo world. Robinson's RagGonNon appears to be a direct application, used here more faithfully to their actual form and meaning: to medicate the textile. Taken together, this exemplifies important aspects of the meaning and power of cloth—and the act of weaving itself in relation to binding community or to communal acts. Robinson's use of the red charms is powerful evidence that her great-aunt transmitted her deep cultural knowledge, rooted in Africa, to her niece.

7. Niane, 1.

*Any work of art must be created by*
*and for the human spirit—must*
*express it, nourish it, enrich it.*
*This work of art is grounded in the*
*physical world, but comes to full*
*bloom in the world of the spirit . . .*

# PORTFOLIO

## HOME AS SANCTUARY

*Whenever I leave my home to visit in another place—I carry in my soul the spirit of Home.*

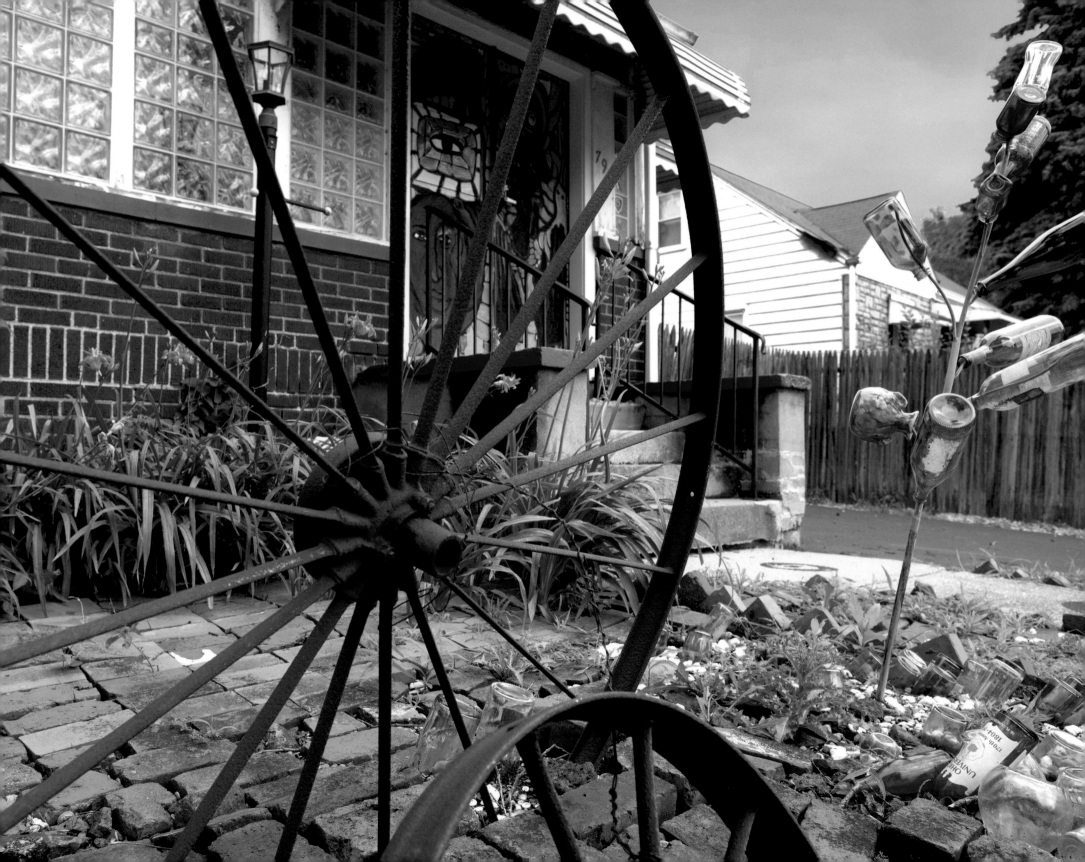

From 1974 to 2015, the year she passed away, Aminah Brenda Lynn Robinson lived on Sunbury Road in the Shepard Community on the near east side of Columbus, Ohio. While a warm and welcoming host at times, she considered her home a sanctuary where she treasured the opportunity to work in solitude. The photographs and objects that follow strive to capture the magic of her home and the spirit of her creative journey. Robinson's home became an artist's residence in 2020.

**1** (PRECEDING PAGE): Exterior of home with bottle garden and carved and painted doors, 2015

**2** *Untitled (Exterior doors)*, 2002, carved and painted wood, 77½ × 60¾ in.

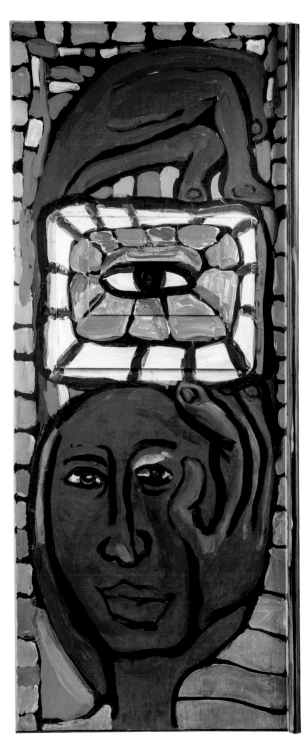
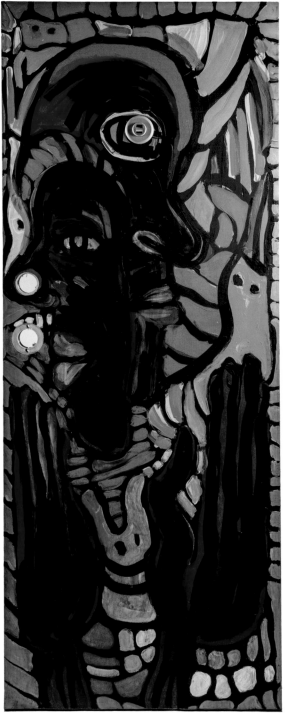

In 2002, Robinson's front doors had to be enlarged in order to move *Gift of Love* (plate 5) to the *Symphonic Poem* exhibition at the Columbus Museum of Art. Robinson immediately began carving and painting new doors (fig. 1) to fit the new spaces. For her, doors held spiritual meaning: "Life becomes an open door to the ancestral waters of memory."

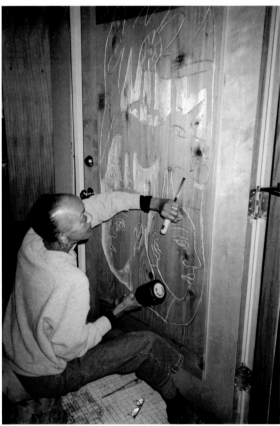

FIG. 1

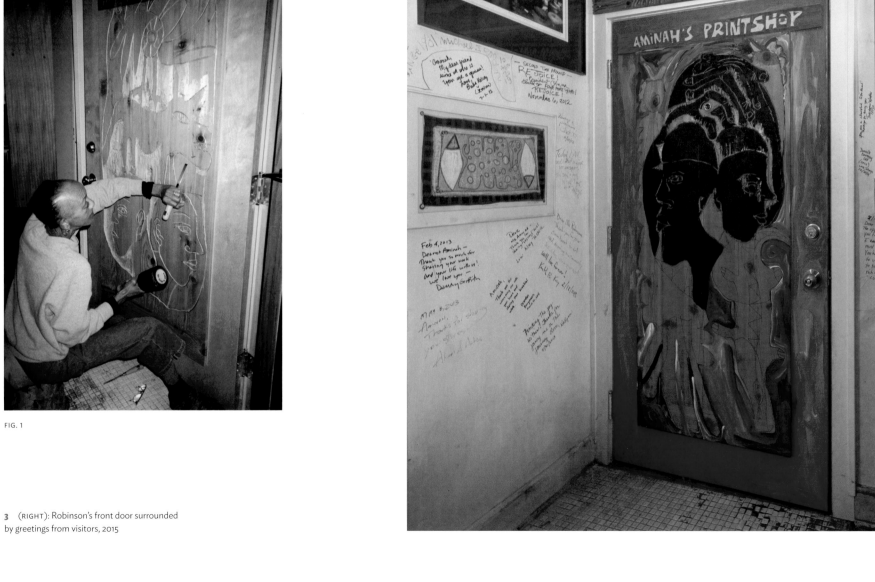

**3** (RIGHT): Robinson's front door surrounded by greetings from visitors, 2015

# LIVING ROOM

Occupying much of the living room was a massive cloth RagGonNon, which Robinson worked on for years at a time. Shelves and cabinets filled with books transformed the space into a library whose walls were adorned with paintings, drawings, and photographs she traded with other artists.

4  Living Room, 2015

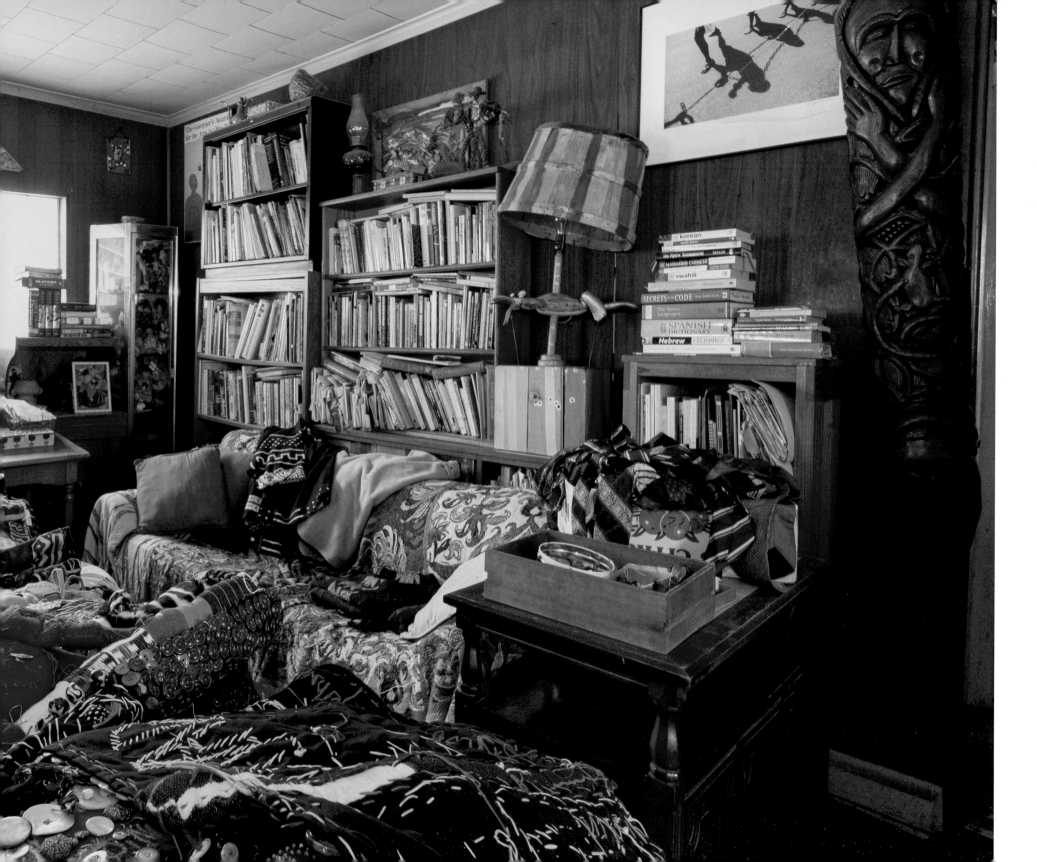

Robinson began working on this chair in 1974, after she purchased the house, and continued adding to it until 2002, when it was transported to the Museum for exhibition. Embellished with music boxes and hogmawg figures of the artist's mother and father, an African king, folk artist Elijah Pierce, and a figure looking backward but moving forward to represent the African concept of *Sankofa,* the throne-like chair provided a safe retreat for Robinson or any guest who occupied it.

**5** *Gift of Love,* 1974–2002, wood, hogmawg, mud, leather, music boxes, and found objects; 61 × 35 × 56 in., Columbus Museum of Art, Gift of the Artist, 2008.005

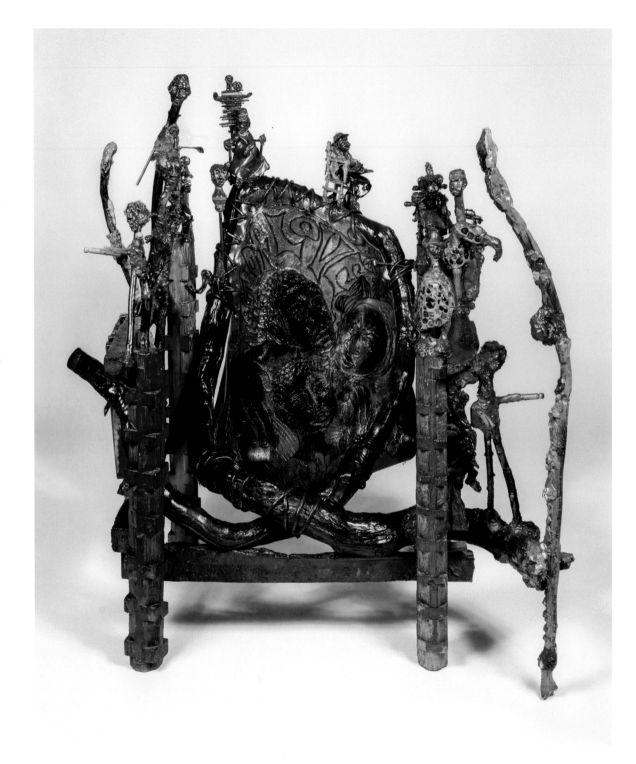

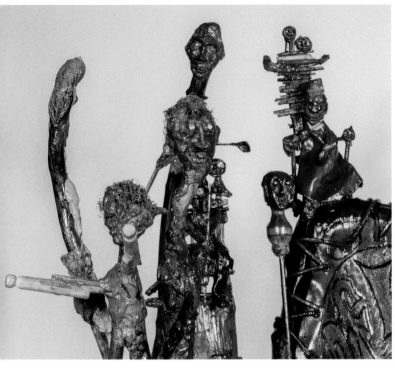

**5A** *Gift of Love*, detail

**5B** *Gift of Love*, detail

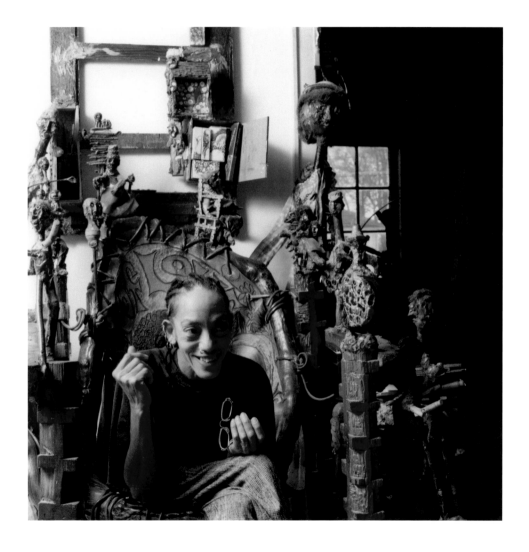

FIG. 2: Robinson seated in *Gift of Love*

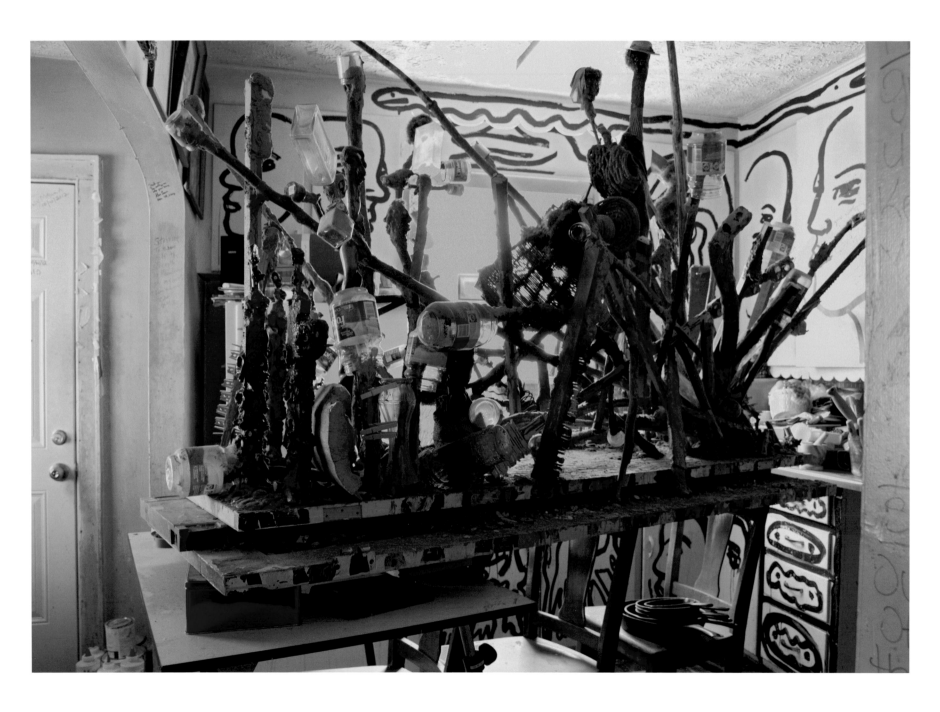

**6B** Rabbit glue and other ingredients Robinson used in making hogmawg

**6C** Kitchen floor mosaic by Robinson, prior to 2005

**6D** Frame construction with Robinson's collection of thimbles

**6E** *The Man Who Crossed the River with a Fox, a Chicken, and a Bag of Grain*, mosaic detail

Robinson furnished the house with treasures she found at garage sales, secondhand stores, and antique shops. Wooden furniture and boxes became the surface for fanciful carvings; and old knobs and handles became a caddy for her paint-brushes (fig. 3, opposite).

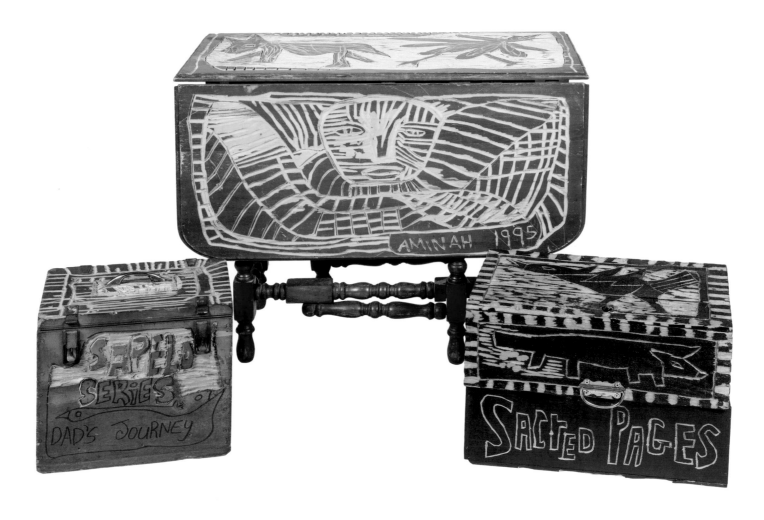

**7** *Untitled (table)*, 1995, carved wood, 30½ × 51 × 36 in.; *Sapelo (box)*, date unknown, carved wood, 13¼ × 14½ × 10⅞ in.; *Sacred Pages (box)*, 1998–2002, carved wood, 14 × 19¼ × 12¾ in.

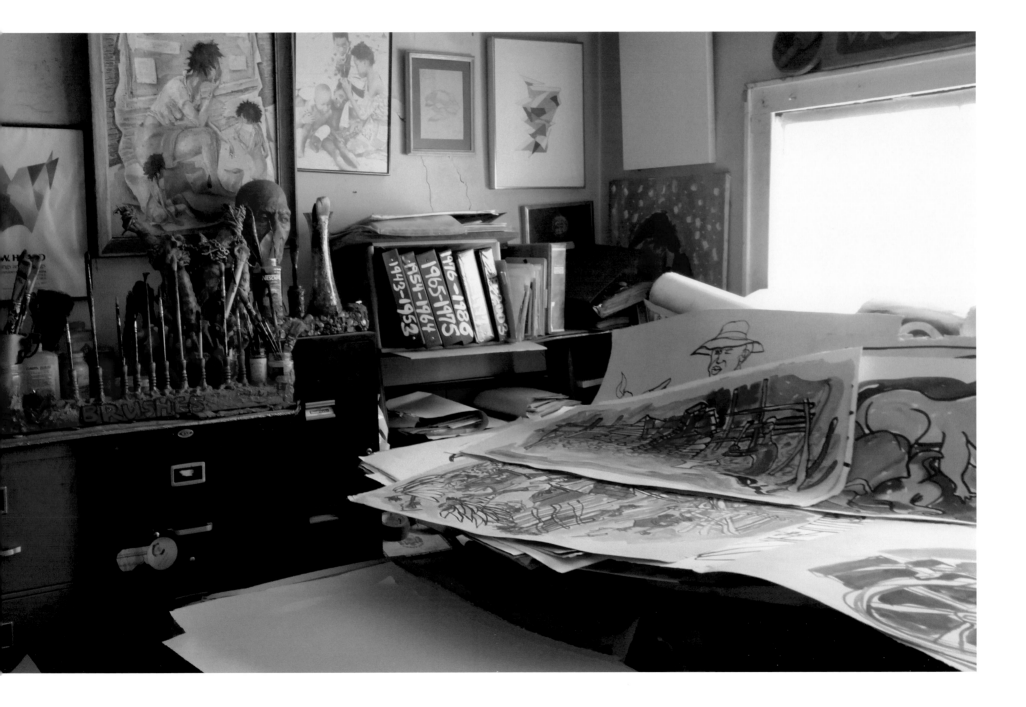

# DOLL HOUSE STUDIO

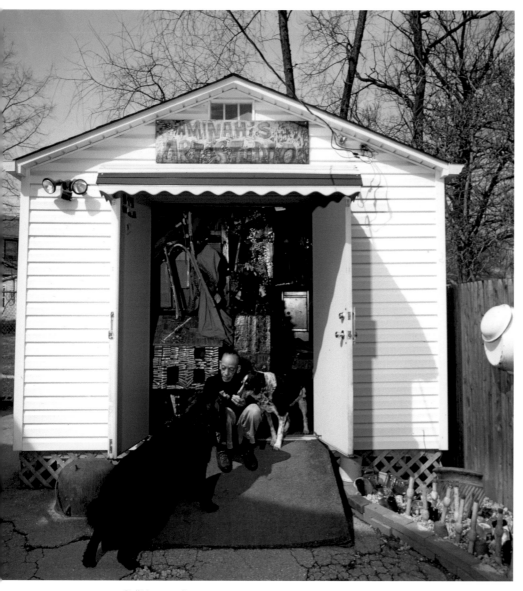

**9**   Doll House studio, 2002

**9A**   Fence adjacent to Doll House Studio

In 1998, Robinson had a free-standing studio built near the house.

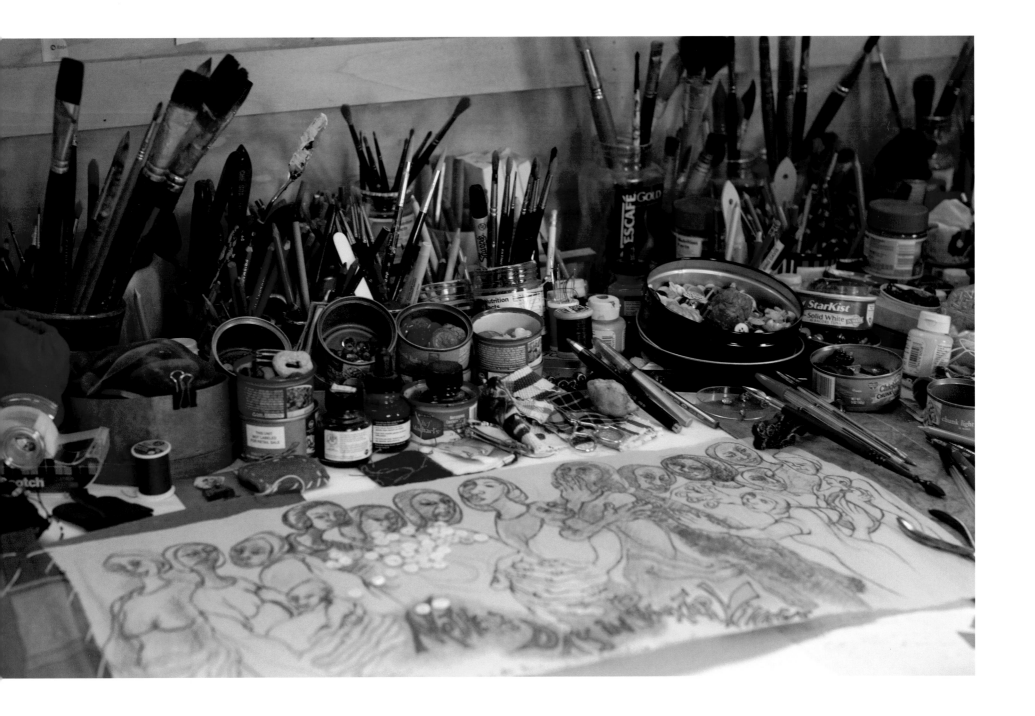

After receiving a MacArthur
Fellowship and its monetary
prize in 2004, Robinson had a
new studio constructed at the
rear of the house. She called the
space "Aminah's Sanctuary."

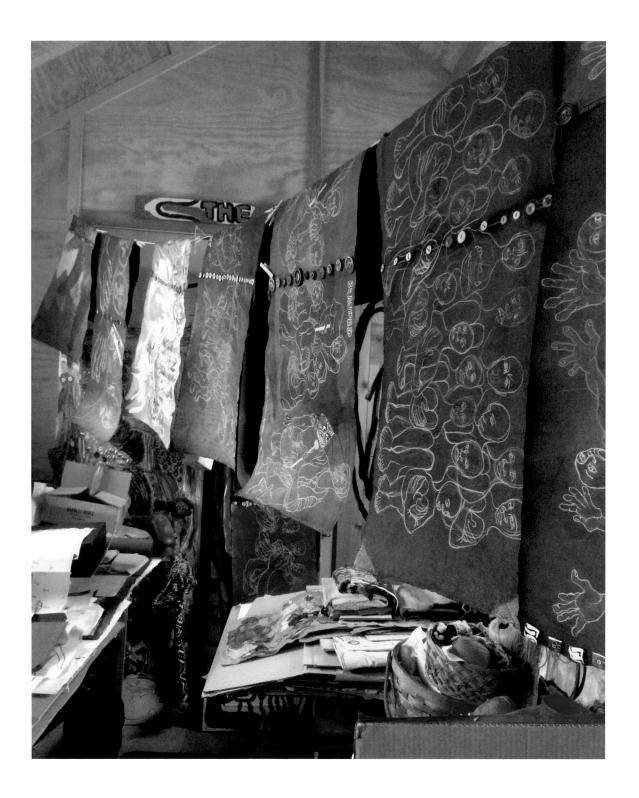

**10A** (OPPOSITE): Sanctuary Studio, detail, 2015

**10B** Sanctuary Studio, 2015

# WRITING ROOM

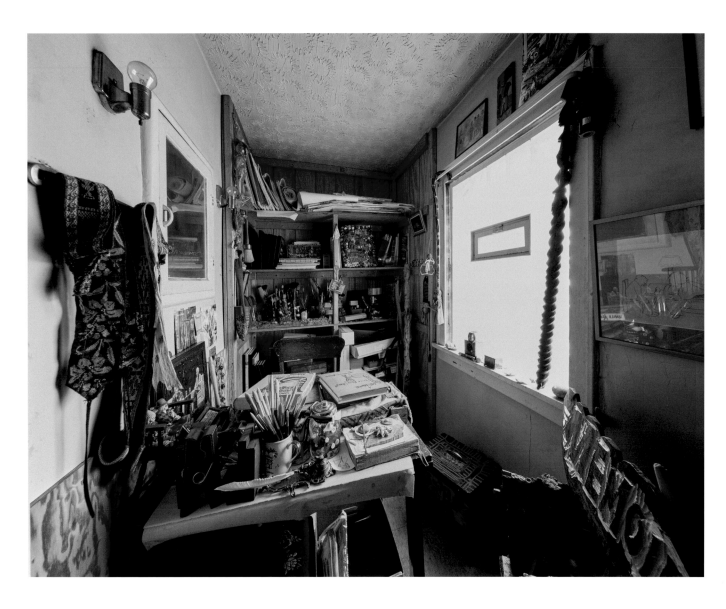

Robinson converted a small upstairs space to a private area where she wrote amid collections of pens, pencils, colored inks, family photographs, keepsakes, and art. The Writing Room was a sanctuary where, in the solitude she valued so highly, she penned letters to friends and acquaintances, recorded histories and legends of her elders on irregular pieces of parchment, and wrote journal entries and memoirs. Long-treasured record albums provided a soothing backdrop of classical, jazz, and gospel music.

**11A, 11B**  Writing Room, 2nd floor, 2015

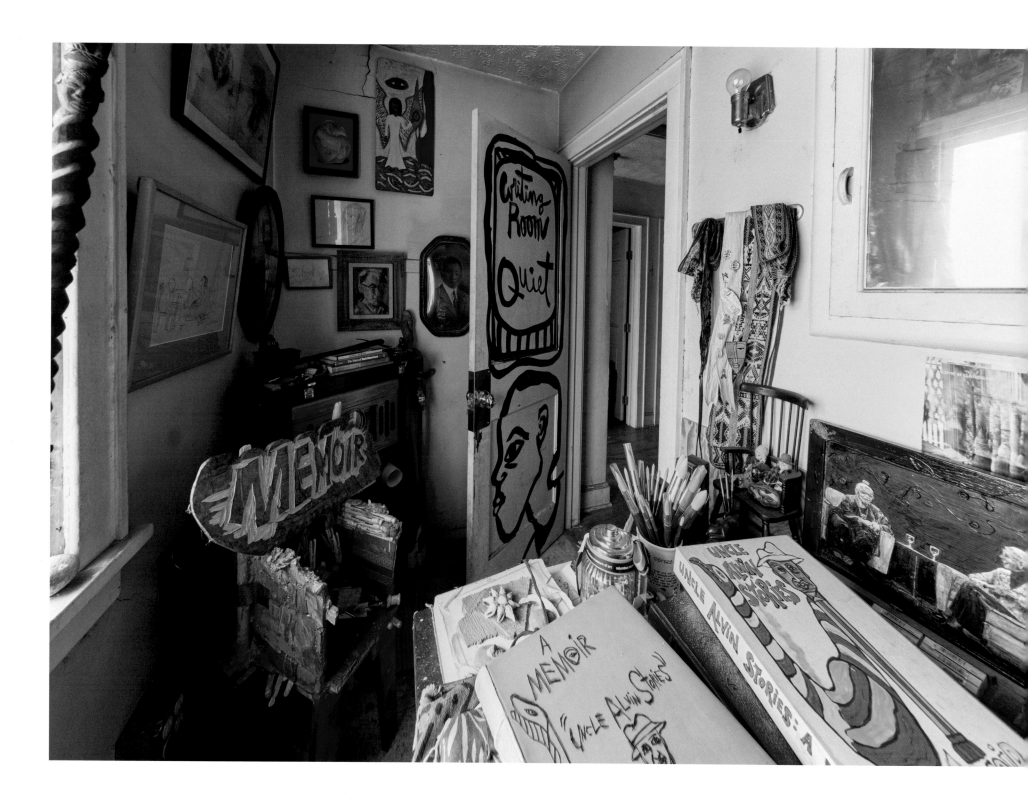

## BEGINNINGS

*The dreams, visions, and images of my
early childhood life have never left me—
wherever I am, wherever I journey, the
early life in Poindexter Village is always
with me. It was a rich community where
generations of families have lived out their
lives. This early life keeps my spirit free
and always meditative.*

12 *Self (Self-Portrait)*, 1948, watercolor,
23¾ × 17¾ in.

By the time Robinson was eight years old, she was adept at using oil, watercolor, pastel, charcoal, and graphite to produce landscapes, still lifes, self-portraits, and portraits of family and friends.

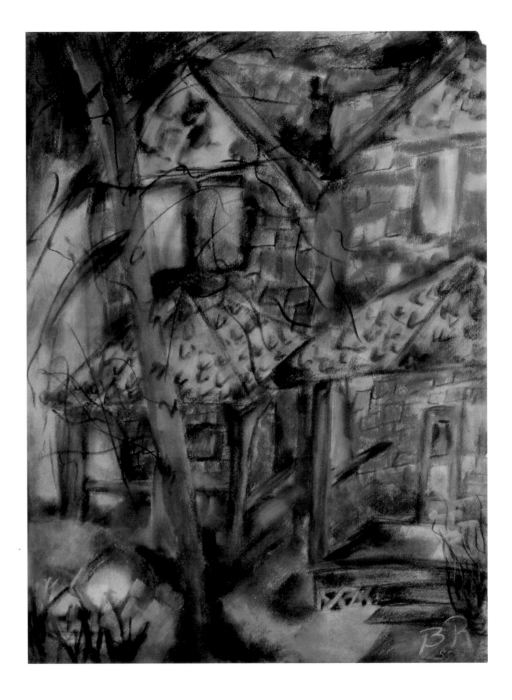

**13**  *Untitled (Two Houses)*, 1950, pastel on paper, 23¾ × 17¾ in.

**14** *Untitled [Child and Malcolm X?]*
(*Dedicated to Pepo Vitani*), 1956, graphite on
heavy stock, 19¼ × 20 in.

**15**  *My Sister Sharron* (Robinson's younger
sister), 1950, oil on board, 20 × 15½ in.

**16**  *Sue* (Robinson's older sister), 1952,
oil on board, 30 × 25 in.

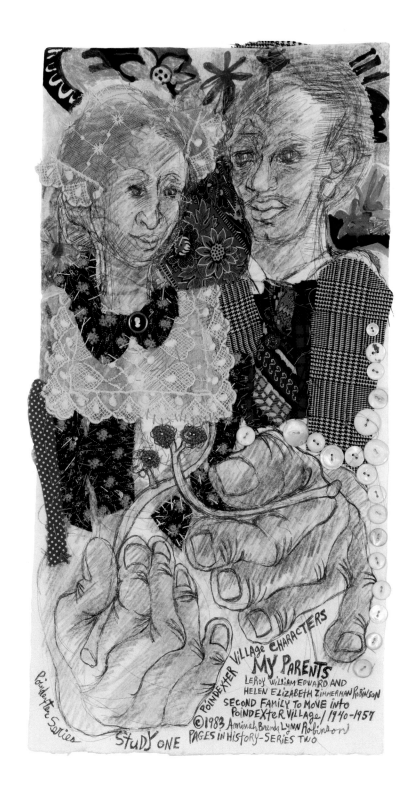

**17** *My Parents,* 1983, pen and ink with found objects on paper, 19½ × 10 in.

In this surrealistic portrait, Robinson's pet rabbit emerges from the young artist's head. Robinson described paintings like this one as "dreams on canvas."

**18** *Self-Portrait with Rabbit,* 1959, oil on canvas, 38¼ × 29¼ in.

After her marriage to Clarence Robinson, a member of the Air Force, Robinson traveled to several military bases with him including one in Biloxi, Mississippi, where she gave birth to a son, Sydney, who became the subject of many portraits.

**20** *Sydney,* 1972, oil on canvas, 28 × 22 in.

**19** *Sydney, 4 yrs, Puerto Rico,* 1971, pen and ink on paper, 17¾ × 12 in., Columbus Museum of Art, Gift of the Artist, 2007.038.008

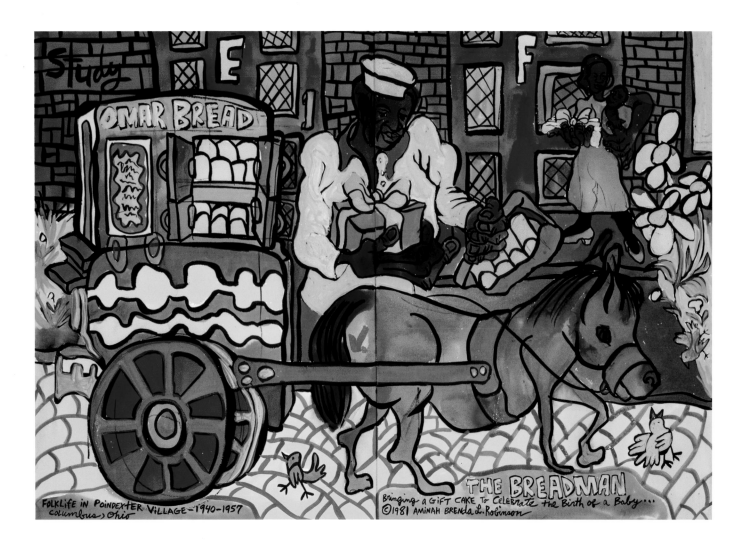

**21** *The Breadman,* 1981, watercolor with thread, 29¾ × 44 in.

Later in life, Robinson depicted remembered scenes of celebrating holidays and growing up in her family's Poindexter Village apartment. She painted these scenes in glowing colors on both paper and cloth.

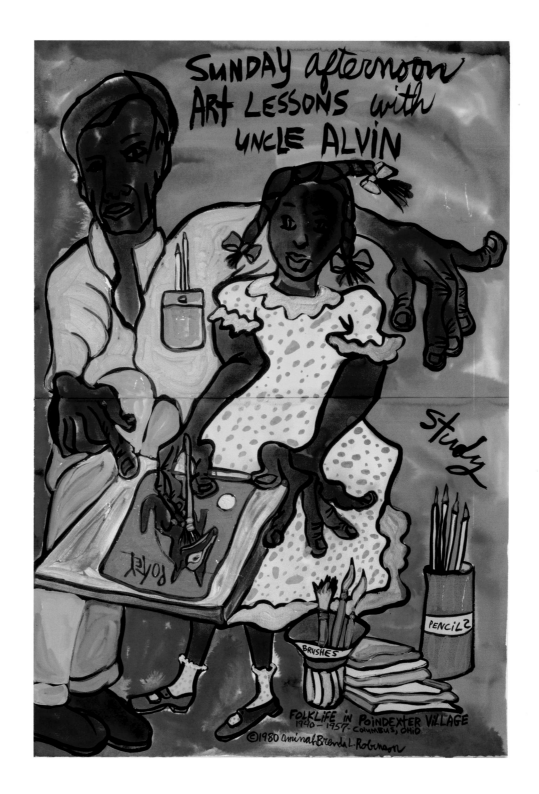

**22** *Sunday Afternoon Art Lessons with Uncle Alvin,* 1980, watercolor with thread, 44 × 29 in.

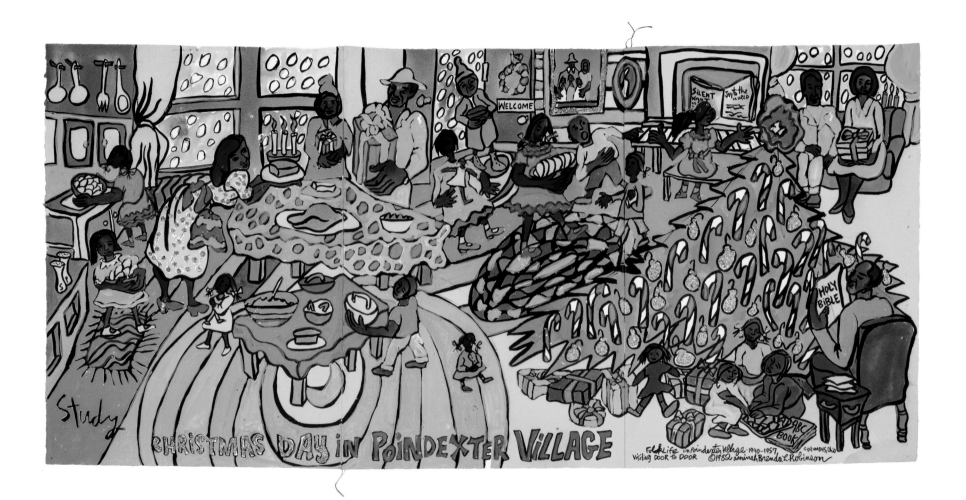

**23**  *Christmas Day in Poindexter Village*, 1982,
watercolor with thread, 29¾ × 44 in.

*Song for Poindexter Village. . . . These were wonderful days! The days of our learning and growing and being always together. . . . Beatty Recreation Center was located across the street from our house. Now, everything was here in this community—the school; the churches; Franklin Park; the street people and markets.*

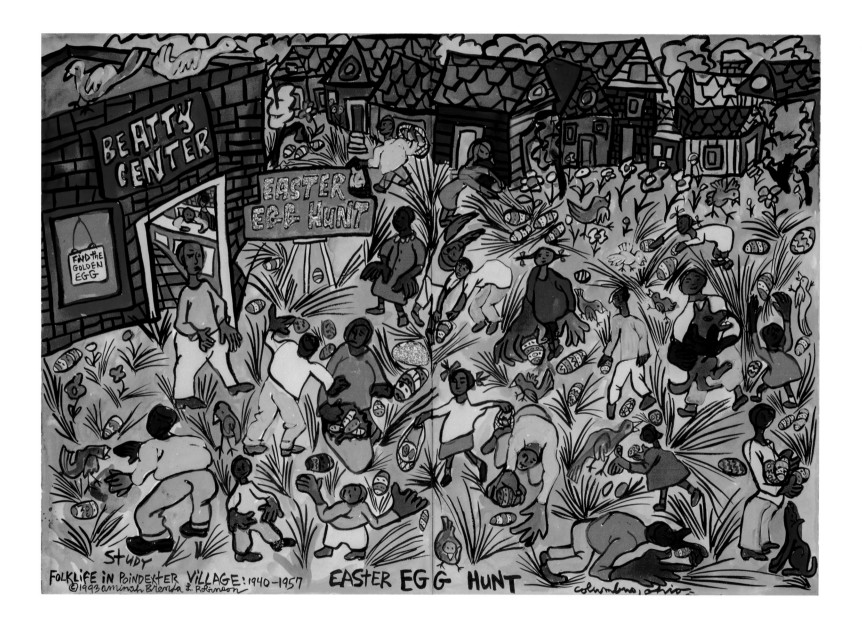

**24**  *Easter Egg Hunt*, 1993, watercolor with
thread, 29¾ × 44 in.

## STREET CRIES

*From way back deep—there is a simple song, a people that echoes through me and through my work. This echo, this simple song is the spirit and soul of my people. . . . It is a song that must be appreciated. One must feel its beauty, its love. And its sadness.*

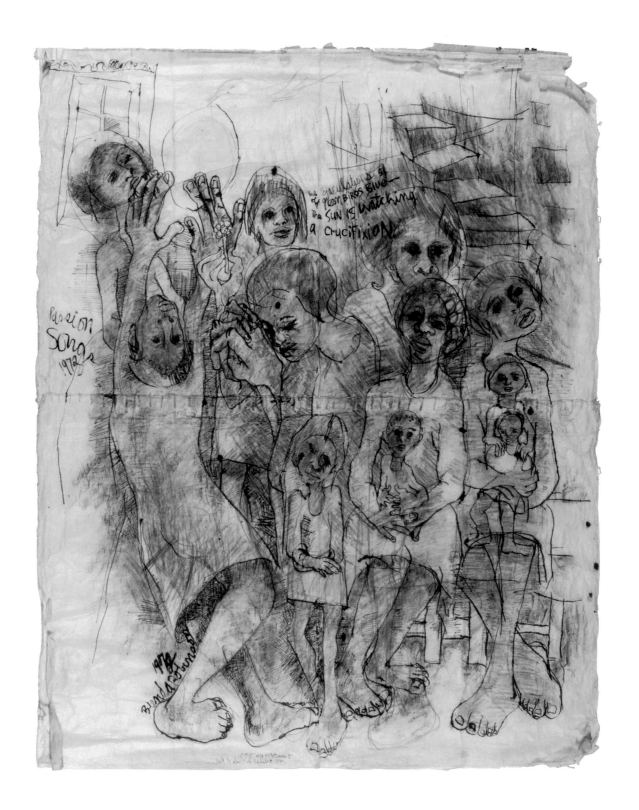

**25** *Passion Songs*, 1972, pen and ink with pastel on rice paper, 45½ × 37¾ in.

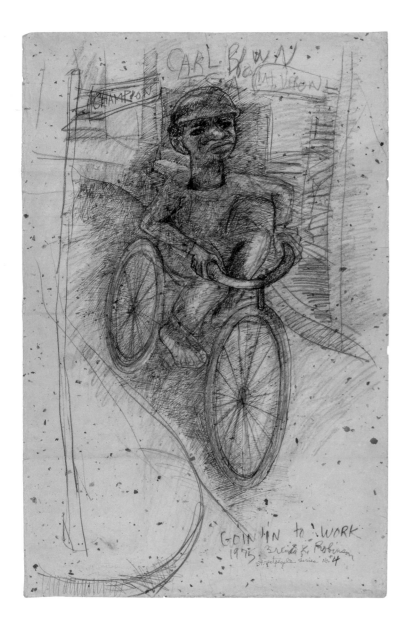

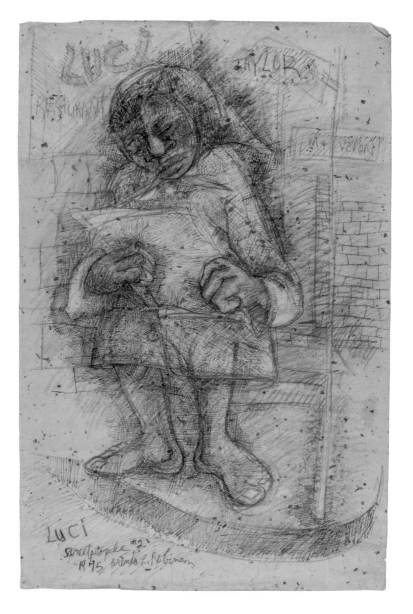

**26** *Goin' to Work*, 1975, pen and ink with pastel on handmade paper, 36½ × 24¾ in.

**27** *Luci*, 1975, pen and ink with pastel on handmade paper, 36½ × 24¾ in.

During the period when Robinson struggled as a single parent, she turned to the welfare system for financial relief. Her own situation sensitized her to the "street cries" of those living in poverty. Throughout her career, she returned to this theme and compassionately depicted street people and those who were homeless.

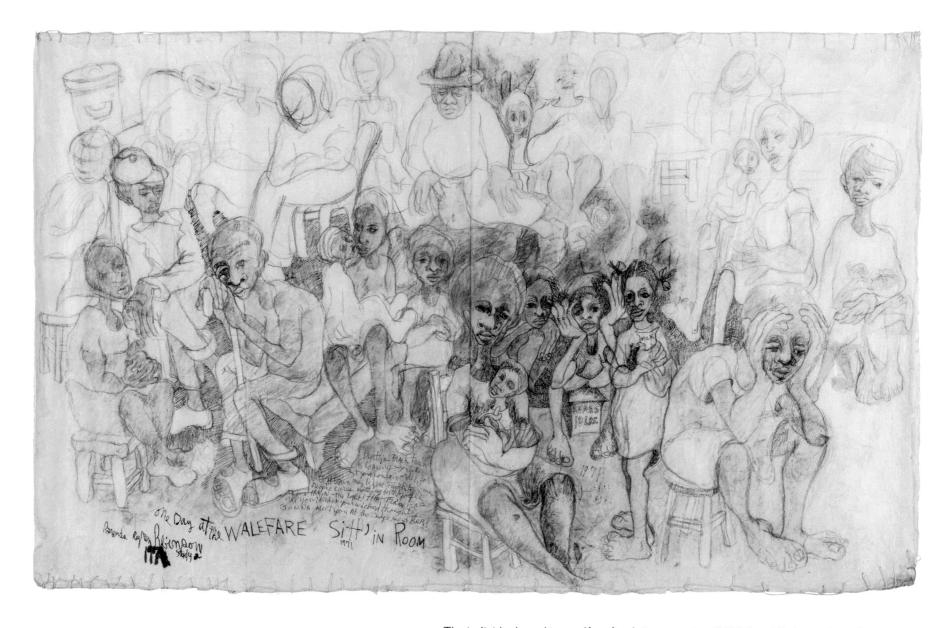

**28** *One Day at the Walefare Sitt'in Room*, 1971, pen and ink with pastel on rice paper, 24 × 38 in.

The individuals seeking welfare funds in this scene reflect the reality of their dire situations. The seated woman and child in the center of the picture may be a self-portrait of Robinson and her son. The grim words about death and judgment further emphasize a scene of despera-tion. "Walefare," Robinson's spelling of welfare might refer to the meaning of the word "wale" as the raised scars that slaves endured as a result of being beaten. In other drawings and in her journals, Robinson equated the welfare system with slavery.

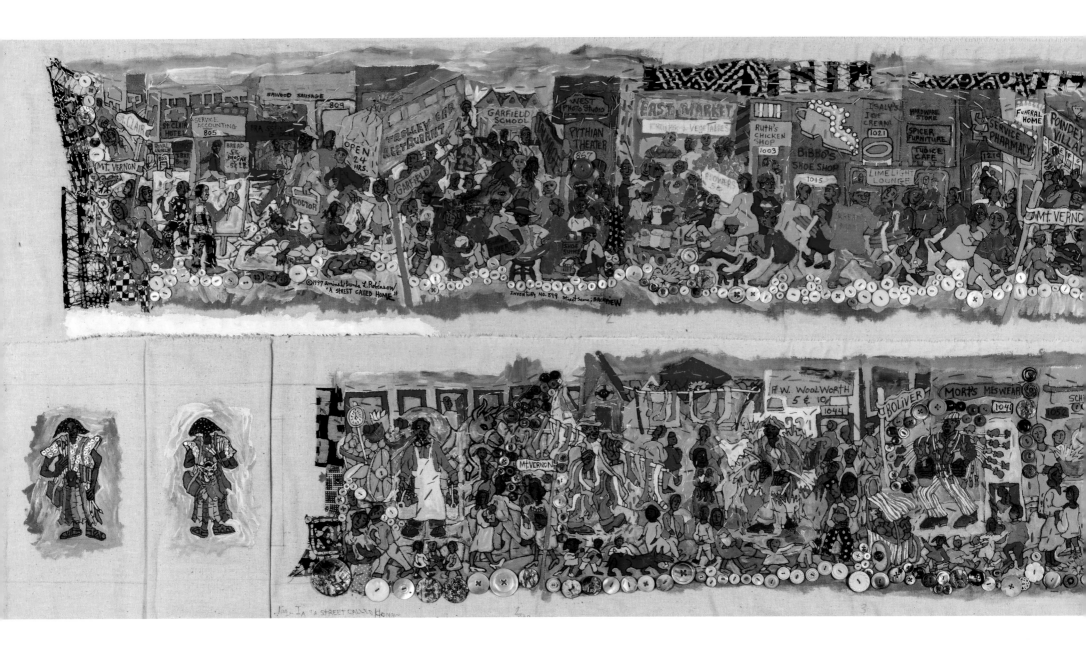

In colorful, scroll-like "memory maps," Robinson captured a very upbeat kind of street cry—that of the unforgettable characters who lived and worked on Mount Vernon Avenue, the business and entertainment center of the city's African American community. This memory map is the original art for Robinson's book *A Street Called Home* (Harcourt Brace & Company, 1997).

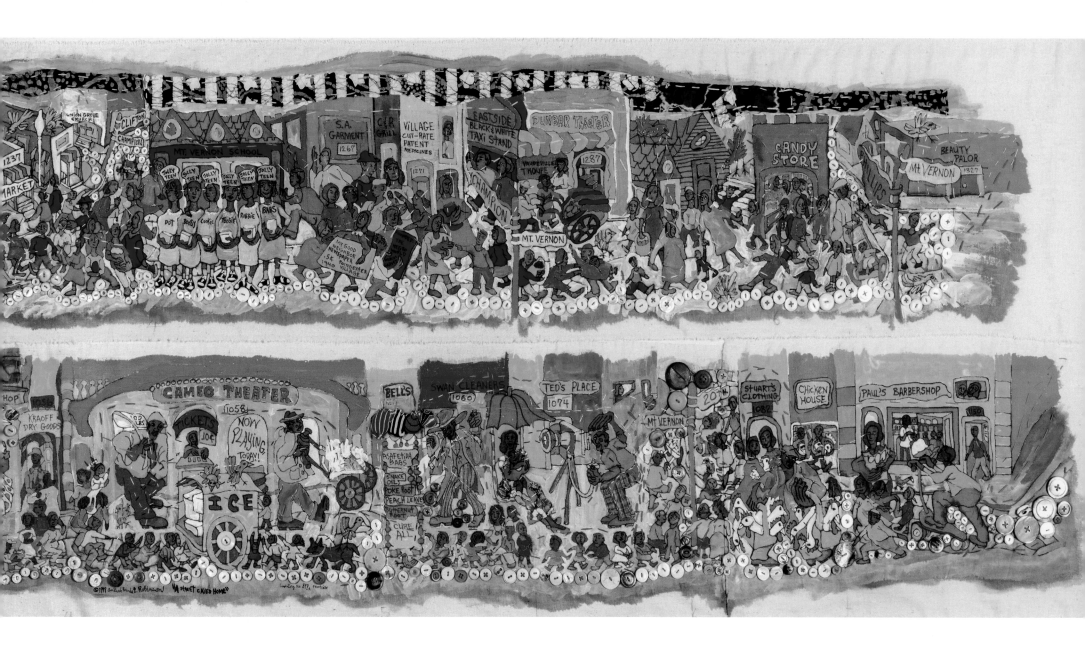

**29A**   *A Street Called Home,* 1997, mixed media
on cloth, 28 × 89½ in., Columbus Museum of
Art, Museum Purchase with funds donated by
Wolfe, Associates, Inc., 1997.010a–g

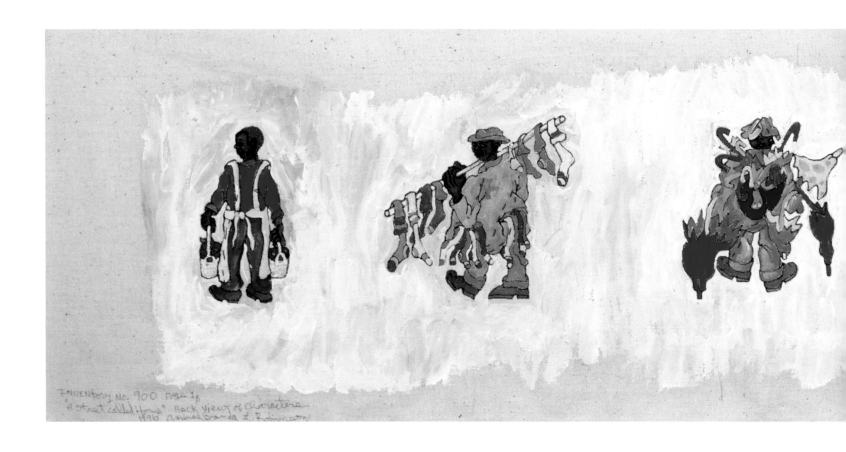

**29B** *A Street Called Home (characters)*, 1997, mixed media on cloth, 28 × 89½ in., Columbus Museum of Art, Museum Purchase with funds donated by Wolfe, Associates, Inc., 1997.010a–g

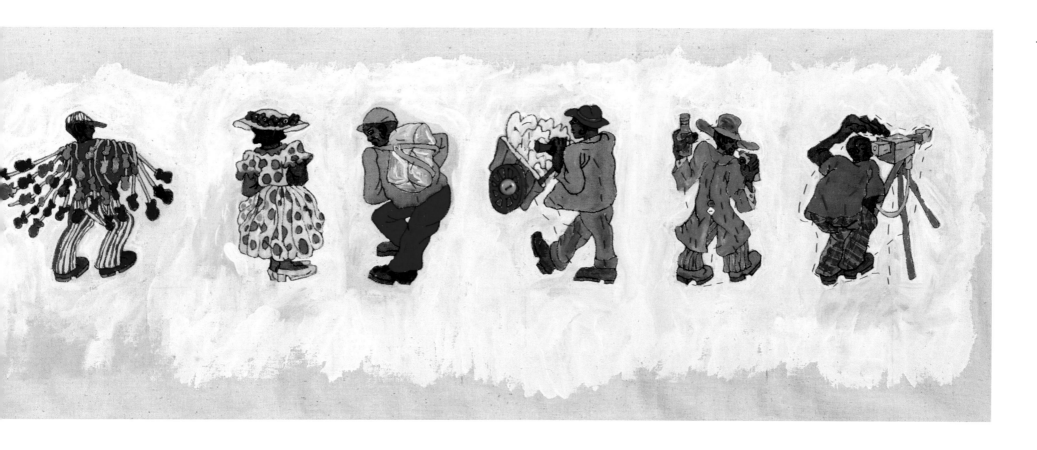

Robinson designed her book, *A Street Called Home,*
to include "doors" that opened to reveal the backs
of the characters she depicted in the street scene.

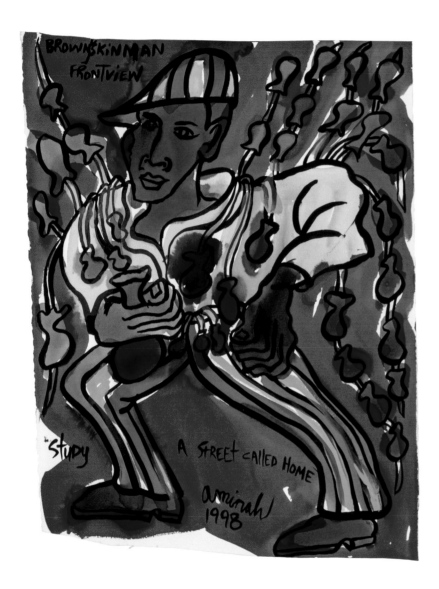

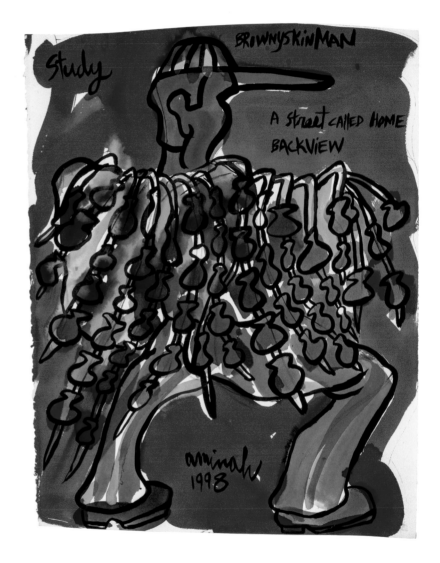

**30** *Brownyskin Man, (front view),* 1998, watercolor, 30 × 22 in.

**31** *Brownyskin Man, (back view),* 1998, watercolor, 30 × 22 in.

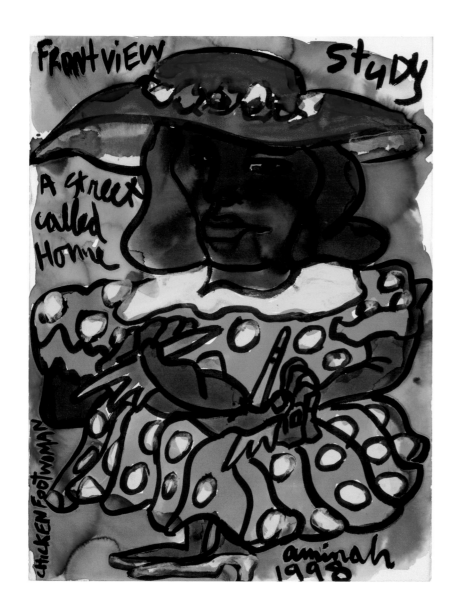

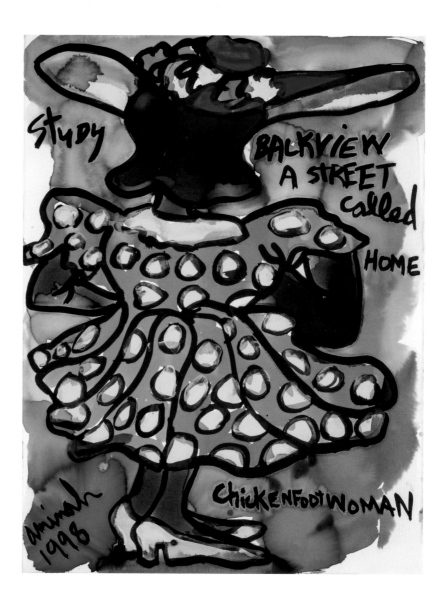

**32** *Chickenfoot Woman (front view)*, 1998,
watercolor, 30 × 22 in.

**33** *Chickenfoot Woman, (back view)*, 1998,
watercolor, 30 × 22 in.

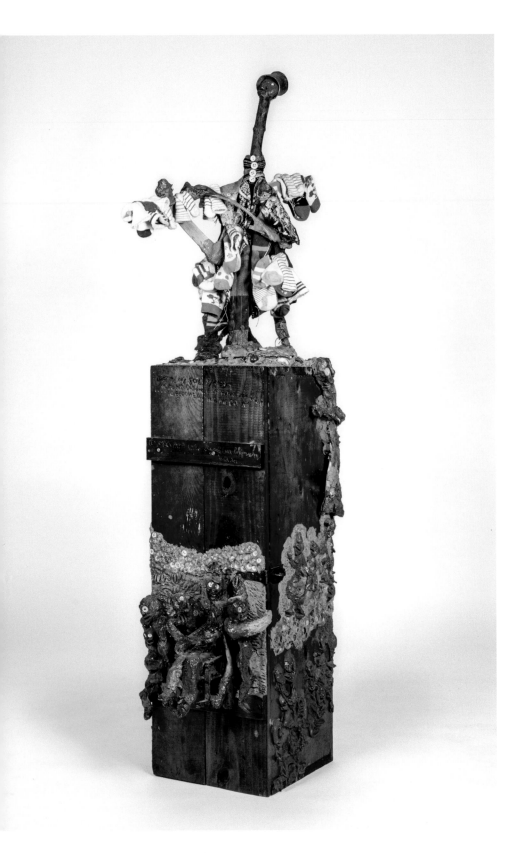

Using hogmawg and found objects, Robinson turned this wooden box she bought at a yard sale into a platform for the Sockman, a peddler who sold his wares on Mount Vernon Avenue.

**34A**  *Sockman*, detail

**34**  *Sockman*, 1980, Mixed media: wood, fabric, hogmawg, and found objects, 64½ × 14¼ × 21 in.

**35** *Bryce Florist*, 1982, pastel, charcoal, thread, and mixed media on paper, 16 × 32 in., Columbus Museum of Art, Museum Purchase, 2019.015.002

After consulting historic city directories at the library, Robinson documented many of the businesses that lined Mount Vernon Avenue and nearby Long Street from the 1930s to the 1960s. In this scene, she honors Edna Bryce, owner of the flower shop, and the *Call and Post* newspaper, both strong advocates for social justice.

Robinson's research revealed the locations and names of these historic schools that served children from the Blackberry Patch, an early African American neighborhood on Columbus's east side.

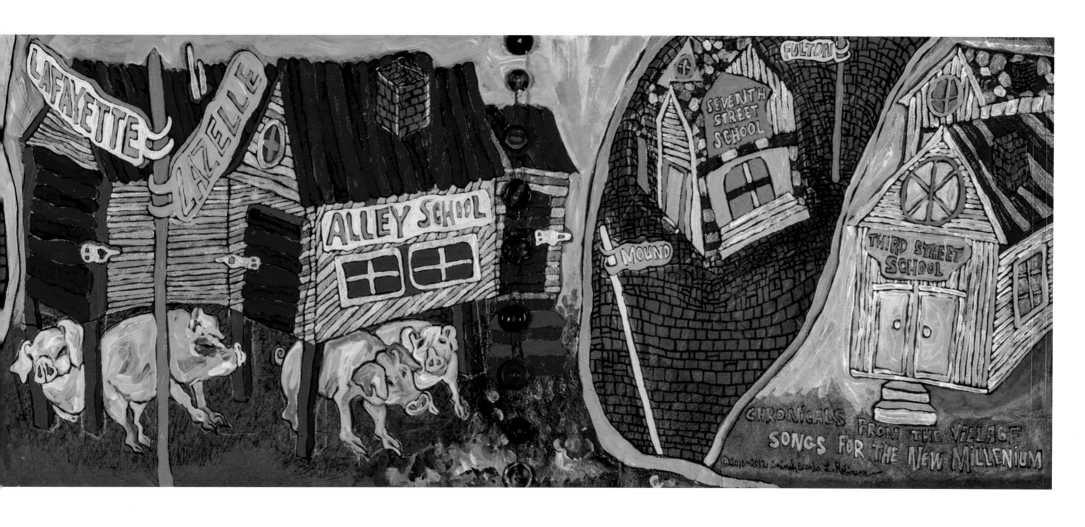

**36** *School Days in Columbus, Ohio* (from *Songs for the New Millenium* series), 2006, mixed media on paper, 17½ × 66 in., Columbus Museum of Art, Bequest of the Artist, 2018.035.001

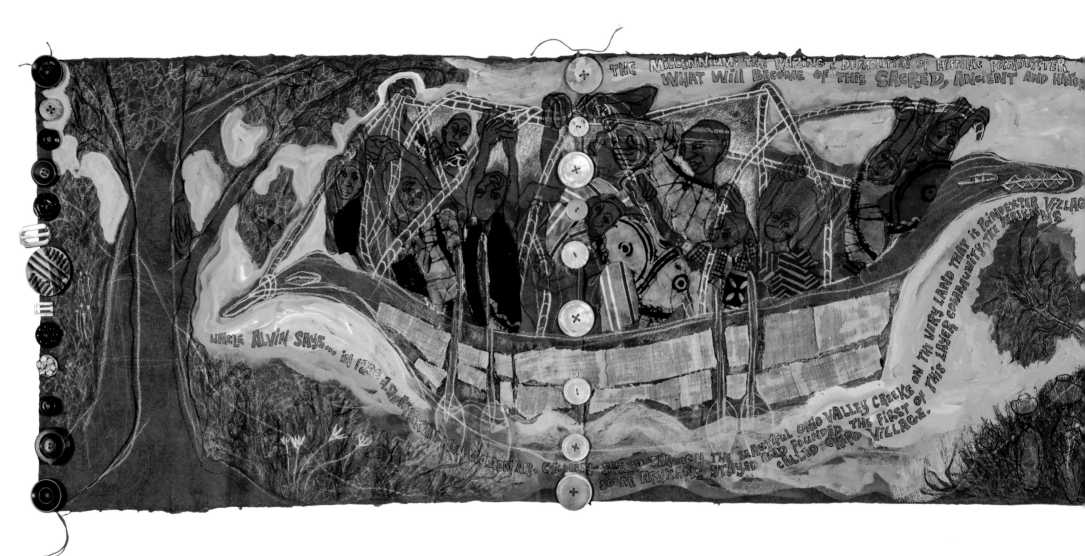

THE MILLENNIUM: THE RAZING & DEMOLITION OF HISTORIC POINDEXTER
WHAT WILL BECOME OF THIS SACRED, ANCIENT AND HISTORIC

UNCLE ALVIN SAYS... IN 1300 A.D. AFRIKAN MEN WOMEN AND CHILDREN SAILED THROUGH THE BEAUTIFUL OHIO VALLEY CREEKS ON THE VERY LAND THAT IS POINDEXTER VILLAGE, THE FIRST OF THIS LAYER COMMUNITY, THE AFRICANS. SOME AFRICANS STAYED AND FOUNDED CALLED CHIPO VILLAGE.

**37** *Uncle Alvin Says … in 1200 AD …* (from
*Songs for the New Millennium* series), 2010,
18 × 67½ in., Columbus Museum of Art,
Bequest of the Artist, 2018.035.002

In this series, *Songs for the New Millennium*,
Robinson depicted her Uncle Alvin's legends
about African explorers who settled in the Ohio
Valley as early as the 1200s.

## ANCESTRAL VOICES

### FROM BONDAGE TO FREEDOM

*Afrikan people throughout the world must commit themselves completely to the paintings and writing of our own history, with emphasis on a pan-Afrikan approach and knowledge should be available to peoples of the world.*

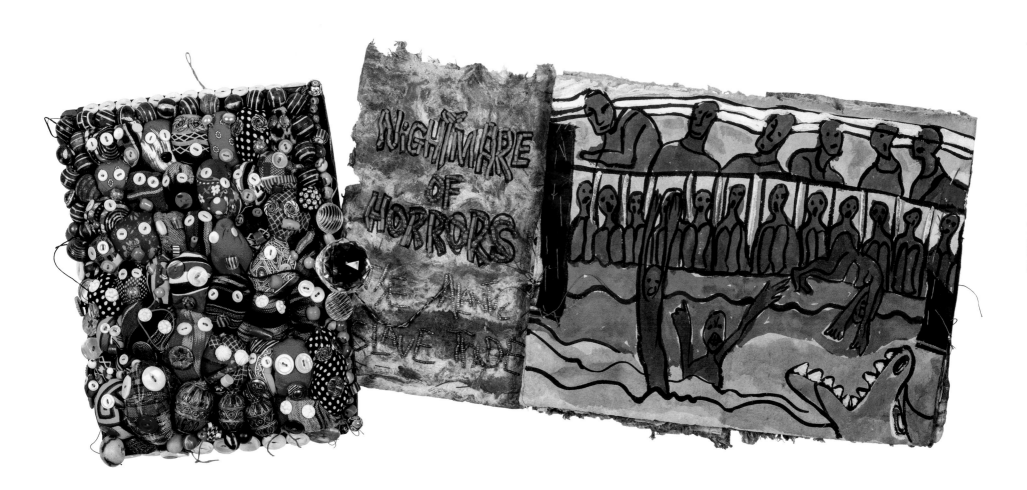

**38** *Nightmare of Horrors: The Atlantic Slave Trade* (from *Dad's Journey* series), 1995, mixed media cover and hand-colored lithograph, 13½ × 10 × 3½ in.

*Dad's Journey*, a multi-layered tapestry is about Robinson's father, and more broadly about the experience of millions of Africans who became slaves in the Americas, their emancipation, and migration north. It contains an accordion book, *Nightmare of Horrors* (plate 38), which memorializes those who suffered the tragedy of being kidnapped and enslaved.

Made over three decades, *Dad's Journey* demonstrates Robinson's concept of a RagGonNon—a complex work of art that evolves over time and "rags on" as those who experience it expand its meaning.

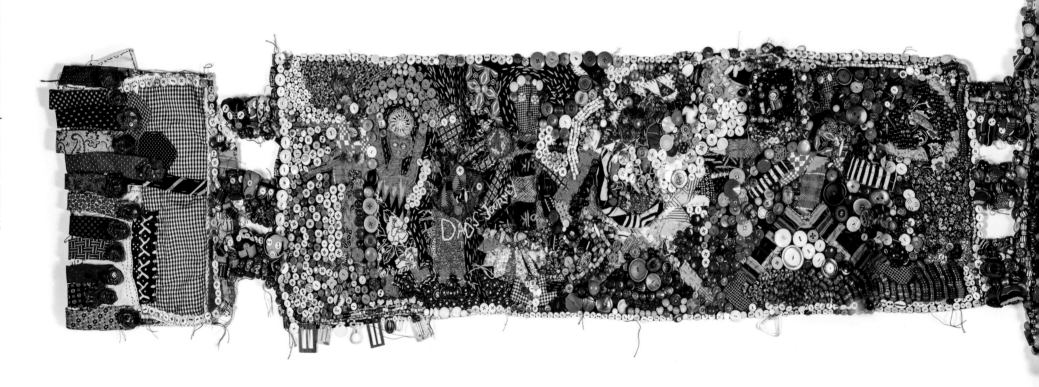

**39**  *Dad's Journey*, 1972–2006, button-beaded RagGonNon music box pop-up book, 28 × 172 in., Columbus Museum of Art, Gift of the Artist, 2011.006.001a&b

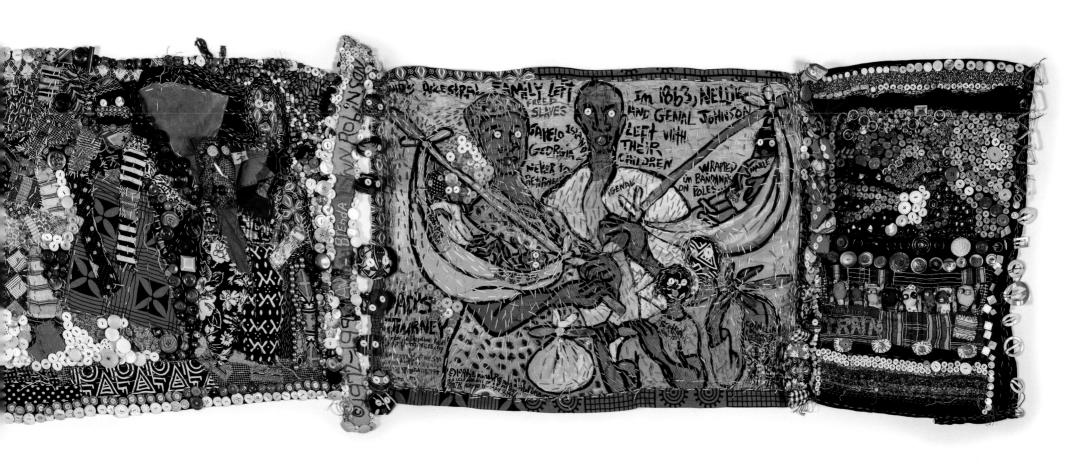

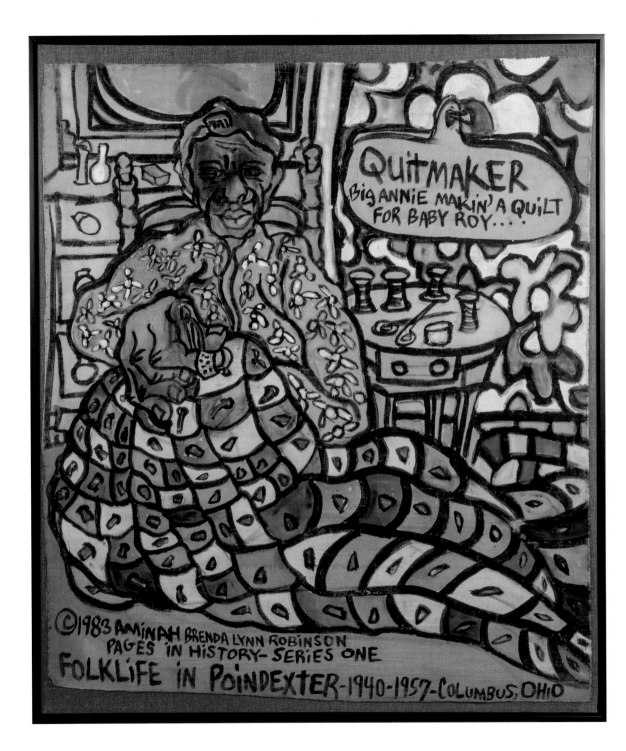

Robinson's Great-Aunt Cornelia was also known as Big Annie. She was a warmhearted woman whom Robinson considered a healer—due to her expertise in dispensing herbs and natural remedies—and a prophetess with spiritual connections to the ancestral past. Robinson celebrated Big Annie/Cornelia and her familial roots in Africa in the *Themba* series. "Baby Roy" was Big Annie's nephew and Robinson's father, Leroy Robinson.

**40**  *Big Annie Makin' a Quilt for Baby Roy,* 1983, cloth painting, 42 × 37½ in., Columbus Museum of Art, Museum Purchase, 2019.015.001

*Aunt Themba's life is an extension of my soul. Her life became the ghost who dared to live—to dream—to hope for a transformative Awakening grounded in memory . . . she was a Devine [sic] Healer: using the Rites of her spirituality for the purpose of curing the sick, divining the hidden, and controlling events and happenings in the world. These cultural and Healing Traditions continue to live in me—Aunt Themba taught me well!*

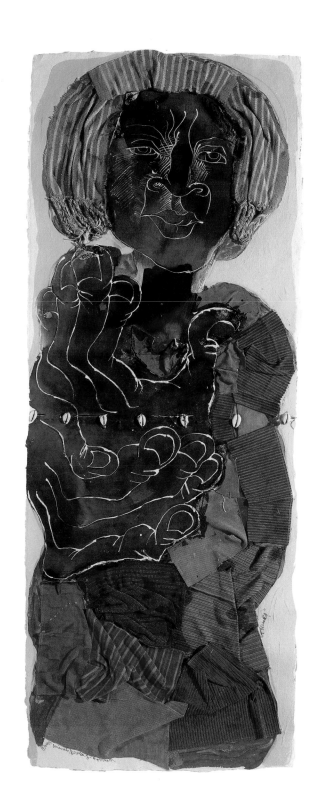

**41**   *Themba,* 2015, mixed media, 48 × 19 in.

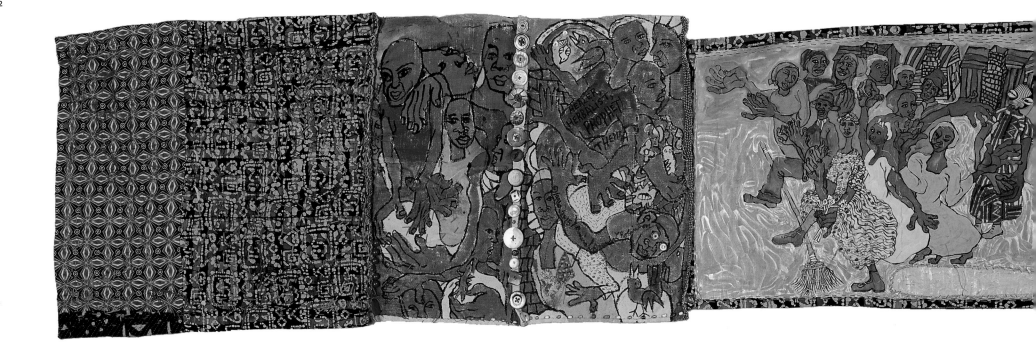

**42**   *Themba: Healer, Herbalist, Prophet* (from
*Themba: A Life of Grace and Hope* series),
1996–2015, cloth painting, 21¾ × 91½ in.

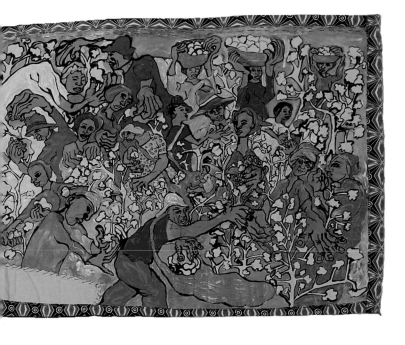

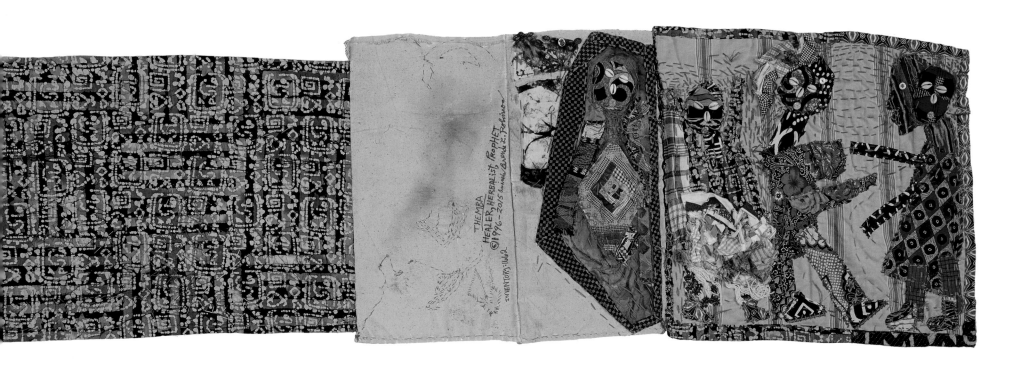

After the Civil War, Robinson's family left Sapelo Island, Georgia, for the journey that ultimately brought them to Ohio. The horrific scene of lynched bodies hanging from a tree and the hooded Ku Klux Klan perpetrators depicted in this scroll creates an ominous backdrop to the procession and a grim reminder of the long, arduous road to freedom that remains.

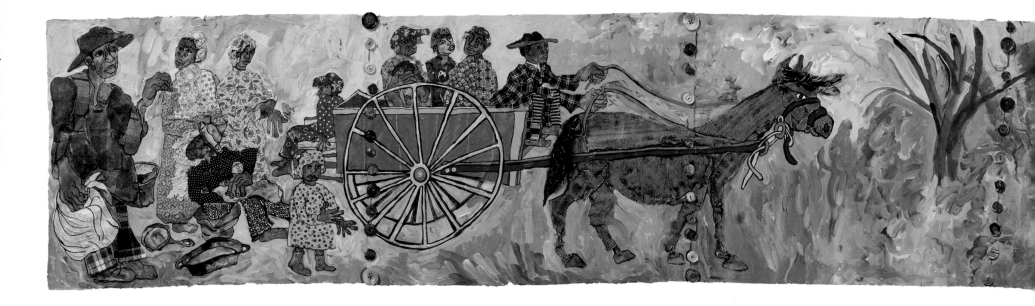

**43**  *Themba Bears Witness* (from *Themba: A Life of Grace and Hope* series), 1996–2012, mixed media on paper, 18 × 216 in.

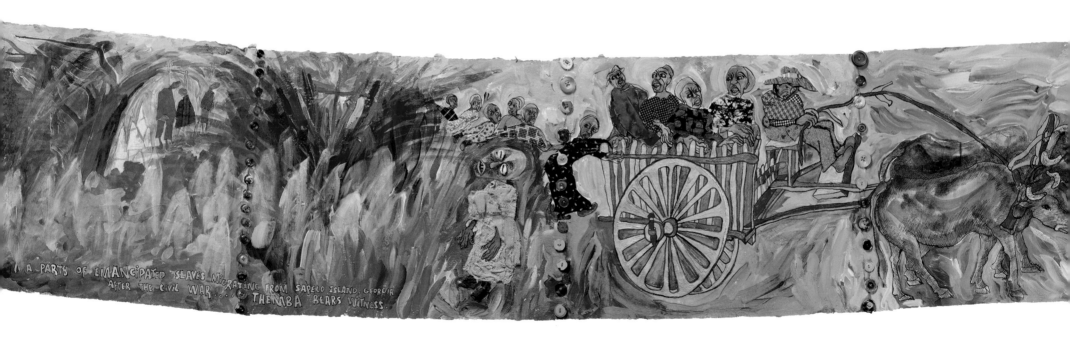

A PARTY OF EMANCIPATED SLAVES MIGRATING FROM SAPELO ISLAND, GEORGIA
AFTER THE CIVIL WAR..... THEMBA BEARS WITNESS.

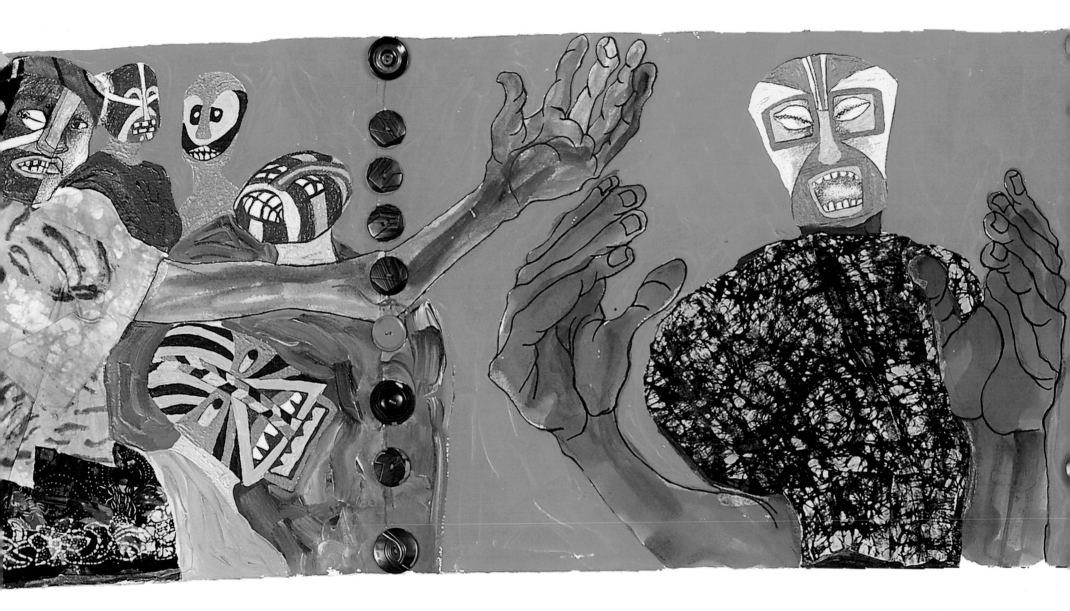

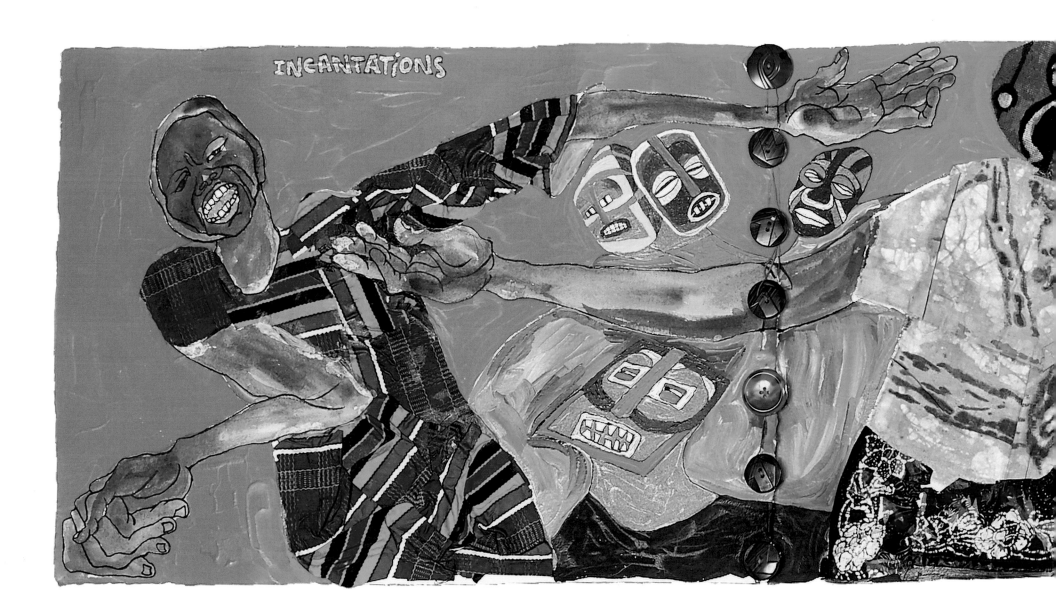

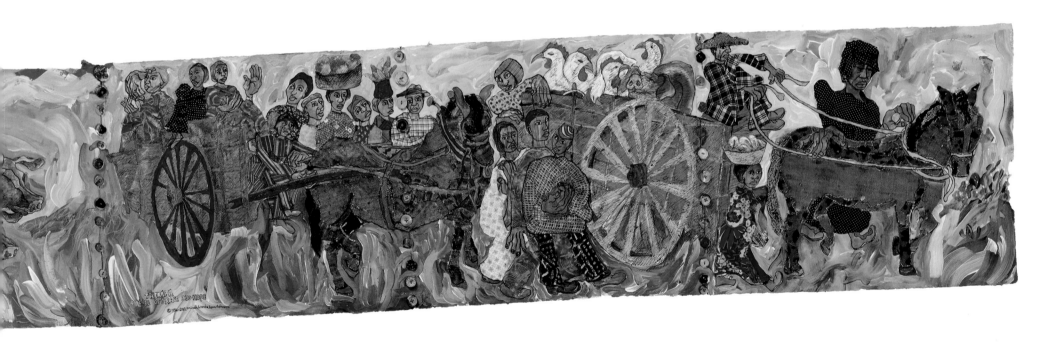

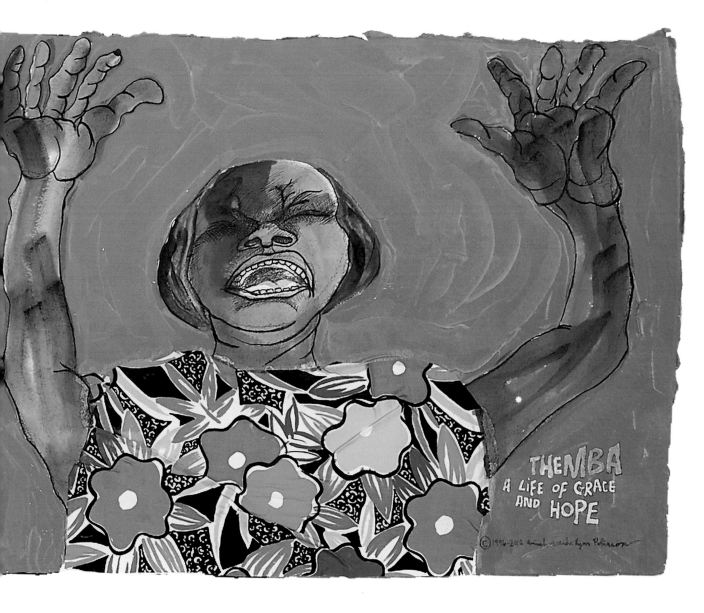

Robinson began working on the series *Themba: A Life of Grace and Hope* in 1996 and continued until the end of her life. The numerous masks in the paintings from this series symbolize the continuing presence of African culture and ancestors in the lives of African Americans.

**44**  *Incantations* (from *Themba: A Life of Grace and Hope* series), 1996–2012, mixed media on paper, 20 × 107 in.

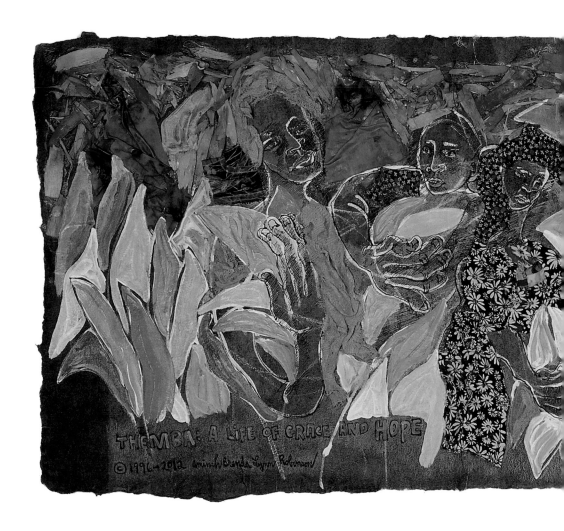

**45** *The Village Ceremony Celebrates Ancestors*
(from *Themba: A Life of Grace and Hope* series),
1996–2010, mixed media on paper, 17½ × 63¾ in.

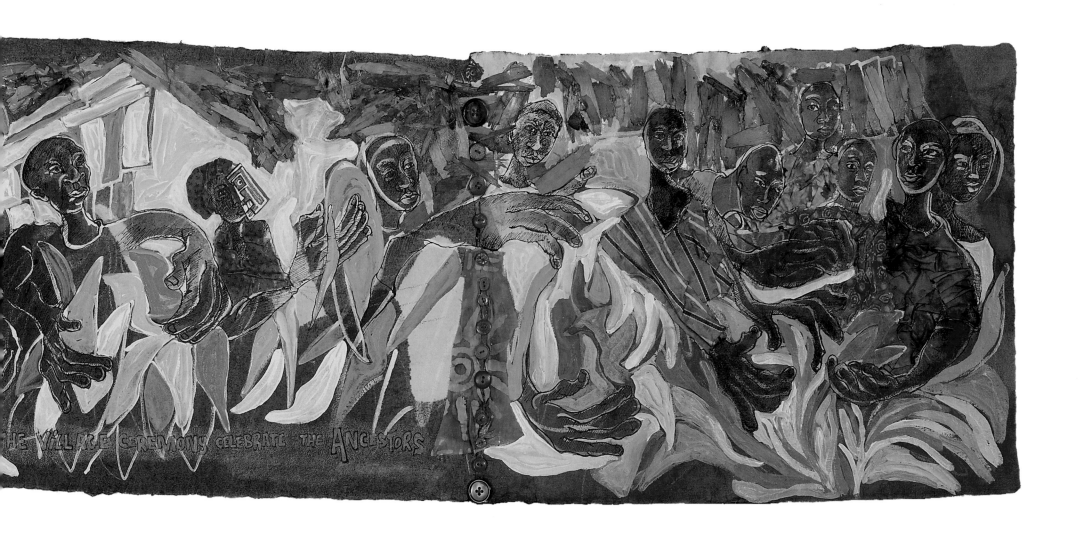

THE VILLAGE CEREMONY CELEBRATE THE ANCESTORS

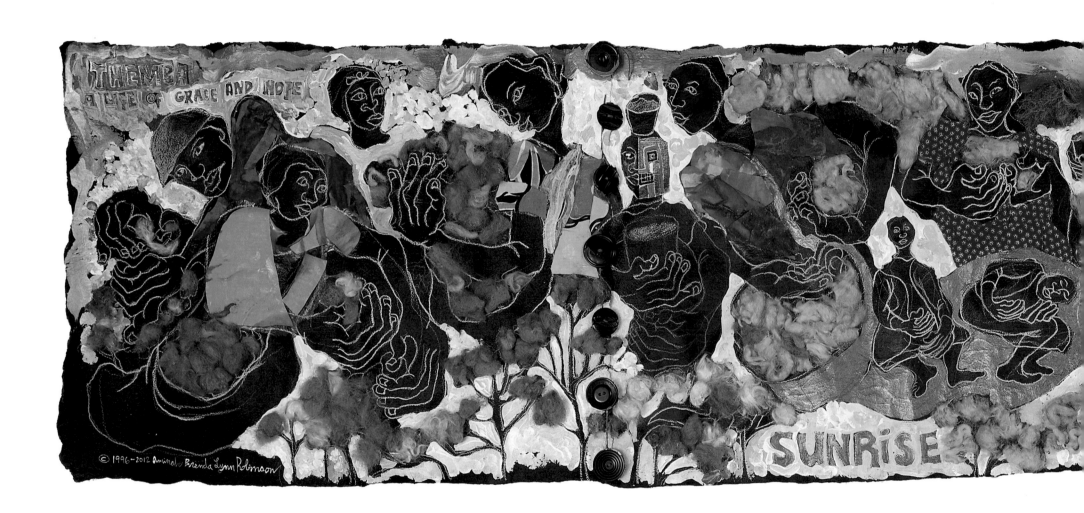

THEMBA
A LIFE OF GRACE AND HOPE

SUNRISE

© 1996-2012 Aminah Brenda Lynn Robinson

Working at dawn in the American South, these field hands are imprisoned by the cotton industry that flourished as a result of their enslaved labor. The figure wearing a mask indicates the ever-present connection of African Americans to African ancestors and culture.

**46** *Themba: Sunrise* (from *Themba: A Life of Grace and Hope* series), 1996–2012, mixed media on paper, 21 × 83 in.

This drawing on handmade paper and the preparatory watercolor study capture Robinson's emotional response to visiting the House of Slaves on an island off the west coast of Senegal in 1979. "I heard my ancestors," Robinson recalled. "I could feel them. I could smell them, and I wanted to bring that to this piece."

**47** *Roots Begin with Gorée Island* (from *Afrikan Pilgrimage: The Extended Family* series), 1980, pen and ink with colored pencils, thread, and beads on homemade paper, 10½ × 55¼ in., Columbus Museum of Art, Gift of the Artist, 2014.050.012

**48** *Roots Begin with Gorée Island, study* (from *Afrikan Pilgrimage: The Extended Family* series), 1979, pen and ink with watercolor, thread, and buttons on paper, 8 × 52 in.

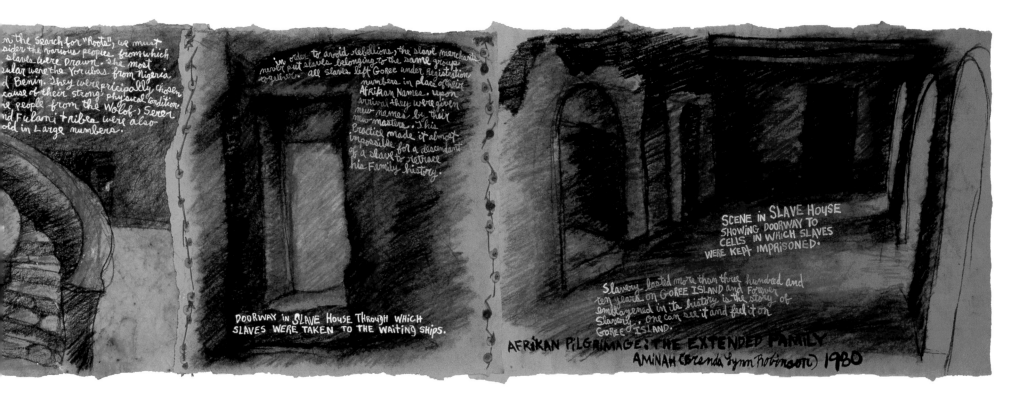

In the search for "Roots", we must consider the various peoples from which slaves were drawn. The most popular were the Yorubas from Nigeria and Benin. They were principally chosen because of their strong physical condition. The people from the Wolof, Serer and Fulani tribes were also sold in large numbers.

In order to avoid rebellions, the slave merchants never put slaves belonging to the same group together. All slaves left Goree under registration numbers in place of their Afrikan Names. Upon arrival they were given new names by their new masters. This practice made it almost impossible for a descendant of a slave to retrace his family history.

DOORWAY IN SLAVE HOUSE THROUGH WHICH SLAVES WERE TAKEN TO THE WAITING SHIPS.

SCENE IN SLAVE HOUSE SHOWING DOORWAY TO CELLS IN WHICH SLAVES WERE KEPT IMPRISONED.

Slavery lasted more than three hundred and ten years on GOREE ISLAND and forever emblazoned in its history is the story of Slavery. One can see it and feel it on GOREE ISLAND.

AFRIKAN PILGRIMAGE: THE EXTENDED FAMILY
AMINAH (Brenda Lynn Robinson) 1980

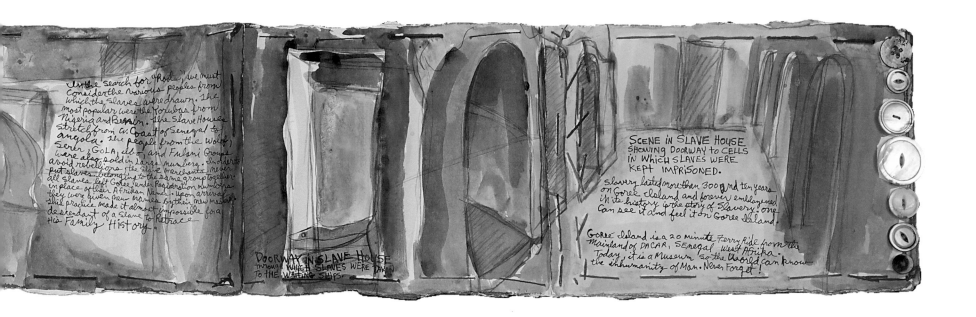

In the search for "Roots", we must consider the various peoples from which the slaves were drawn. The most popular were the Yorubas from Nigeria and Benin. The Slave Houses stretch from W. Coast of Senegal to Angola. The people from the Wolof, Serer, Gola, Ibo, and Fulani Groups were also sold in large numbers. In order to avoid rebellions, the slave merchants never put slaves belonging to the same group together. All slaves left Goree under registration numbers in place of their Afrikan Names. Upon arrival they were given new names by their new masters. This practice made it almost impossible for a descendant of a Slave to retrace his family History.

DOORWAY IN SLAVE HOUSE through which slaves were taken TO THE WAITING SHIPS.

SCENE IN SLAVE HOUSE SHOWING DOORWAY TO CELLS IN WHICH SLAVES WERE KEPT IMPRISONED.

Slavery lasted more than 300 and ten years on Goree Island and forever emblazoned in its history is the story of Slavery. One can see it and feel it on Goree Island.

Goree Island is a 20 minute ferry ride from the mainland of DACAR, Senegal, West Afrika. Today, it is a museum so the World can know the inhumanity of Man. Never Forget!

Crammed into the belly of a ship, these ghost-like Africans suffer the horror of being kidnapped and transported to enslavement in the Americas. Robinson memorializes those who died during the transatlantic crossing, known as the Middle Passage, and honors those who survived and were the forebears of families like hers.

**49** *Life in the Big Boat* (from *Themba: A Life of Grace and Hope* series), date unknown, white ink on blue paper with thread and buttons, 17½ × 109 in.

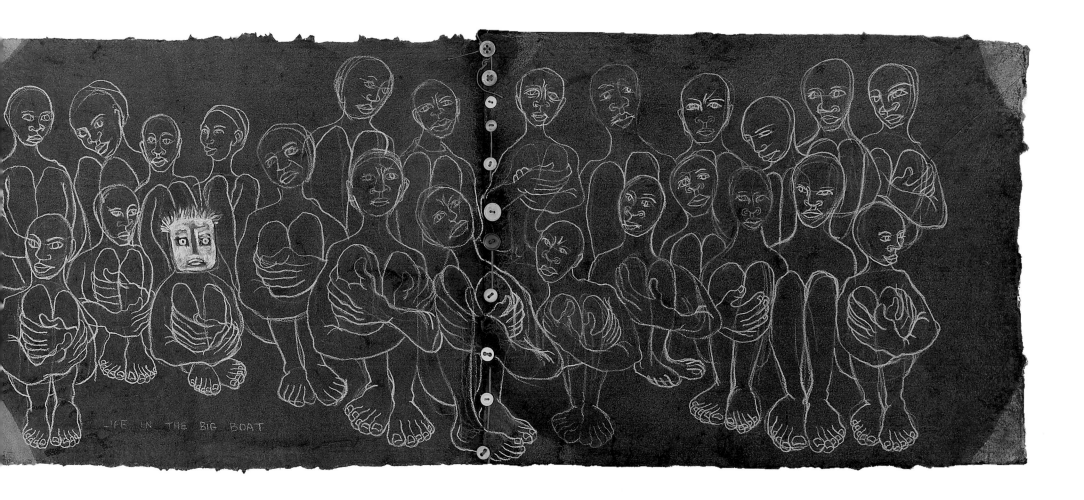

LIFE IN THE BIG BOAT

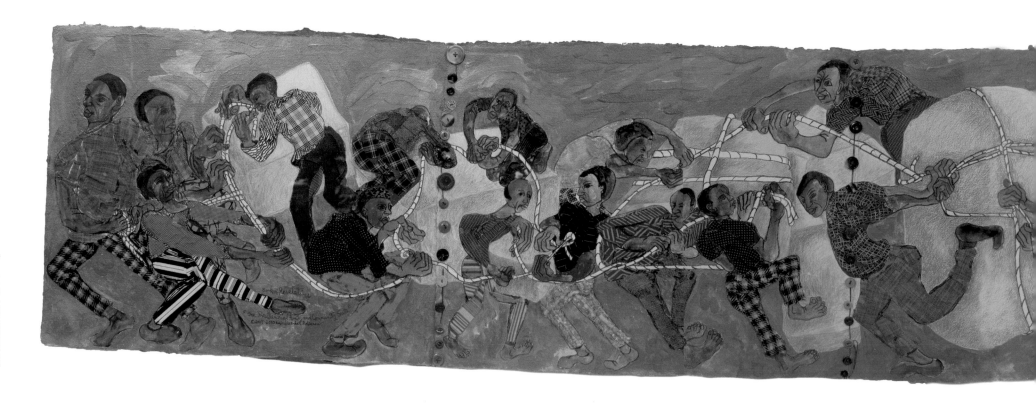

Robinson pays homage to the slaves whose back-
breaking labor built the Capitol in Washington, D.C.
She reminds us that this revered symbol of Ameri-
can democracy and freedom, like the White House,
was built in part on the forced labor of slaves. Ironi-
cally, after completion of the original Capitol build-
ing in 1820, it was often referred to as the "Temple
of Liberty." This rag painting is part of the *Presiden-
tial Suite* series, which celebrates President Barack
Obama, his family, and their ancestors.

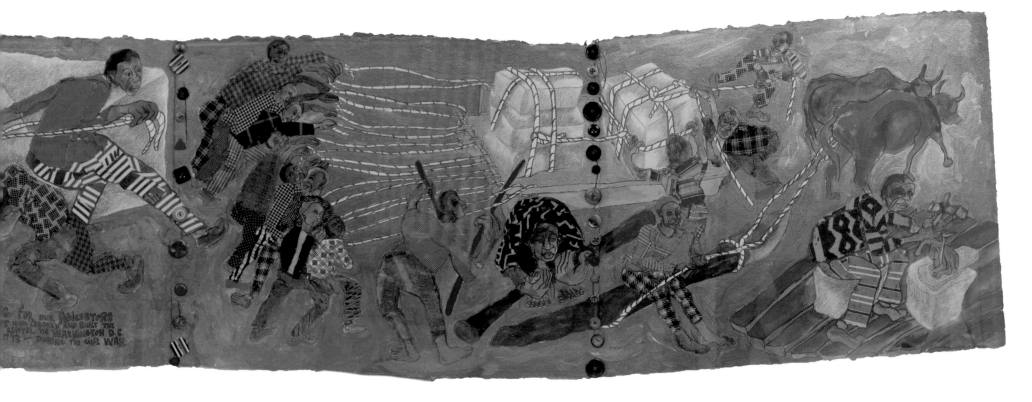

**50** *Wings for Our Ancestors; Slaves who
Labored and Built the Nation's Capital in Wash-
ington, D.C.* (from *Presidential Suite* series),
2007–10, rag painting, 19 × 121 in.

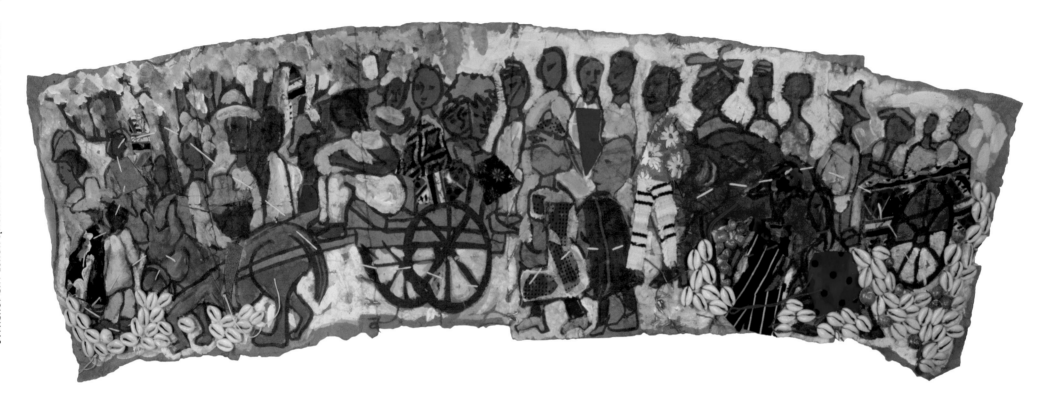

**51** *Untitled (migration),* date unknown, mixed media, 12 × 41½ in.

After the Civil War, many African American families left the South for better lives in other parts of the country. The families in this scene travel on a road paved with cowrie shells, a reference to Africa where the shells were valued both as currency and as important cultural symbols. Robinson often used cowries to represent eyes in three-dimensional, hogmawg figures and to embellish cloth paintings and one-of-a-kind books.

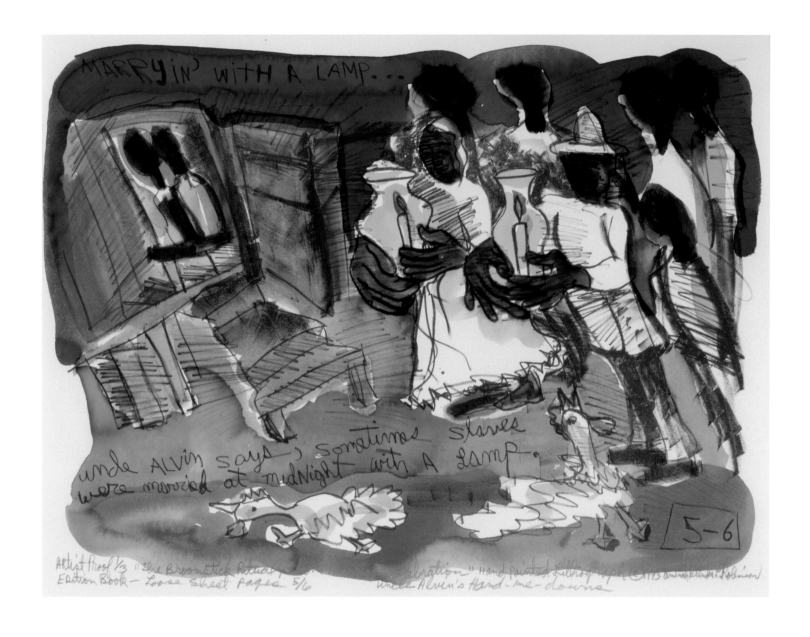

**52**  *The Broomstick Ritual, Slave Marriage Cele-brations, Marryin' with a Lamp,* 1993, hand-painted lithograph, 18 × 23¾ in.

Because most slaves were not permitted to legally marry, customs such as "jumping the broom" sub-stituted for a formal ceremony. In a series of lith-ographs, Robinson depicted a variety of legendary marriage customs her Uncle Alvin described.

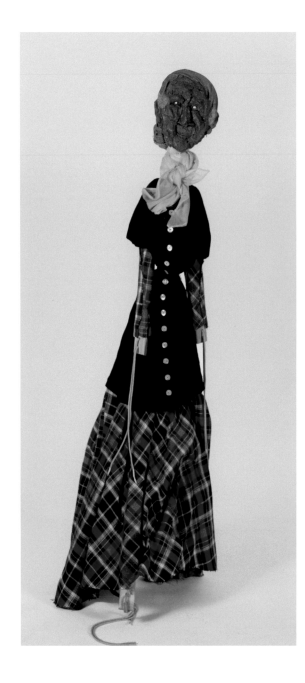

Robinson designed these puppets to be attached to the performer's hands, feet, and waist. Sojourner Truth and Harriet Tubman, abolitionists and women's rights activists, would be brought to life by the movement of those "wearing" them. The drawing of a Rev. Martin Luther King, Jr. puppet and puppeteer illustrates Robinson's concept.

**53**  *Harriet Tubman*, 1988, hogmawg and found objects on wooden stick, 35 × 18 × 7 in.

**54**  *Sojourner Truth*, 1988, hogmawg and found objects on wooden stick, 58 × 12 × 8 in.

**55**  *Rev. Martin Luther King Feet-Hand Puppet with Person Working It*, 1986, pen and ink with colored pencil on paper, 12½ × 8½ in.

Through her elders, Robinson learned that her father's family had been enslaved on Sapelo Island, Georgia, before they migrated to Ohio after the Civil War. She visited the island several times and documented Hog Hammock, a small community inhabited by descendants of slaves. In the Sapelo drawings, sculptures, paintings, and quilt she captures the people and a way of life "slowly passing." The quilt references the women of Hog Hammock and links them to Robinson's mother, whose portrait appears in the lower right.

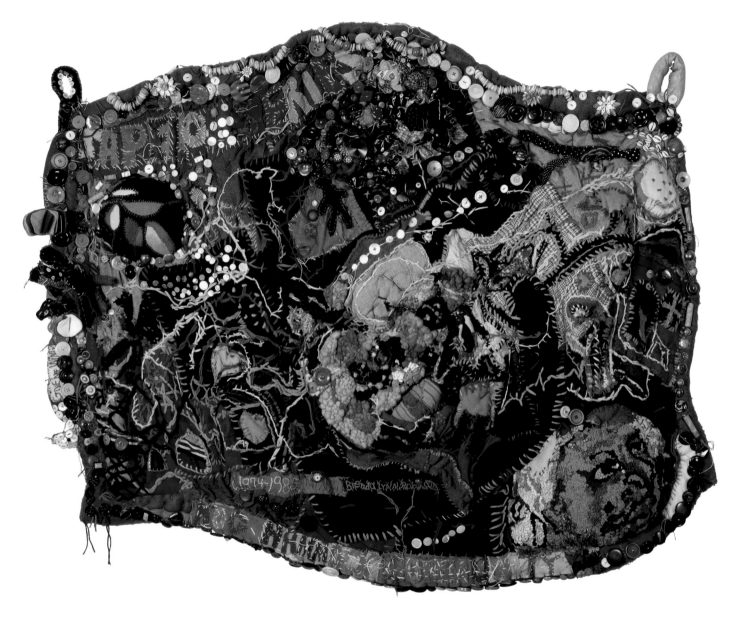

**56**  *Sapelo Island, Hog Hammock Community Quilt*, 1977–1986, wool, buttons, beads, music box, and found objects, 49 × 64 in., Columbus Museum of Art, Gift of the Artist, 2014.050.013

**57**   *Chicken Yard in Sapelo* (from *Sapelo Series*),
1994, watercolor, 22½ × 30 in.

**58** *Farm Study* (from *Sapelo Series*), 1994,
watercolor, 22½ × 30 in.

**59** *Sapelo Walkers*, 1986, mixed media.
(LEFT TO RIGHT): *Pogo Hop*, 57 × 26 × 20½ in.;
*Crabber*, 81 × 12 × 30 in.; *Resting*, 49 × 32 × 26 in.

**60**  *Basketmaker* (from *Sapelo Series*), 1989, pen and ink with colored pencil, 12½ × 9½ in.

**61**  *Gift Eggs* (from *Sapelo Series*), 1984, pen and ink with colored pencil, beads, and thread, 12½ × 9½ in.

**62**  *Cotton Pickers* (from *Sapelo Series*), 1989, pen and ink with watercolor, 9½ × 12½ in.

**63**  *The Vegetable Peddlers* (from *Sapelo Series*), 1989, pen and ink with colored pencil, 9½ × 12½ in.

## RAGGIN' ON

## A CLUTCH OF BLOSSOMS

*We come . . . standing on the shoulders
of our ancestors. We Come. The women,
the daughters, wives, healers, midwives,
scribes, artists, poets, laborers and
domestics, priestesses and shamans,
warrior and women goddesses—we come.*

Robinson honored African American women in these small drawings and in many paintings and sculptures. She described the women and the work: "Achievement against the odds—a series of visual works celebrating heroines from a host of pioneers who persisted in their battles against oppression and achieved a better equality for all of us."

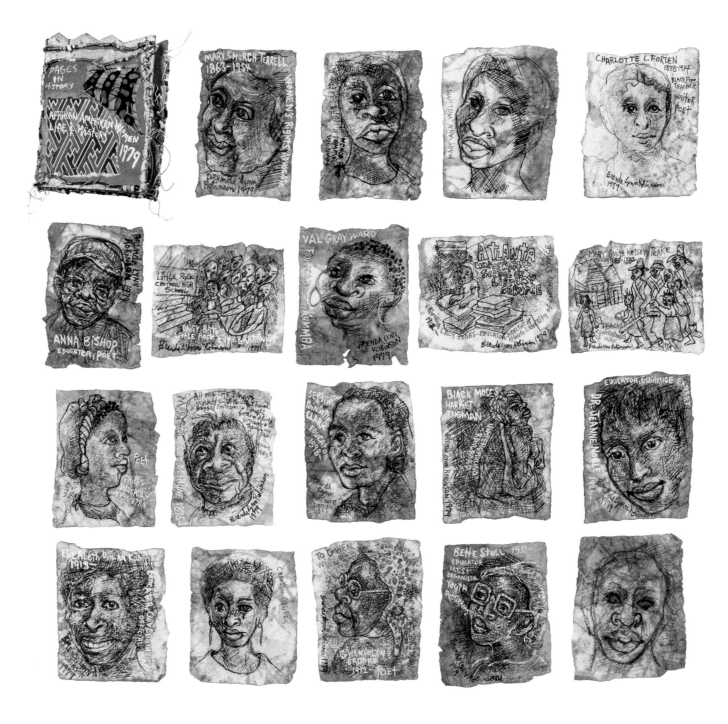

**64** *Afrikan Amerikan Women Life & History,* 1979, drawings on handmade paper in a cover with buttons, beads, and thread, 4½ × 3½ in. (each drawing)

**65** *Untitled* (portrait from *Clutch of Blossoms* series), 1999, pen and ink with pastel on paper, 12¼ × 9¼ in.

**66** *Untitled* (portrait from *Clutch of Blossoms* series), 1999, pen and ink with pastel on paper, 12¾ × 9¾ in.

**67** *Blossom, Folk Life in Poindexter Village,*
1982, pen and ink with pastel on paper,
10¾ × 7 in.

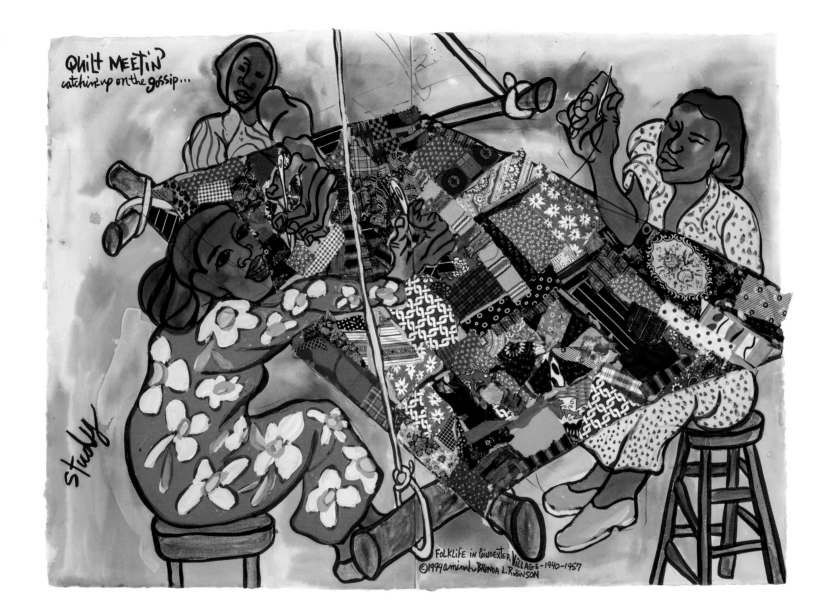

**68**   *Quilt Meetin' (Catchin' Up on the Gossip)*, 1994,
rag painting on paper, 35½ × 45½ in.

Robinson understood the power of African American spirituals as a survival mechanism during slavery and as an ongoing source of strength in her own life. In her book *The Teachings* (Harcourt Brace Jovanovich, 1992), she depicted dozens of spirituals personified as determined women capable of nurturing, inspiring, and motivating those around them. This figure adorned the cover of the book.

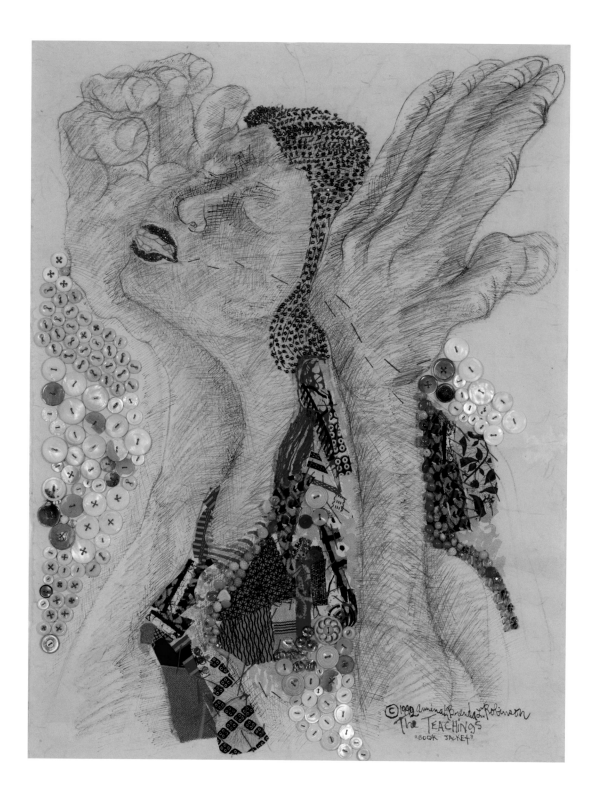

**69** *The Teachings* (cover), 1992, pen and ink, buttons, beads, thread, and fabric on paper, 26 × 20 in., Columbus Museum of Art, Gift of the Artist, 2014.050.024

70A

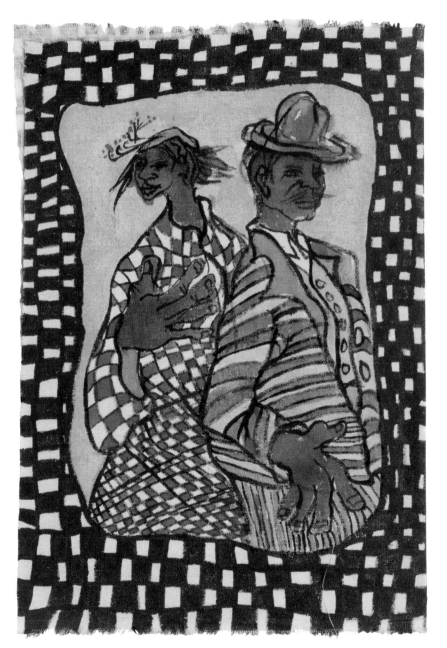

70B

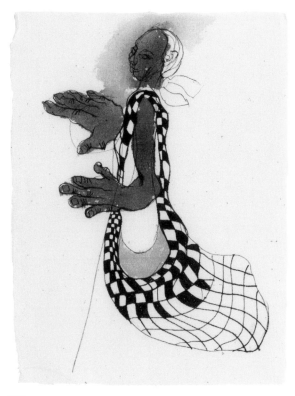

**70C**

**70D**

**70E**

**70F**

**70A–F** *Studies into the Folk Costumes of the Blackberry Patch/Poindexter Village Community, Early 1800–1957,* 1980–86, paint on cloth, (A) 11 × 7⅞ in. (B) 11 × 7⅞ in. (C) 11 × 7¾ in. (D) 6¾ × 9½ in. (E) 9¾ × 5¾ in. (F) 9½ × 7¼ in.

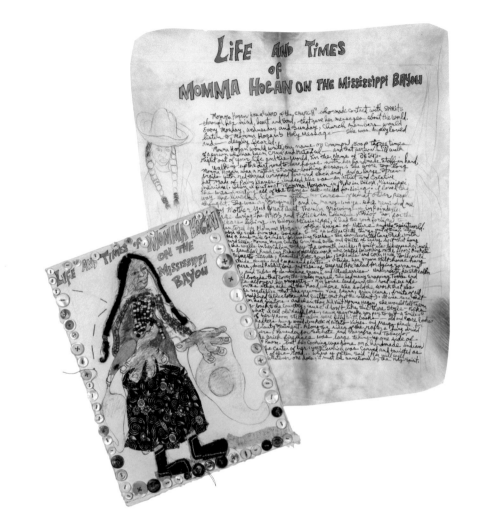

In the late 1960s, when Robinson lived in Mississippi as a military spouse, she met Momma Hogan, who lived in a house on stilts above the marshes of the bayou. Completely self-sufficient, Momma Hogan grew her own food, made and sold quilts, embroidered tablecloths, painted gourds, and assembled corn husk dolls. She was revered as a holy person with the capacity to heal the sick and see into the future.

**71** *Life and Times of Momma Hogan on the Mississippi Bayou*, undated, pen and ink on parchment, 30 × 16 in.

**72** *Life and Times of Momma Hogan on the Mississippi Bayou*, undated, mixed media book, 13½ × 9¾ in.

**73** *Life and Times of Momma Hogan on the Mississippi Bayou*, 2007, paint on heavy stock, 22¼ × 88¼ in.

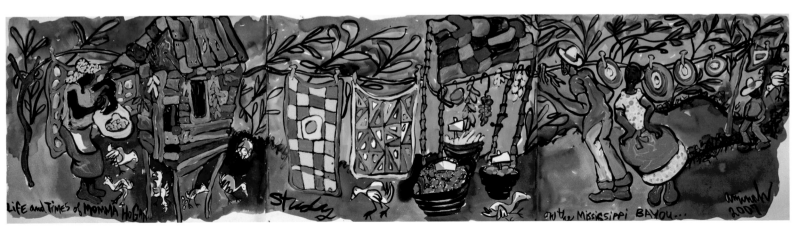

This figure honors those women who toiled in the fields during slavery and also used their skills to enhance their families' lives by creating clothes and quilts that were both functional and of great beauty.

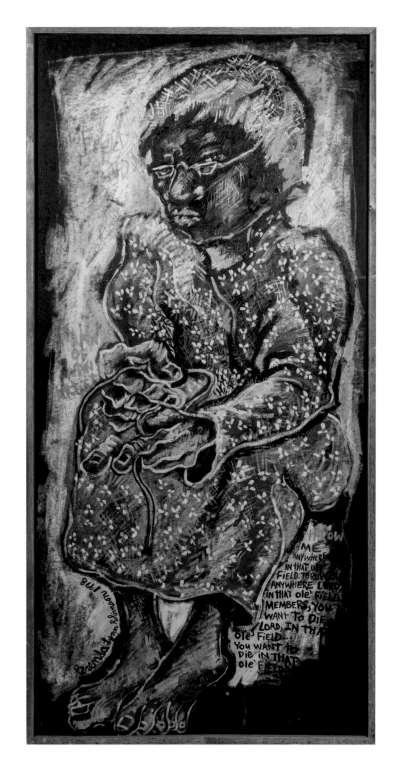

**74** *Field Hand—Hands of an Artist*, 1978, pastel and acrylic on Pellon™, 72½ × 35½ in.

## RAGGIN' ON
### THE CIRCUS

*Sellsville was an integrated neighborhood
with its residents living side by side on the
friendliest of terms.*

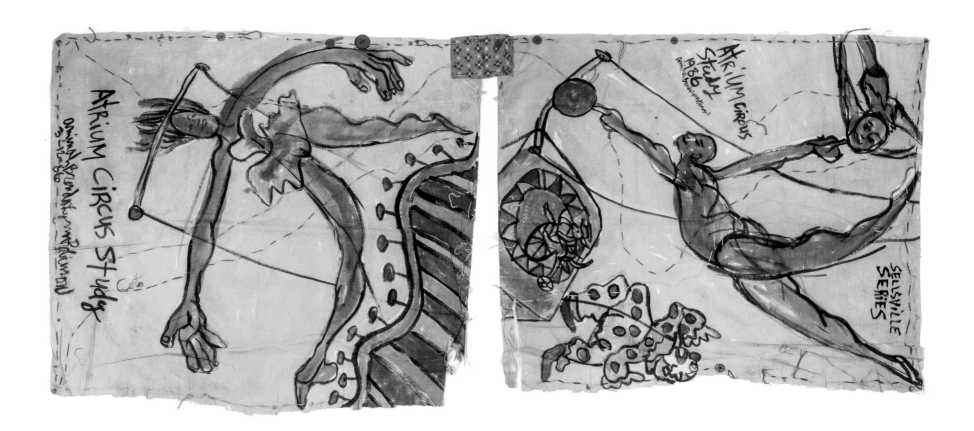

**75** *Atrium Circus Study* (from *Sellsville Circus*
series), 1986, paint on muslin, two panels:
38 × 32 in. and 37 × 34 in.

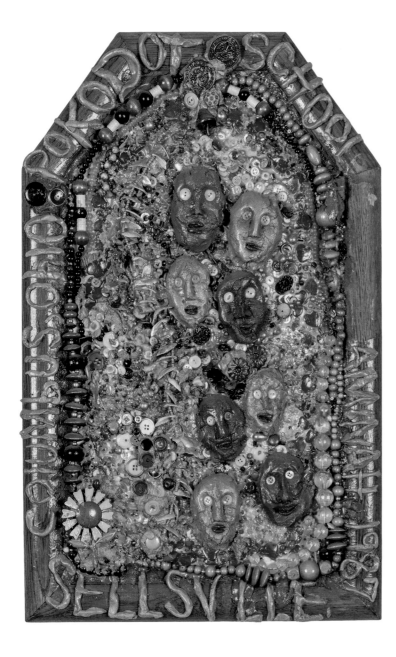

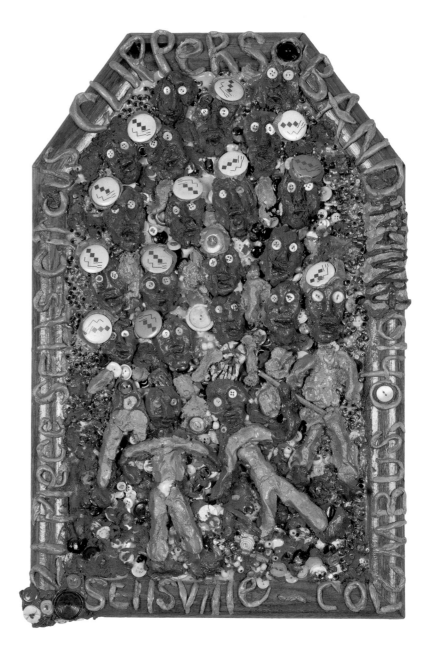

**76** *Sellsville Circus Polkadot School* (from *Sellsville Circus* series), 1987, hogmawg and found objects, 27 × 17 × 2 in.

**77** *21 Piece Sells Circus Band* (from *Sellsville Circus* series), date unknown, hogmawg and found objects, 27 × 17 × 2 in.

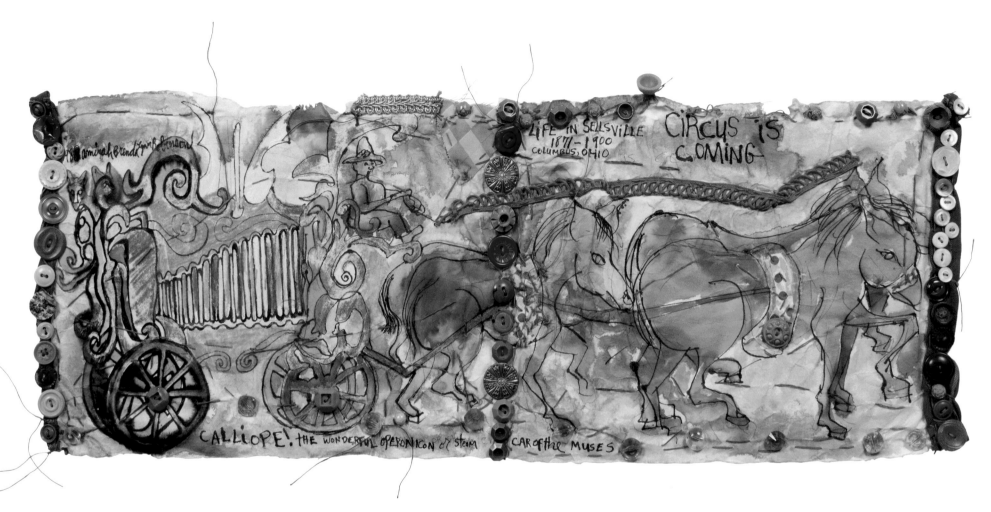

**78** *Circus is Coming* (from *Sellsville Circus* series), 1988, pen and ink with watercolor, thread, and buttons on paper, 9 × 24 in.

By the late 1800s, the Sells Brothers Circus, based in Columbus, was one of the biggest circuses in the country. Children of the African Americans who worked for the circus were educated with white children and the school became known as the "Polkadot School." The circus had an all-black band, the Clippers; and an all-black baseball team, the Sluggers. Robinson was fascinated by the circus's history, and in 1988 she submitted a proposal to create a circus-themed installation in the atrium of a local hospital. Although her plan was not selected, she completed many drawings and paintings that celebrate the circus.

# RAGGIN' ON

## JOURNEYS

*I believe that traveling is one of the highest means of obtaining a formal education.*

In the summer of 1998, Robinson received an Ohio Arts Council Visual Arts Fellowship to travel and work in Israel. In addition to touring with a group, she spent several days in Jerusalem on her own, exploring and sketching the Armenian, Christian, Jewish, and Muslim sections of the old city.

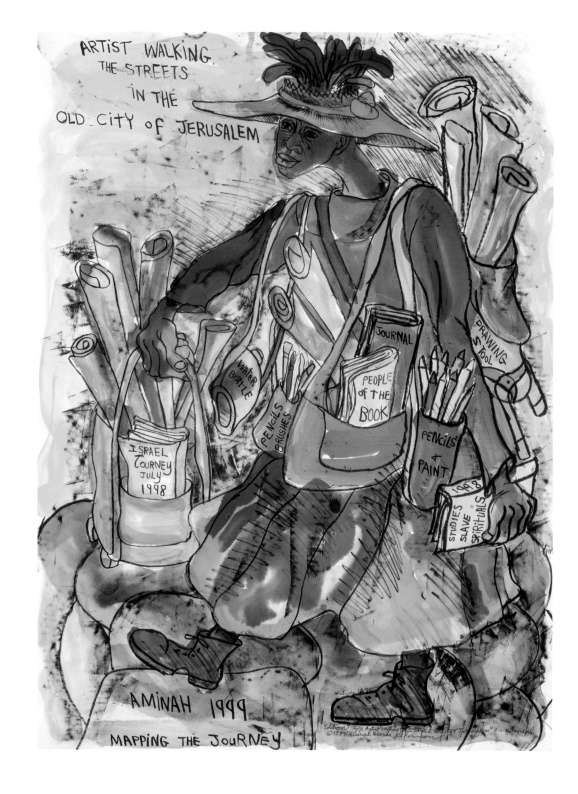

**79** *Artist Walking the Streets in the Old City of Jerusalem (Self-Portrait)*, 1999, hand-painted lithograph, 33 × 24 in.

# ISRAEL

Robinson took a special interest in the small Ethiopian Christian community that has had a presence in Jerusalem for hundreds of years. She found her way to its village on the rooftop of the Church of the Holy Sepulcher and was befriended by the monks and nuns who lived there.

**80**  *Ethiopian Village and Orthodox Monastery on the Rooftop of the Holy Sepulcher Church, the Old City of Jerusalem Afrikan Village*, 1998, cloth painting, 69½ × 42 in.

**81** *Bedouin Woman of Jericho*, 1999, water-color and fabric, 42½ × 36⅜ in.

*Walking through the streets of Jerusalem forms a bridge from past to the present. Biblical chronicles are no longer merely ancient religious history. They are the records of life of a people.*

# CHILE

During and after traveling to Chile in 2004 for an Ohio Arts Council residency, Robinson created *Chilean Suite,* a series of drawings, carved doors, paintings, and a RagGonNon that were exhibited at the Museo Nacional de Bellas Artes in Santiago, where she was the first American woman to have a solo exhibition.

**82** *Seaweed at Tunquén, Chile,* 2004, watercolor, 17 × 21 in.

**83**   *The Hevens, Tunquén, Chile,* 2004, water-
color, 15½ × 20 in.

*In the night sky, above the eternal mountain, brilliant
constellations rambled through autumn skies, ascend-
ing and descending in a suite. . . . this I saw one night at
Tunquén on March 14, 2004.*

# ITALY

From the time she was in art school, Robinson dreamed of visiting Italy. Many years later, in 2005, she made the trip with stops in Rome, Florence, Padua, Vinci, Venice, and Lucca.

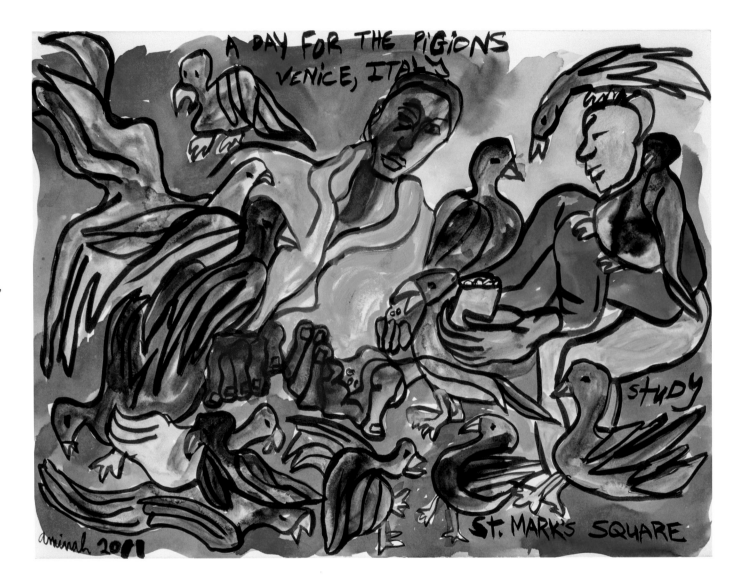

**84** *A Day for the Pigions, Venice, Italy, St. Mark's Square,* 2011, watercolor, 22½ × 30 in.

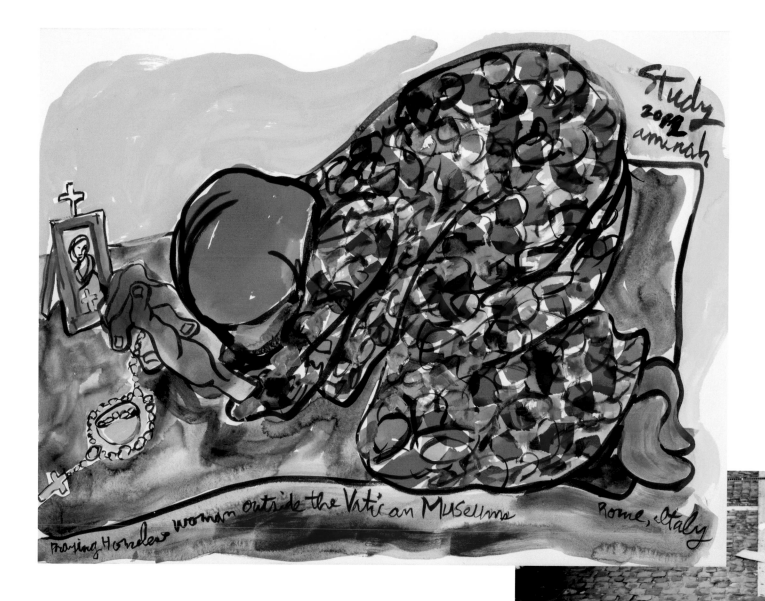

**85** *Praying Homeless Woman outside the Vatican Museums, Rome, Italy,* 2012, watercolor, 22½ × 30 in.

FIG. 4: Robinson's photograph of a homeless woman in Rome

# PERU

Inspired by the ancient culture of
the Inca civilization and the magnif-
icence of its ruins high in the Andes,
Robinson titled the Peruvian series,
*I Touched the Divined*. In addition to
visiting Machu Picchu during her
2006 trip, she met with groups of
women artisans.

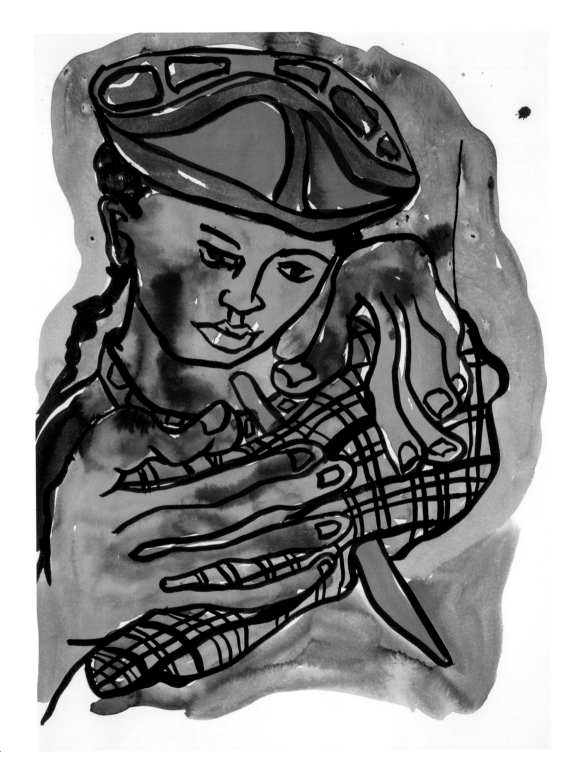

**86** *Untitled*, 2006, watercolor, 30 × 22½ in.

*For myself, Peru is part of my ongoing documentation of a Global Afrikan Presence.*

**87** *Untitled (Peruvian woman)*, 2006, watercolor, 30 × 22½ in.

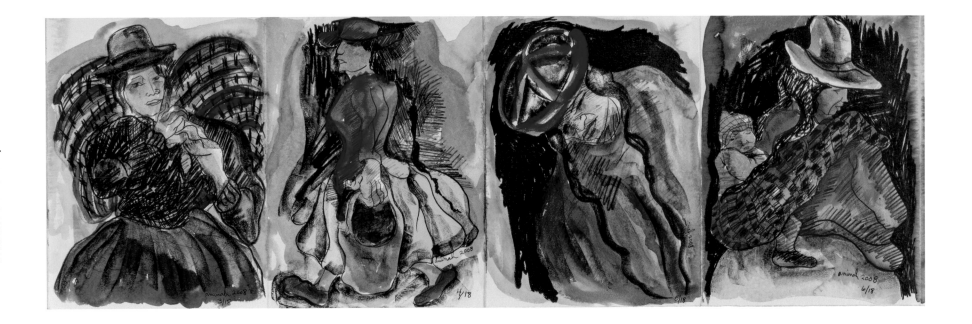

**88** *I Touched the Divined . . . Journey to Peru,* 2008,
8 of 16 hand-painted lithographs in an accordion
book, each 15½ × 12 in.

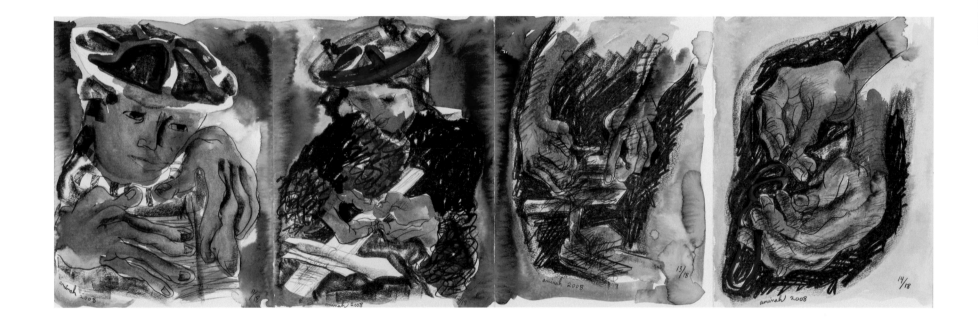

# JOURNALS, TEXTS, AND MUSIC

*It is impossible to separate the writing from the drawing, or the drawing from the writing.*

Writing takes center stage in the more than 125 journals Robinson kept from the time she was in art school until her death. In many of the journals, her essays, poems, and commentaries are animated with drawings of all kinds—from a few quickly formed pencil lines to detailed watercolors and pastels. This powerful combination of writing and drawing provides insight into her creative process and her artistic aspirations.

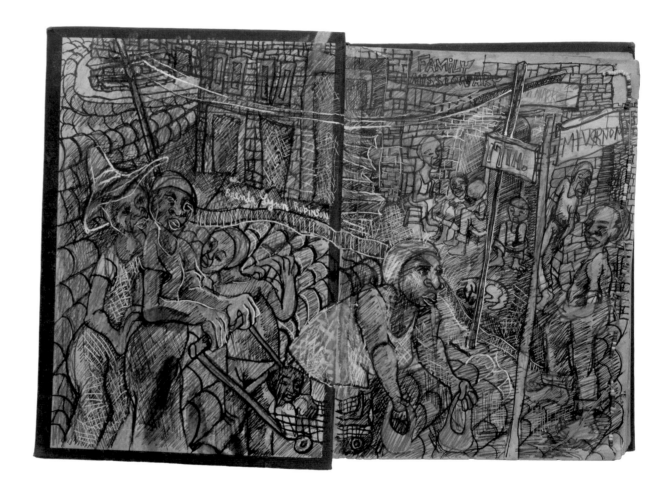

**89** *17th and Mt. Vernon* (from *Timelessness of Life* journal), 1981–82, pen and ink on paper, 11½ × 9¼ in., ABLR 19-59

Detailing Robinson's study trip to Africa in 1979, this journal is a day-to-day account of her experiences in Ethiopia, Senegal, Kenya, Nigeria, and Egypt. The themes, observations, and vignettes that Robinson chronicled here affected her work for the rest of her life. For example, she added the figure of the Oba (opposite) to *Gift of Love* (plate 5), the chair she constructed for the living room of her Sunbury Road home.

**90** *Afrikan Journal*, 1979, carved leather cover, 10 × 7⅝ in., ABLR 19-56

**90A** (OPPOSITE): *Palace of the Oba* (from *Akrikan Journal*), 1979, pen and ink with pastel, 10 × 15¼ in., pp. 88–9, ABLR 19-56

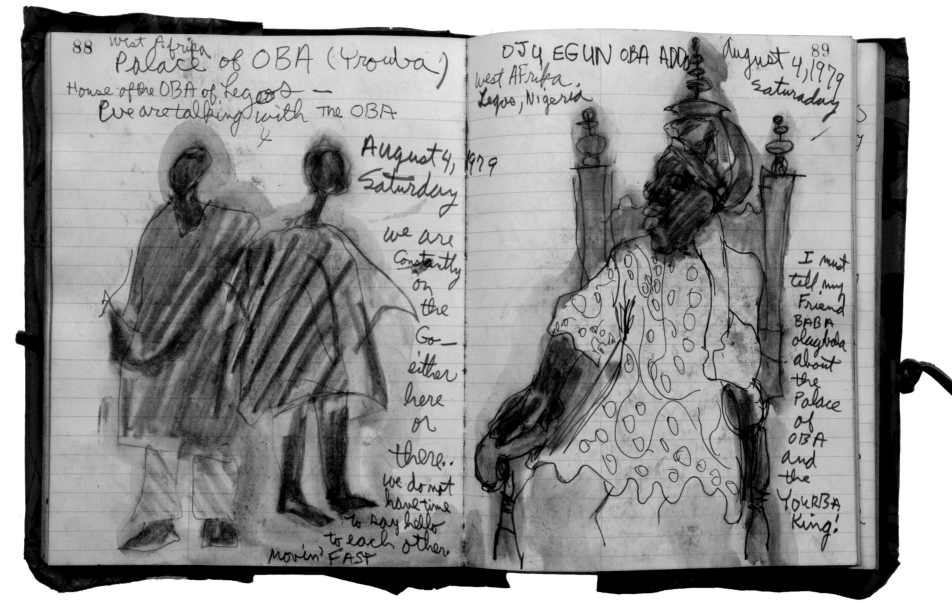

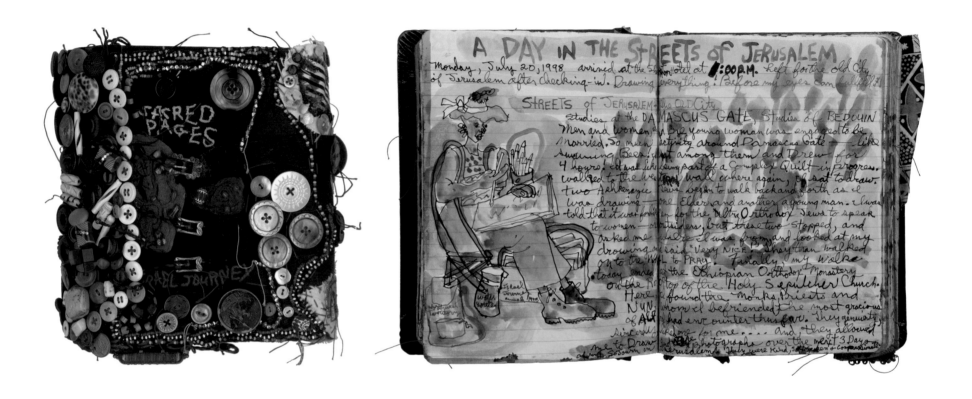

**91** *Sacred Pages, Israel Journey*, 1998, journal, mixed media cloth cover, 10 × 9½ in., ABLR 19-70B

**91A** *A Day in the Streets of Old Jerusalem* (from *Sacred Pages, Israel Journey* journal), 1998, pen and ink with watercolor, 9 × 16 in.

This journal is a detailed, daily documentation of Robinson's five-week residency in Herzliya, Israel, in 1998.

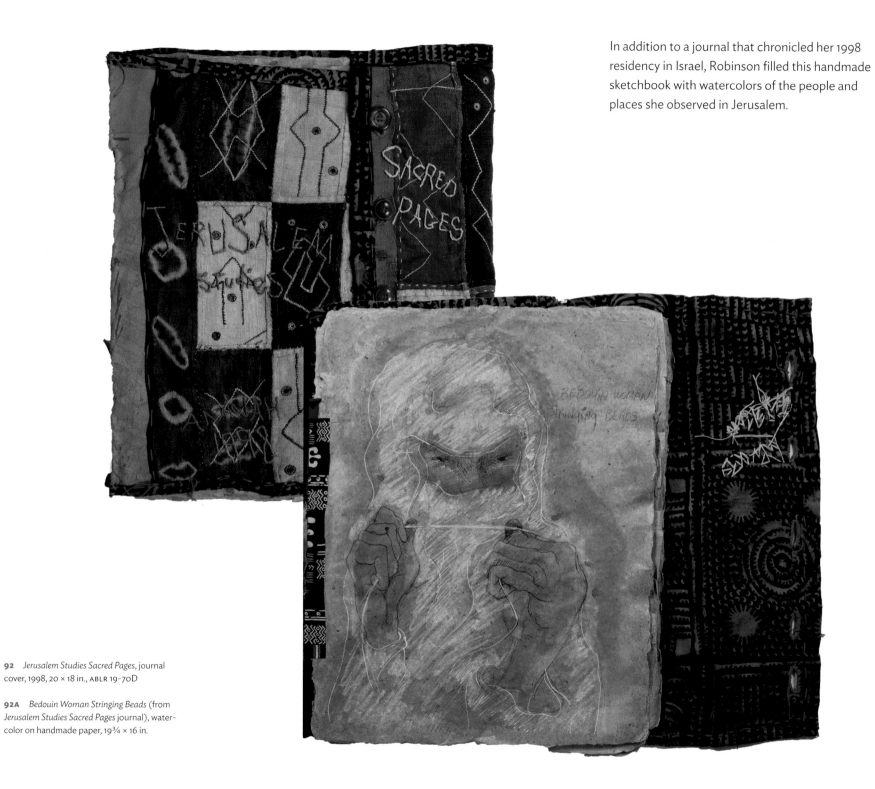

In addition to a journal that chronicled her 1998 residency in Israel, Robinson filled this handmade sketchbook with watercolors of the people and places she observed in Jerusalem.

**92** *Jerusalem Studies Sacred Pages*, journal cover, 1998, 20 × 18 in., ABLR 19-70D

**92A** *Bedouin Woman Stringing Beads* (from *Jerusalem Studies Sacred Pages* journal), watercolor on handmade paper, 19¾ × 16 in.

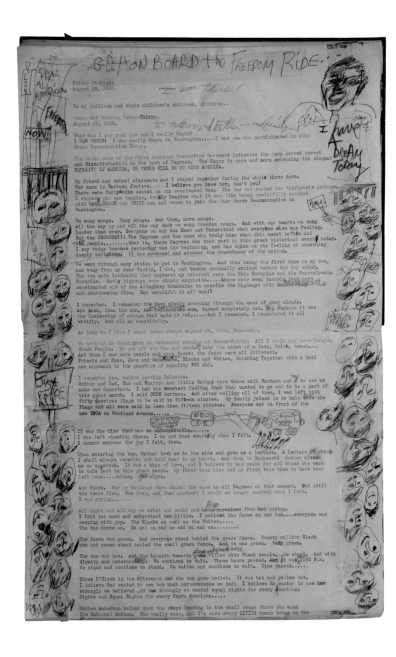

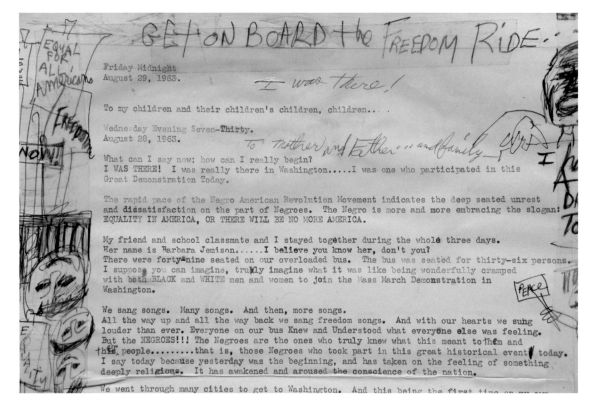

**93** *To my children…* (from *March on Washington* journal), August 19, 1963, typewritten letter and detail, 11 × 8½ in., ABLR 19-11

After returning to Columbus from the 1963 March on Washington, twenty-three-year-old Robinson wrote this passionate letter and sent copies to family and friends. It captures her joy in meeting James Baldwin and other civil rights leaders, her deeply felt rage against the racism that permeated American society, and her hopeful confidence in the possibility of complete freedom for African Americans.

In numerous journal entries, Robinson recorded stories and images of the individuals who lived and sold their wares on Mount Vernon Avenue in the early- to mid-20th century on Columbus's east side.

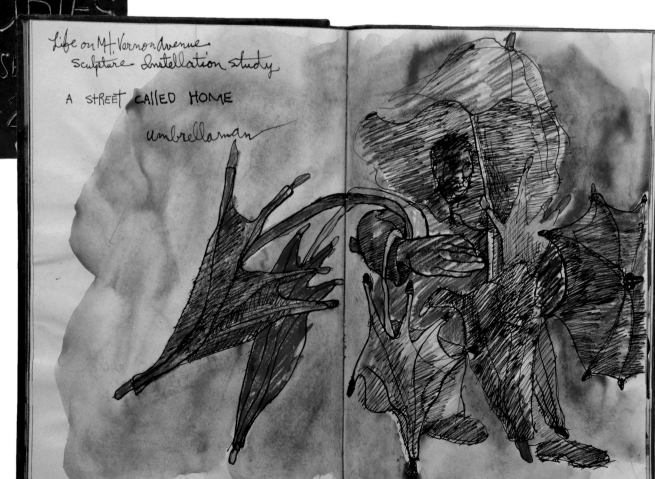

**94** *Symphonic Poem, My Constant Companion, Studies, Doll House Story* journal cover, 2001–03, leather with mixed media, 11¼ × 8 in., ABLR 19-72

**94A** *Umbrellaman*, 2001–03, pen and ink with watercolor, 11 × 16 in., ABLR 19-72

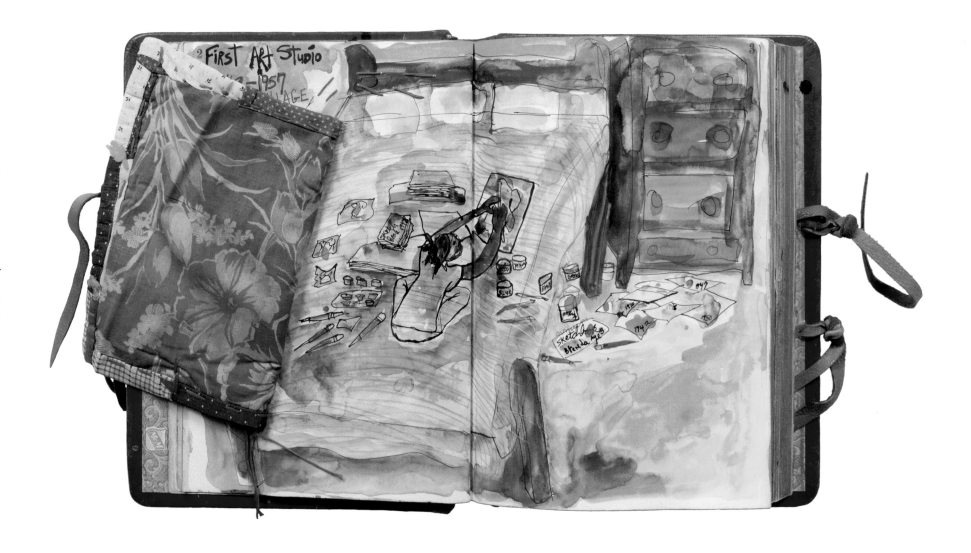

**95A** *First Art Studio* (from *Poindexter Village As I Walk…* journal), 2001–06, pen and ink with watercolor, cloth, and thread, 11¾ × 18 in., ABLR 19-73

In this journal compiled over a period of five years, Robinson detailed important aspects of her life and art, beginning with a vivid childhood memory: "Here underneath this bed—I lived out my early years as an artist. I could not have been any closer to God than being here, drawing and painting."

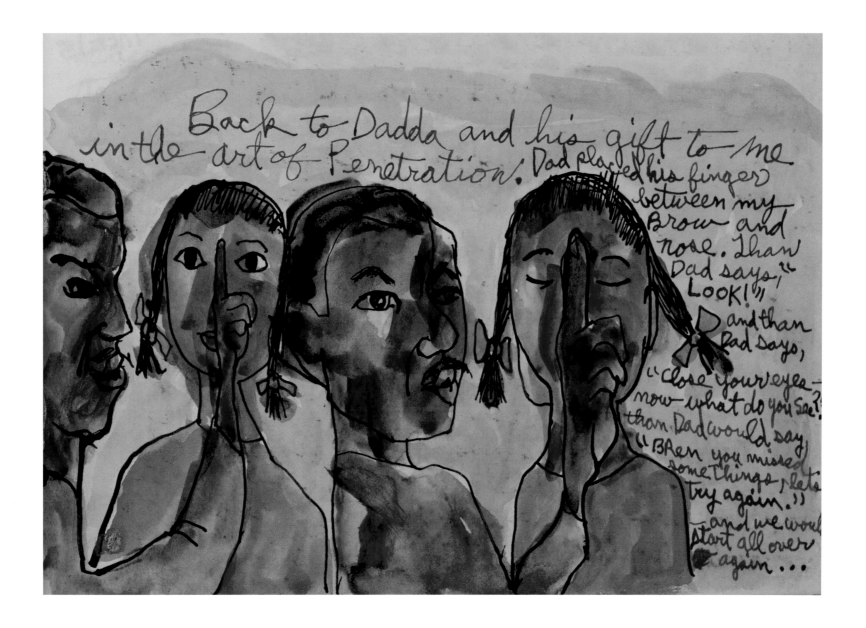

**95B** *Back to Dadda* (from *Poindexter Village
As I Walk . . .* journal), detail, 2001–06, pen and
ink with watercolor, p. 157, ABLR 19-73

In this detail from a journal page, Robinson explains
with words and illustrations the concentration tech-
nique of "penetration" she learned from her father.

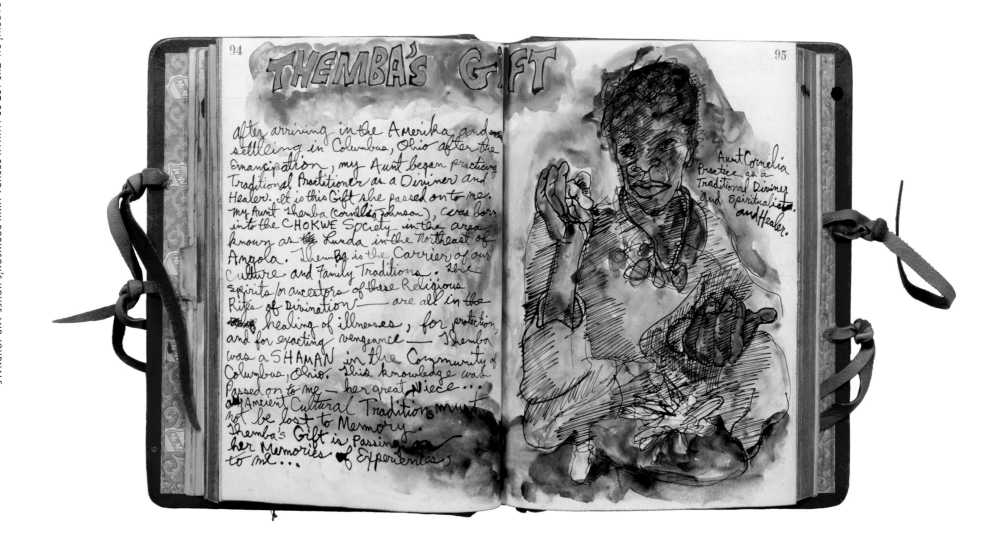

**95C** *Themba's Gift* (from *Poindexter Village As I Walk . . .* journal), 2001–06, pen and ink with watercolor, 11¾ × 18 in., pp. 94–5, ABLR 19-73

In several journals, Robinson detailed her relationship with Great-Aunt Cornelia, who became the basis for the series, *Themba: A Life of Grace and Hope.* Robinson regarded herself as the successor to her great-aunt's shamanistic healing and divining capabilities.

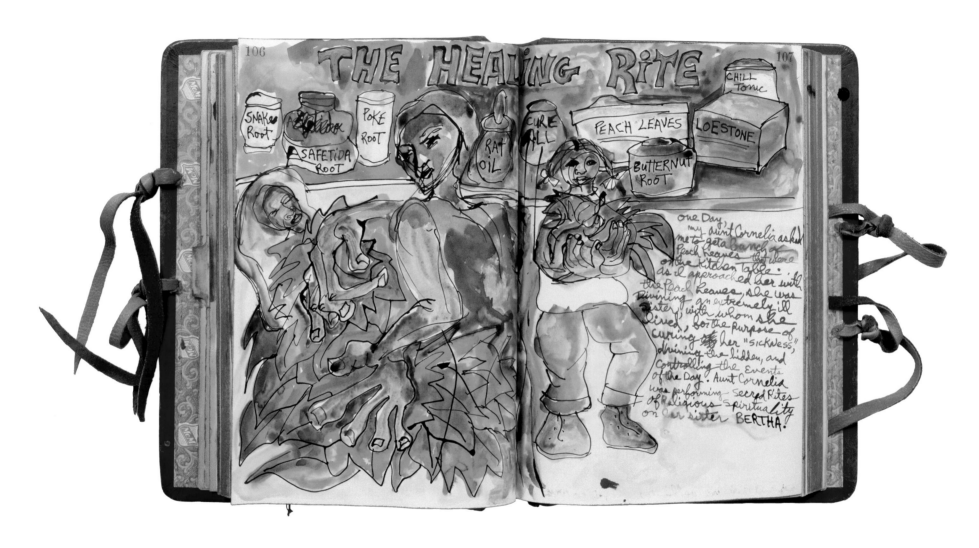

**95D** *The Healing Rite* (from *Poindexter Village As I Walk . . . journal*), 2001-06, pen and ink with watercolor, 11¾ × 18 in., pp. 106-07, ABLR 19-73

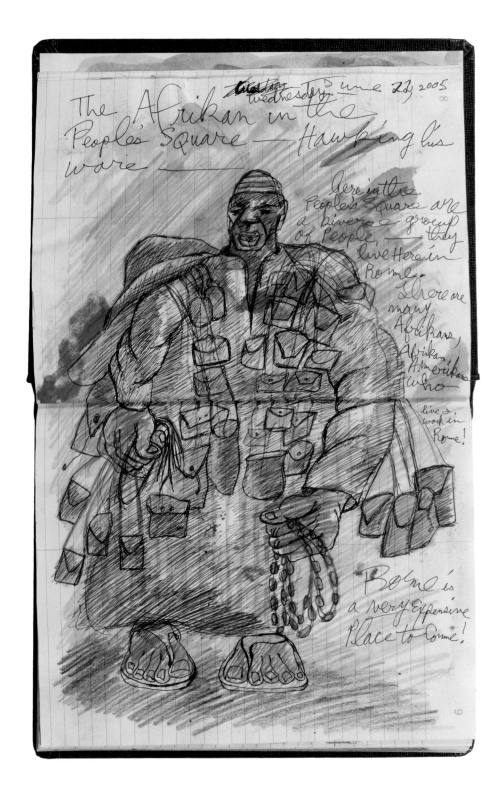

On her trip to Italy in 2005, Robinson depicted an African street vendor she encountered in Rome.

**96** *The Afrikan in the People's Square* (from *A Spirit of My Soul* journal), 2005, pen and ink with colored pencil and watercolor, 16¼ × 9¾ in., pp. 8–9, ABLR 19-80

In Peru, Robinson felt a kinship with the women artisans of Chinchero, who wore distinctive, handmade hats and clothes (fig. 5).

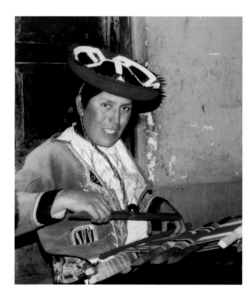

FIG. 5

**97** *Woman Artisans of Chincheros, Peru* (from *I Touched the Divined . . . Journey to Peru* journal), 2006, pen and ink with pastel, 10 × 7⅜ in., ABLR 19-83

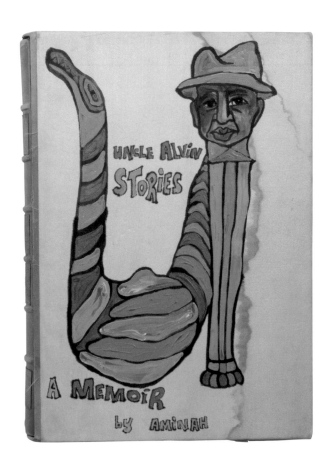

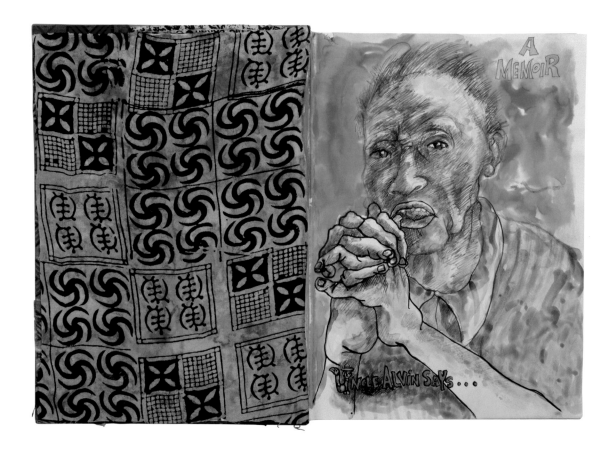

**98**  *Uncle Alvin Stories* (journal and cloth-covered, painted slipcase), 2010, 13½ × 10 in., ABLR 19-89

**98A**  *Uncle Alvin Says* (from *Uncle Alvin Stories* journal), 2010, pen and ink with watercolor, 13 × 9½ in., ABLR 19-89

Uncle Alvin Zimmerman was Robinson's mother's oldest sibling. His "hand-me-down" stories were the basis for historical and fabled themes Robinson returned to throughout her career.

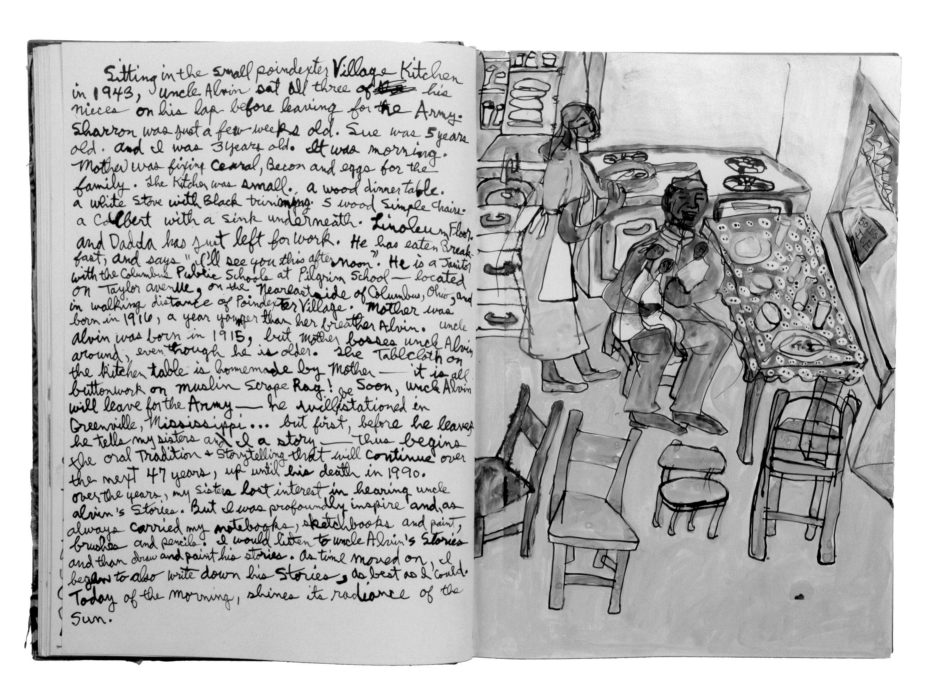

Sitting in the small poindexter Village Kitchen in 1943, uncle Alvin sat all three of his nieces on his lap before leaving for the Army. Sharron was just a few weeks old. Sue was 5 years old. And I was 3 years old. It was morning. Mother was fixing Cereal, Becon and eggs for the family. The Kitchen was small. a wood dinner table. a white stove with Black triming. 5 wood Simple chairs. a Colbert with a sink underneath. Linoleum Floor. and Dadda has just left for work. He has eaten Breakfast, and says "I'll see you this afternoon". He is a Janitor with the Columbus Public Schools at Pilgrim School — located on Taylor avenue, on the Neareast side of Columbus, Ohio, and in walking distance of Poindexter Village. Mother was born in 1916, a year younger than her breather Alvin. Uncle alvin was born in 1915, but Mother bosses uncle Alvin around, even though he is older. The Tablecloth on the kitchen table is homemade by Mother — it is all buttonwork on muslin Scrape Rag! Soon, uncle Alvin will leave for the Army — he will stationed in Greenville, Mississippi... but first, before he leaves he tells my sisters and I a story — Thus begins the oral Tradition & Storytelling that will continue over the next 47 years, up until his death in 1990. Over the years, my sisters lost interest in hearing uncle alvin's Stories. But I was profoundly inspire and, as always carried my notebooks, sketchbooks and paint, brushes and pencils. I would listen to uncle Alvin's Stories and then draw and paint his stories. as time moved on, I began to also write down his Stories, as best as I could. Today of the morning, shines its radiance of the Sun.

**98B** *Sitting in the small Poindexter Village Kitchen* (from *Uncle Alvin Stories* journal), 2010, pen and ink with watercolor, 13 × 9½ in., ABLR 19-89

In the Poindexter Village apartment of the Robinson family, Uncle Alvin holds Robinson and her sisters and visits with their mother. The tablecloth is covered with buttons—a sewing tradition Mrs. Robinson passed on to her daughters.

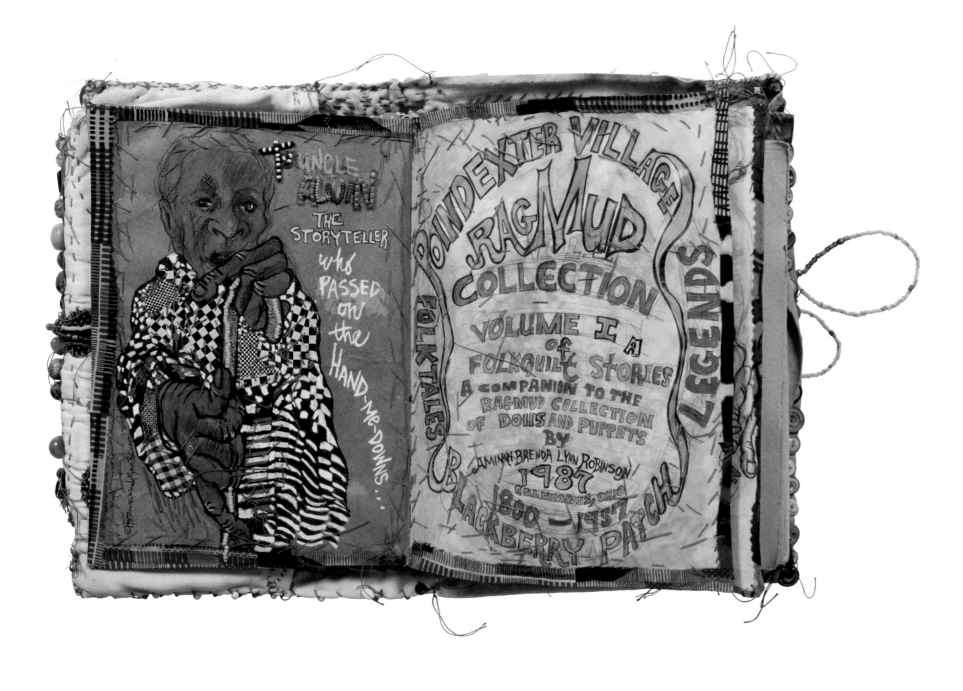

**99**  *Poindexter Village Ragmud Collection,*
1987, fabric book with found objects,
13 × 9½ × 2½ in.

Combining historic passages, handed-down legends, and tributes to her elders, the Ragmud Collection of books features buttons, beads, other found objects, and books-within-books. Ten of these complex, intricate volumes are in the collection of the Toledo Museum of Art.

Robinson combined traditional symbols of western musical notation with recognizable forms to create expressive illustrations that hover between art and music. For a discussion of the artist's musical notation, see "Aminah's Music," p. 69.

**100** *Music Score, Book of Revelations* accordion book cover (from *Presidential Suite* series), 2007–10, pen and ink, 18½ × 14 × 1½ in.

**100A** *Music Score, Book of Revelations* (from *Presidential Suite* series), inside page, 2007–10, pen and ink on heavy stock, 18 × 22 in.

## MATERIAL MATTERS

*I let all forms inspire me and set me in motion. . . . I begin to listen to the language of forms. The whole world is there to be looked at in creative and exploratory fashion.*

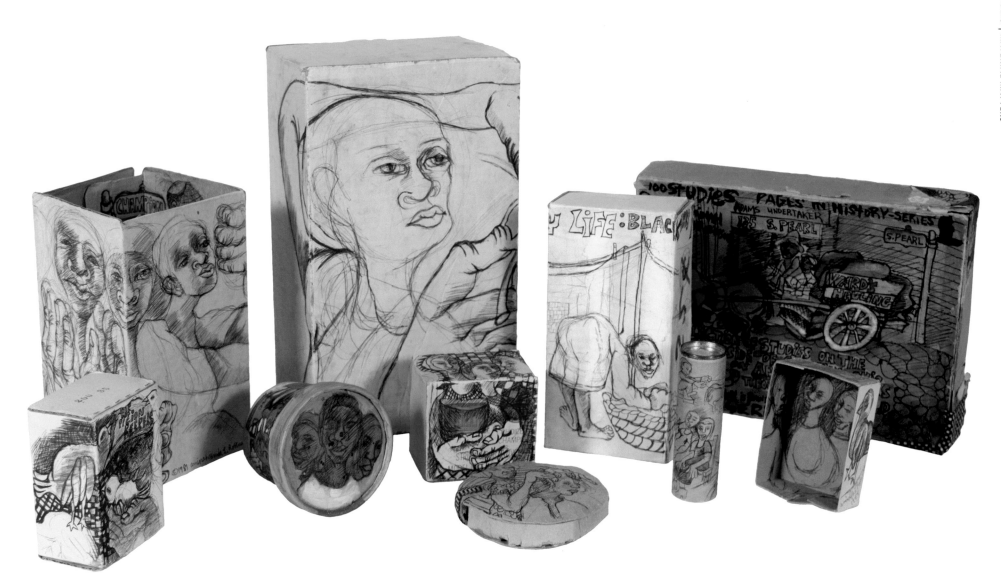

**101** Boxes, dates unknown, pen and ink with pastel on cardboard

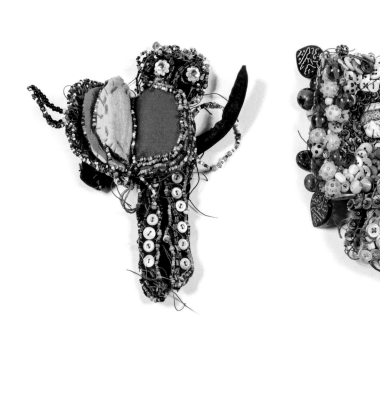

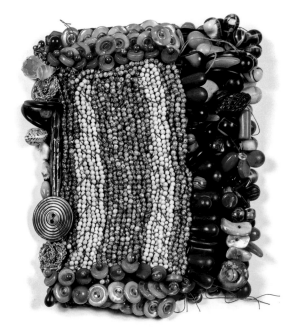

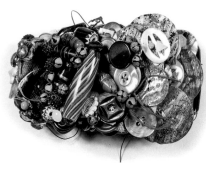

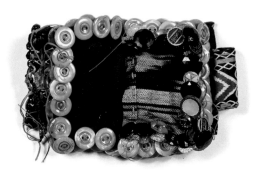

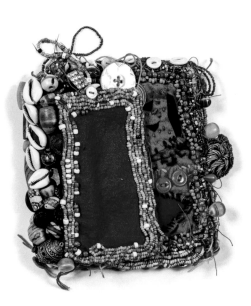

**102** *Button Beaded Books,* dates unknown, mixed media

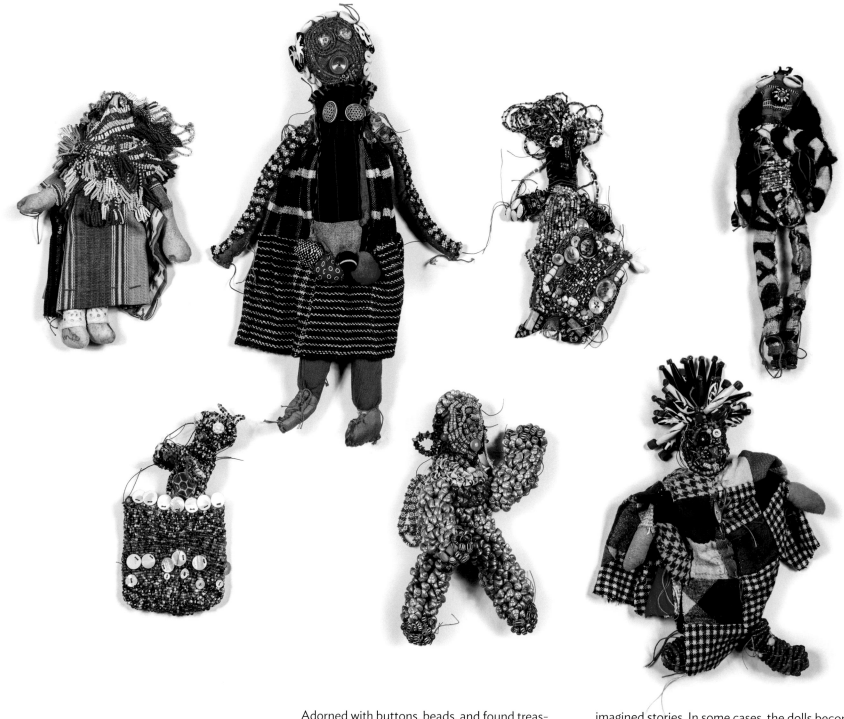

**103** *Button Beaded Dolls,* dates unknown, mixed media

Adorned with buttons, beads, and found treasures, Robinson's dolls assume distinct personalities and the books' blank pages (plate 102) encourage imagined stories. In some cases, the dolls become books and the books become dolls.

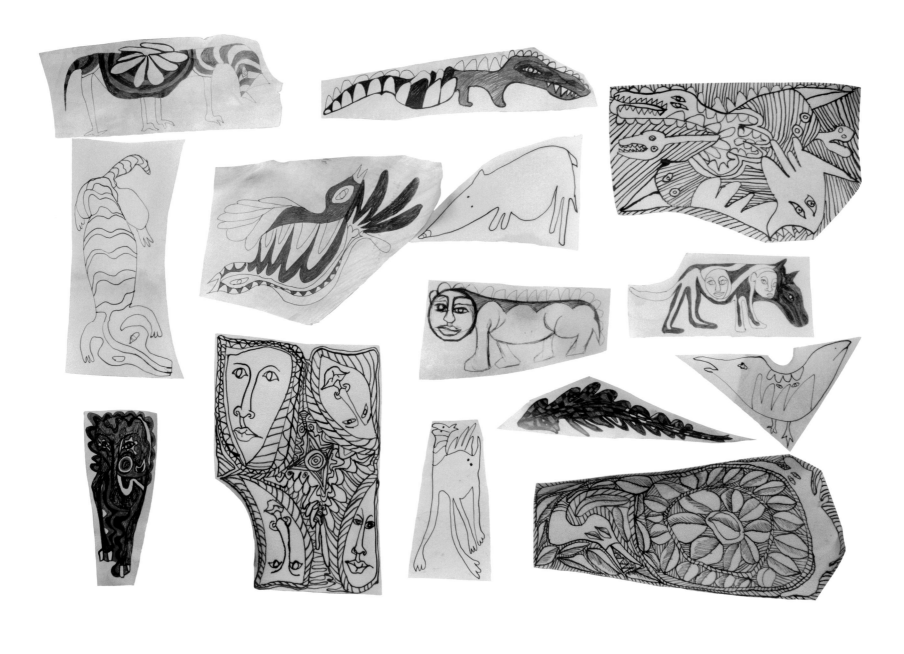

**104** *Gupas,* dates unknown, pen and ink on parchment

A *gupa* is Robinson's invented word for symbolic creatures that represent aspects of oral traditions, folktales, or mysteries of life. They are often drawn in pen and ink on irregular pieces of parchment.

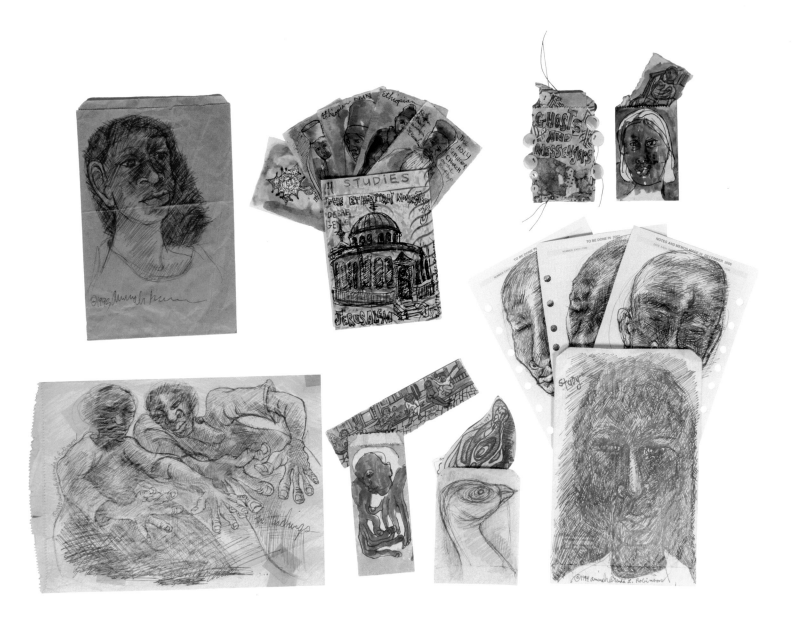

**105** *Untitled*, dates unknown, mixed media on paper bags

On large and small paper bags accumulated at home and in her travels, Robinson made captivating drawings and often filled the bags with related illustrations.

In the late 1980s, Robinson began recycling letterhead and envelopes she received in the mail to create an ongoing series titled *Unwritten Love Letters*. The stationery and steamed-open envelopes became the surfaces for pen and ink and watercolor drawings embellished with canceled stamps and other found objects. Each "love letter" celebrated a significant person or event in African American history and culture.

**106** *Dear Columbus Community Today Is the Grand Opening* (from *Unwritten Love Letters* series), 1987, pen and ink with watercolor on King Center (now King Arts Complex) letterhead, 11 × 8½ in.

**107** *Untitled* (from *Unwritten Love Letters* series), 1987, pen and ink with watercolor on King Center (now King Arts Complex) letterhead, 11 × 8½ in.

**108** *Maya Angelou* (from *Unwritten Love Letters* series), 1990, pen and ink with pastel on The Studio Museum in Harlem envelope, 9 × 15¾ in.

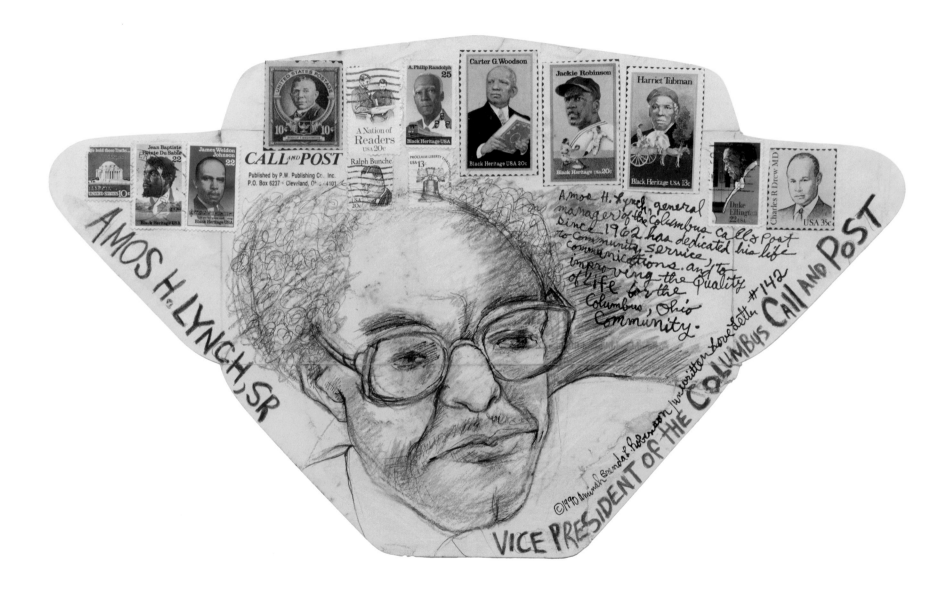

**109**   *Amos H. Lynch, Sr.* (from *Unwritten Love Letters* series), 1990, pen and ink with pastel and canceled stamps on *Call and Post* envelope, 9 × 15¾ in.

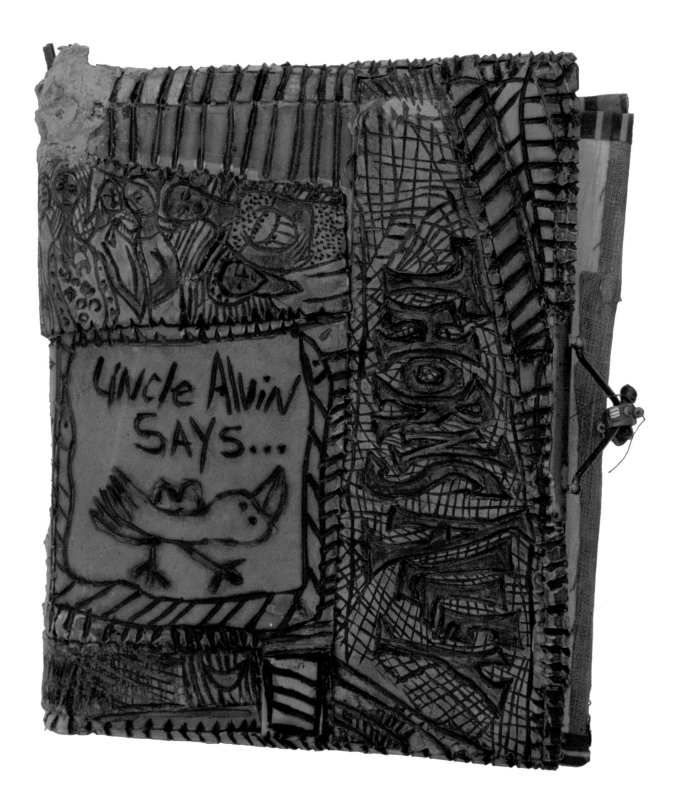

**110**   *Uncle Alvin Says, Thorn Alley*, date unknown, leather book cover, 10¾ × 9¼ × 4 in.

**111**   (OPPOSITE): *Untitled* (man and woman on horse), date unknown, mixed media, 31 × 12 × 12 in. and *Untitled* (man on horse), date unknown, mixed media, 24 × 21 × 10 in.

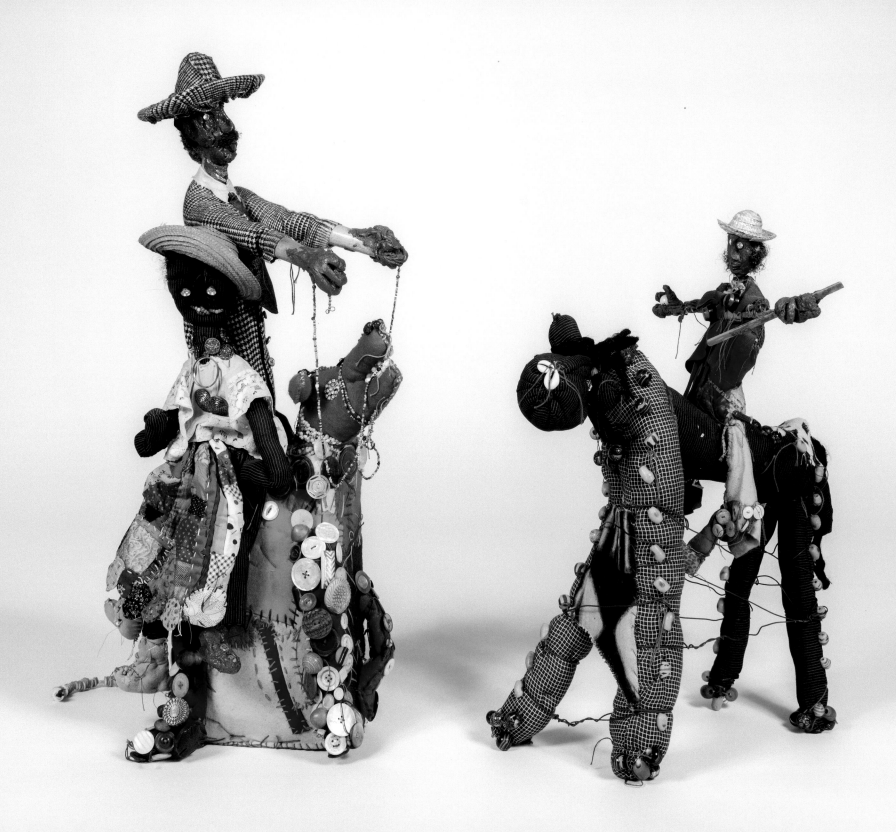

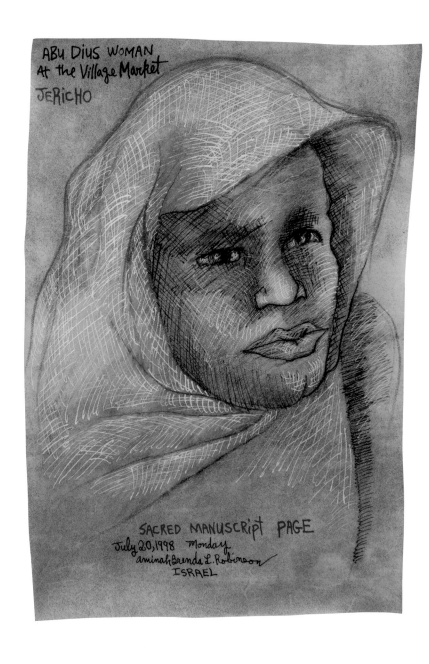

112 *Village of Abu Dius, Market Woman, Jericho, Sacred Manuscript Page,* 1998, pen and ink on parchment, 6¼ × 7 in.

113 *Untitled (Portrait of an Arab man),* 1998, pen and ink with pastel on parchment, 7½ × 6½ in.

When Robinson traveled to Israel in 1998, she recorded the faces of the people she encountered on parchment and papyrus she had packed and brought with her.

**114** *Orthodox Jew at the Western Wall, Sacred Manuscript Page,* 1998, pen and ink with pastel on papyrus, 14 × 9½ in.

**115** *Muslim Woman, Old City of Jerusalem, Sacred Manuscript Page,* 1998, pen and ink with pastel on papyrus, 14 × 11 in.

Printmaking fascinated Robinson and she made nearly forty editions of lithographs, etchings, and woodcuts on a variety of subjects. Before *Symphonic Poem*, the retrospective exhibition of her work travelled to the Brooklyn Museum in 2006, she created a series of eleven large woodcuts about the African American history of Brooklyn.

FIG. 6 (OPPOSITE): Robinson relished the physicality of using her tools to carve stories and designs into the pliable surface of wood or leather

**116** *One Day in the History of Brooklyn, New York*, 2005, woodcut, 48 × 36 in.

# Chronology

### 1940

On February 18, Brenda Lynn Robinson is born to Leroy Edward William Robinson and Helen Elizabeth Zimmerman Robinson in Columbus, Ohio. Her older sister, Sandra Sue, is two at the time. In September, the family moves to Poindexter Village, a newly constructed Federal housing development for African Americans on the east side of Columbus (fig. 1).

FIG. 1: Robinson, age two

### 1943

Sister Sharron Elizabeth Robinson is born.

### 1945

Enters kindergarten at Mount Vernon Avenue Elementary and remains there through sixth grade. Attends Pilgrim School for seventh grade; Franklin Junior High for eighth and ninth grades (fig. 2).

FIG. 2: Robinson, age ten

### 1948

At the age of eight, first exhibits her art on a makeshift clothesline on the corner of Champion and Mount Vernon Avenues during a church revival taking place nearby.

### 1955

Begins attending Saturday classes at the Columbus Art School (now the Columbus College of Art and Design).

### 1957

Graduates from East High School (fig. 3) and enters the Columbus Art School (fig. 4) The Robinson family moves to a home on Dartmouth Avenue, northeast of Poindexter Village.

FIG. 3: Robinson (center) graduates from East High School

FIG. 4: Robinson (front row, second from right), second-year class, Columbus Art School, 1960

### 1958 (fig. 5)

Begins her first job in various departments of the Columbus Public Library (now the Columbus Metropolitan Library).

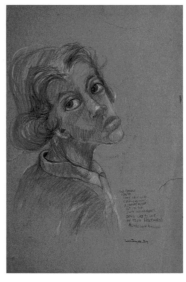

FIG. 5: *Self-Portrait*, 1958, graphite and colored pencil on paper, 18 × 12 in., Columbus Museum of Art, Estate of the Artist

### 1959

Wins a prize in an illustration contest of *Seventeen Magazine*, New York City. Receives first prize in the professional graphic section of the Ohio State Fair art exhibition for a drawing titled *Reminiscence* (fig. 6).

FIG. 6: *Reminiscence*, 1959, pen and ink with pastel on paper, 18 × 9½ in., Columbus Museum of Art, Estate of the Artist

**1960**

Attends classes in art history and philosophy at The Ohio State University.

**1963**

Participates in the March on Washington, a monumental civil rights demonstration where Rev. Martin Luther King, Jr. delivers his "I Have a Dream" speech on August 28 (fig. 7).

FIG. 7: Robinson at March on Washington

**1964**

Marries Clarence Robinson, a Korean War veteran, and moves with him to Boise, Idaho, where he is stationed with the Air Force. Works as a draftsperson for the Mountain States Telephone Company (fig. 8).

FIG. 8: Robinson on September 26, 1964, at St. Dominic's Church, Columbus

**1966**

Moves with Clarence Robinson to Keesler Air Force Base in Biloxi, Mississippi. Works as an illustrator for the Television Operations branch of the base.

**1967**

Gives birth to son, Sydney Edward Robinson, on January 11 in Biloxi (fig. 9).

FIG. 9: Sydney, age six months

**1968**

Robinson and Sydney move in with her parents in Columbus when Clarence is sent to Vietnam. Works as a senior illustrator at North America Rockwell Corporation. Columbus arts supporter Fran Luckoff introduces Robinson to woodcarver Elijah Pierce at the International Art Festival, held at the YWCA building in downtown Columbus.

**1969**

When Clarence Robinson returns from Vietnam, the family moves to Nebraska and then to Ramey Air Force Base, Aquadilla, Puerto Rico. Brenda Lynn is a lecturer at the University of Puerto Rico in Aquadilla and also works as an instructor of ceramics, painting, and drawing.

**1971** (fig. 10)

Shortly after returning to Columbus from Puerto Rico, Brenda Lynn and Clarence separate; she and Sydney move in with her parents. Robinson first visits Elijah Pierce's barbershop with arts supporter Ursel White Lewis.

FIG. 10: *Self-Portrait*, 1971, graphite and colored pencil on blue paper, 26 × 20 in., Columbus Museum of Art, Gift of the Artist, 2007.038.007

**1972**

Begins a nineteen-year career working as an art instructor for Columbus Recreation and Parks Department.

**1974**

Acquires her home on Sunbury Road, in the Shepard neighborhood of Columbus where she lived and worked until her passing in 2015 (fig. 11).

FIG. 11: Robinson home in Columbus

**1978**

Receives the KUUMBA Black Liberation Award in the Visual Arts from Malcolm X College in Chicago (fig. 12).

FIG. 12: Kuumba Award Program

**1979** (fig. 13)

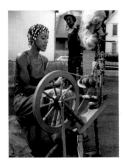

FIG. 13: *Brenda Spinning,* 1979

Adrienne W. Hoard, "The Vision that Was once a Reality: The Art of Brenda Lynn Robinson," is published in *Mahogany: The National Magazine for Black Entertainment* on May 6.

Kojo Kamau, Dr. Mary Ann Williams, and a group of Robinson's Columbus friends raise funds to send her to Africa on a trip organized by the Cleveland-based American Forum for Study.

In Egypt, a holy man gives Robinson the name "Aminah," which in Arabic means trustworthy, honest, and faithful. She would later learn that the name Aminah was a family name, given to her father's sister and his mother.

Robinson's father, Leroy William Edward Robinson, dies.

**1980**

A solo exhibition of her work, *Afrikan Pilgrimage: The Extended Family,* is presented at the Kojo Photo Art Studio, Columbus, Ohio.

Receives an Ohio Arts Council Individual Artist Fellowship.

The November issue of *Living Single* publishes "Four Single Artists: Mind, Eye & Hand," on Robinson and three other artists, by John E. Jones.

**1981**

Legally adds "Aminah" to her name and becomes Aminah Brenda Lynn Robinson.

Studies bookmaking and papermaking at The Ohio State University; begins *Pages in History,* a body of over one thousand works about the history of Columbus and figures from African American history.

**1982** (fig. 14)

FIG. 14: Robinson, 1982

*Pages in History: Part I* is exhibited at Otterbein College in Westerville, Ohio, and *Pages in History, Part II* is exhibited at Franklin University Gallery, Columbus, Ohio.

The July issue of *Columbus Monthly* includes "The Roots of Aminah" by Jacqueline Hall.

Robinson is included in a group exhibition, *Selections: Six in Ohio,* at the Contemporary Arts Center, Cincinnati, Ohio.

Included in *Beyond Poindexter Village: "The Blackberry Patch"* edited by Anna S. Bishop and published by the Public Library of Columbus and Franklin County.

**1983**

First group exhibition at the Carl Solway Gallery, Cincinnati, Ohio.

Travels with Sydney to her father's ancestral home, Sapelo Island, Georgia. Begins the *Poindexter Village* series about life in the Columbus neighborhood from 1940 to 1957 and also works on the *Sapelo* Series.

Included in *Beyond Poindexter Village PT. II: "Heroes" of the Blackberry Patch,* by Anna S. Bishop and published by the Public Library of Columbus and Franklin County (fig. 15).

FIG. 15: *Beyond Poindexter Village, PT II*

**1984**

Receives the Ohio Governor's Award for the Visual Arts in the Individual Artist category.

*Poindexter Village Series: Part 1* is exhibited at the Carl Solway Gallery, Cincinnati.

*Aminah in Poindexter Village: Part 2* is exhibited at the Esther Saks Gallery, Chicago.

Elijah Pierce dies at the age of ninety-two.

*Aminah Robinson: Painting and Sculpture* is exhibited at the Akron Art Museum, Ohio.

**1985**

*Aminah Robinson: Recent Work (Sapelo Series: Part 1)* is exhibited at the Kathryn Markel Gallery, New York City; and *A Walk Through the Past, A Way of Life Slowly Passing Away: Hog Hammock Community, Sapelo Island, Georgia (Sapelo Series: Part 2)* at the Carl Solway Gallery, Cincinnati.

Participates in the group exhibition *Books as Sculpture* at the Robeson Center Gallery, Rutgers, The State University of New Jersey.

The September/October issue of *Columbus Homes & Lifestyles* includes a discussion of Robinson in "Art is Alive and Well and Living in Columbus," by Mary Polites Smith.

**1986**

In the *Sellsville* series, Robinson chronicles the Sells Brothers circus (1871–1900) and the community that developed in their winter quarters in Columbus (fig. 16).

FIG. 16: *Circus*, 1987, mixed media, 11 × 14½ in., Columbus Museum of Art, Estate of the Artist

Participates in group exhibitions: *The Arts and African Life: A Past In the Present*, Trenton State College, New Jersey; and *The Book Made Art: A Selection of Contemporary Artists' Books*, The University of Chicago.

Is included in *Contemporary American Women Sculptors: An Illustrated Biographical Directory*, edited by Virginia Watson-Jones, Onyx Press, Phoenix.

**1987**

Receives an Ohio Arts Council Individual Artist Fellowship.

Participates in *Three Voices from the Black Experience: Works in Three Dimensions*, a group exhibition at the University of Chicago, and in *American Policy*, Cleveland State University Art Gallery, Ohio.

The June issue of *Ohio Magazine* publishes a feature on Robinson, "The Magician of Poindexter Village," by Jane Ware.

**1988**

*Aminah Robinson: The Sapelo Series 1983–87* is exhibited at the Women's Building Gallery, Los Angeles. Participates in the group exhibition *Influences from the Untaught: Contemporary Drawings*, The Drawing Center, New York City.

The fall issue of *Acclaim* magazine includes "Storyteller: The Creative Process of Aminah Robinson," by Maureen E. Miller.

**1989** (fig. 17)

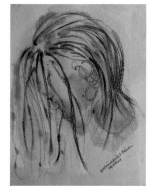

FIG. 17: *Self-Portrait*, 1989, Pen and ink with watercolor on paper, 14 × 12 in., Columbus Museum of Art, Estate of the Artist

*The Life and History of Hog Hammock: Contemporary Sculpture and Drawings by Aminah Robinson* at the Museum of Craft and Folk Art, San Francisco.

Receives an Individual Artist's grant from the Ohio Arts Council. Travels to New York, where she participates in a summer-long residency at PS 1 in Long Island City, New York.

Receives a Minority Artist Fellowship from the National Endowment for the Arts to work with master printmaker Robert Blackburn at the Printmaking Workshop in New York City.

*Unwritten Love Letters* series is shown at Otterbein College, Westerville, Ohio.

Participates in a group exhibition, *Stitching Memories: African-American Story Quilts*, at Williams College Museum, Williamstown, Massachusetts, which then travels to the Studio Museum in Harlem, the Oakland Museum, and the Baltimore Museum of Art.

The summer issue of *The Clarion: America's Folk Art Magazine*, published by the Museum of American Folk Art (now the American Folk Art Museum), New York, includes "Aminah Robinson: One Artist's Ties to Folklife and Folk Art," by Mimi Brodsky Chenfeld.

**1990**

*Pages in History: The Art of Aminah Robinson* is exhibited at the Columbus Museum of Art (fig. 18).

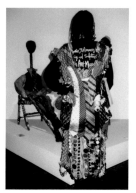

FIG. 18: Robinson and BooBoo in tie-dress and pouch at Columbus Museum of Art, 1990

Is commissioned to design and create art for the main staircase at the Columbus Metropolitan Library.

Participates in group exhibitions: *Separate But Equal: Ohio Women Artists,* The Riffe Gallery, Columbus, which travels to the National Museum of Women in the Arts, Washington, DC, and the Butler Art Institute, Youngstown, Ohio; and *Contemporary American Folk, Naïve, and Outsider Art: Into the Mainstream?* Miami University Art Museum, Oxford, Ohio.

## 1991

After nineteen years, leaves Columbus Recreation and Parks to pursue her art full time.

Receives an Ohio Arts Council Individual Artist Fellowship.

Is the recipient of an Honorary Master's Degree from the Columbus College of Art and Design.

The March/April issue of *Kunstforum International* publishes a profile on Robinson by Bonnie G. Kelm.

## 1992

*Will/Power: New Works by Papo Colo, Jimmie Durham, David Hammons, Hachivi Edgar Heap of Birds, Adrian Piper, Aminah Brenda Lynn Robinson* is exhibited at the Wexner Center for the Arts, The Ohio State University, Columbus.

*Walking with Aminah (The Perspectives Series 1)* is exhibited at the John Michael Kohler Arts Center, Sheboygan, Wisconsin.

Writes and illustrates *The Teachings,* published by Harcourt Brace Jovanovich.

Illustrates *Elijah's Angel,* a children's story by Columbus author Michael J. Rosen, published by Harcourt Brace & Company.

The December 10-24 issue of *Columbus Alive!* includes "The Art and Spirit of Aminah Robinson," by Kay Mallet.

## 1993 (fig. 19)

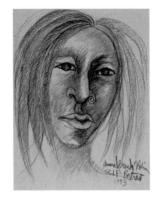

FIG. 19: *Self-Portrait,* 1993, pastel on paper, 12¼ × 9¾ in., Columbus Museum of Art, Estate of the Artist

Completes commission, *The Columbus Foundation Celebrates 50 Years, 1993,* The Columbus Foundation.

Completes commission, *History of Early Springfield,* Clark State Community College Performing Arts Center, Springfield, Ohio.

## 1994

Robinson's son, Sydney Edward Robinson, dies at the age of 27 in Chicago.

Robinson illustrates *Sophie,* a book written by Mem Fox and published by Harcourt Brace & Company.

Participates in a group exhibition, *The Music Box Project,* which travels to the Equitable Gallery, New York City; the Long Beach Museum of Art, California; the Columbus Museum of Art, Ohio; and the Center for Fine Arts, Miami, Florida.

## 1995

Illustrates *The School for Pompey Walker,* written by Michael J. Rosen and published by Harcourt Brace & Company.

Is included in *Gumbo Ya Ya: Anthology of Contemporary African American Women Artists,* edited by Leslie King-Hammond, Midmarch Arts Press, New York City.

Robinson's mother, Helen Elizabeth Zimmerman Robinson, dies.

## 1996

In February, travels to Sapelo Island, Georgia, with her two sisters and Susan Myers, an Ohio State University graduate student and author of a dissertation, "The Art of Aminah Brenda Lynn Robinson: An Analysis of Multiple Viewpoints." Robinson returns to Sapelo in September to participate in a Cultural Arts Day exhibition.

Is included in the group exhibition *Master Printers and Master Pieces,* Kaohsiung Museum of Fine Arts, Taiwan.

## 1997

*A Street Called Home,* written and illustrated by Robinson, is published by Harcourt Brace & Company.

Receives a Pollock-Krasner Foundation Grant, New York.

*Precious Memories* is Robinson's first exhibition at the Hammond Harkins Gallery, Bexley, Ohio.

## 1998

Illustrates *To Be A Drum,* a children's book written by Evelyn Coleman and published by Albert Whitman & Company.

Receives an Ohio Arts Council Visual Arts Travel Fellowship for a five-week residency in Herzliya, Israel (fig. 20).

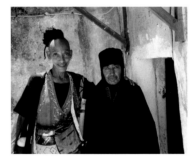

FIG. 20: Robinson at Ethiopian Village, Jerusalem

Completes *15th and High,* a commission for The Ohio State University Fisher School of Business.

Builds backyard studio, the Doll House.

**1999**

Participates in the group exhibition *Art for Community Expression: Twentieth-Century Anniversary Celebration,* Columbus College of Art and Design.

Marvin Bonowitz includes a chapter on Robinson in his book, *Mt. Vernon Avenue: Jewish Businesses in a Changing Neighborhood, 1918–1999.*

**2000**

Illustrates *The Shaking Bag,* written by Gwendolyn Battle-Lavert and published by Albert Whitman & Company.

*Aminah at Sixty: A Celebratory Exhibition,* Hammond Harkins Galleries, Bexley, Ohio.

**2002**

Is included in the group exhibition *Connections: Ohio Artists Abroad,* Riffe Gallery, Columbus, Ohio Arts Council.

Is the recipient of an Honorary Doctor of Fine Arts degree from the Ohio Dominican College, Columbus, Ohio.

*Symphonic Poem: The Art of Aminah Brenda Lynn Robinson,* Columbus Museum of Art, Ohio, December 13, 2002–April 20, 2003. A 204-page book published by the Columbus Museum of Art in association with Abrams accompanies the retrospective.

**2004** (fig. 21)

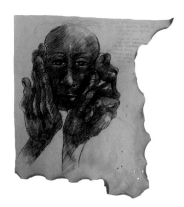

FIG. 21: *Self-Portrait,* 2003–06, pen and ink, graphite, and colored pencil on parchment, 22½ × 21 in., Columbus Museum of Art, Estate of the Artist

Receives the MacArthur Fellowship "genius grant."

Completes RagGonNon, titled *Journeys,* commission for the National Underground Railroad Freedom Center in Cincinnati.

Travels to Chile for Ohio Arts Council residency and exhibition: *The Art of Aminah Brenda Lynn Robinson,* Museo Nacional de Bellas Artes, Santiago, Chile, September 9–October 31.

**2005**

*Sacred Pages: Aminah Robinson in the Holy Land,* Hammond Harkins Galleries, Bexley, Ohio.

Travels to Italy in June and visits Rome, Florence, Padua, Vinci, Venice, and Lucca (fig. 22).

FIG. 22: Robinson in Venice

**2006**

*Symphonic Poem: The Art of Aminah Brenda Lynn Robinson* travels to the Brooklyn Museum of Art (February 24–August 14); Tacoma Art Museum (September 16, 2006–January 28, 2007); and Toledo Museum of Art (February 23–May 20, 2007).

Travels to Peru with DeLynn MacQueen and Lori Rodman (fig. 23).

FIG. 23: Robinson in Peru with Chinchero artisan

*Lyrical Transformations of the Soul: The Life and Work of Aminah Brenda Lynn Robinson,* ACA Galleries, New York City, February 24–April 15.

**2007**

*Water Street: New Work by Aminah Brenda Lynn Robinson,* Columbus Museum of Art, Ohio, July 6, 2007–February 24, 2008; travels to Akron Art Museum, January 9–March 1, 2009); Southern Ohio Museum, Portsmouth, March 27–May 24, 2009; Decorative Arts Center of Ohio, Lancaster, June 25–Sept. 6, 2009; Springfield Museum of Art, Ohio, October 17–November 28, 2009.

Completes *Poindexter Village* commission for the terrazzo floor installation at Ohio University Baker Center (fig. 24), Athens, Ohio.

FIG. 24: Robinson at the Baker Center, Ohio University

*Symphonic Poem: A Case Study in Museum Education,* The Ohio State University, dissertation of Carole M. Genshaft.

*The Stories of Aminah Brenda Lynn Robinson,* Hammond Harkins Galleries, Bexley, Ohio.

**2008**

Art in Embassies Program, United States government, acquires *Life Along Water Street* for its permanent collection, and exhibits the work in Belgrade, Serbia.

*Aminah as Printmaker: The Graphic Works of Aminah Brenda Lynn Robinson,* Hammond Harkins Galleries, Bexley, Ohio.

**2009**

Art in the Atrium, Morristown, New Jersey, *Artistic Vistas,* January 30–March 27.

Is included in *If I Didn't Care: Generational Artists Discuss Cultural Histories,* The Park School, Baltimore, Maryland, January 30–March 30.

*VanGo! All Around the World: People & Places in Art,* The Susquehanna Art Museum, September 13, 2009–July 13, 2010. *People of the Book: Jericho Girl* is exhibited.

*The Stories of Aminah Brenda Lynn Robinson: From Poindexter Village to Today,* Hammond Harkins Galleries, Bexley, Ohio.

**2010**

*Two Black Women: Faith Ringgold and Aminah Brenda Lynn Robinson,* ACA Galleries, New York City, February 6–March 20.

Conversation with artist Mark Bradford at the Wexner Center for the Arts, The Ohio State University, April 22.

Is included in *Women Call for Peace: Global Vistas,* Art League, Bonita Springs, Florida, October 1–December 10; travels to Sheldon Memorial Art Gallery, Lincoln, Nebraska, September 18, 2012–January 13, 2013; J. Wayne Stark University Center Galleries, Texas A & M University, College Station, Texas, March 9–May 28, 2013; John Jay College of Criminal Justice, New York City, September 12–December 10, 2013.

*Shared Stories: Works by Aminah Robinson and Faith Ringgold,* Hammond Harkins Galleries, Bexley, Ohio (fig. 25).

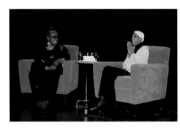

FIG. 25: Robinson and Faith Ringgold at Columbus Museum of Art, September 16

*Aminah Robinson: Voices that Taught Me How to Sing,* Toledo Museum of Art, Ohio, November 19, 2010–April 10, 2011.

**2011**

*Street Talk and Spiritual Matters: Aminah's Mt. Vernon Avenue,* Columbus Museum of Art, Ohio, May 20–September 4.

**2012**

*Chronicles of the Village: Songs for the New Millennium, 1200 AD–1812,* Hammond Harkins Galleries, Bexley, Ohio.

Inducted into the City of Columbus Hall of Fame (fig. 26).

FIG. 26: Robinson and Mayor Michael Coleman at induction into the Columbus Hall of Fame

**2013**

*Stories and Journeys: The Art of Faith Ringgold and Aminah Brenda Lynn Robinson,* Opalka Gallery, Sage Colleges, Albany, New York, January 22–April 21, 2013; Mattituck Museum, Waterbury, Connecticut, March 30–June 8, 2014; with catalogue.

*Textures: The Written Word in Contemporary Art,* ACA Galleries, New York City, May 4–June 15.

*Classless Society,* The Frances Young Tang Teaching Museum and Art Gallery at Skidmore College, Saratoga Springs, New York, September 7, 2013–March 9, 2014.

*Aminah Robinson: Journey from Blackberry Patch to Poindexter Village,* Hammond Harkins Galleries, Bexley, Ohio.

*Aminah Brenda Lynn Robinson: Chronicles from the Village: Songs For the New Millennium,* ACA Galleries, New York City, October 26, 2013– January 4, 2014.

**2014**

*Social Art in America: Then and Now,* ACA Galleries, New York City, May 3–June 14.

**2015**

Interview with Denny Griffith, retired president Columbus College of Art and Design at the Metropolitan Club, Columbus (fig. 27).

FIG. 27: Robinson and Denny Griffith, artist and retired President Columbus College of Art and Design

*Aminah at 75: The Continuing Story,* Hammond Harkins Galleries, Bexley, Ohio.

May 22, Robinson dies of heart failure, leaving estate in care of the Columbus Museum of Art. A memorial is held at the Museum on July 18.

### 2016

Robinson's *Presidential Suite [the Obamas],* at Columbus Museum of Art and at Hammond Harkins Galleries, Columbus, Ohio (fig. 28).

FIG. 28: *Bo Walking First Family Through the Rose Garden,* 2007–10, mixed media, 16 × 36¼ in., Columbus Museum of Art, Estate of the Artist

### 2017

*Women, Art and Fibers: Contemporary Responses to Abolition and the Journey North,* University of Massachusetts, Dartmouth, March 8–April 4. Featured *Chronicles from the Village Series: Afrikan Entering the OH Valley in 1200 AC,* 2010–12.

*3 Artists,* Hammond Harkins Galleries, Columbus, Ohio.

### 2018

*Aminah's World: An activity book and children's guide about artist Aminah Brenda Lynn Robinson,* written by Carole Miller Genshaft, Columbus Museum of Art, Ohio (fig. 29).

FIG. 29: *Aminah's World*

*Kindred Spirits: The Art of Elijah Pierce and Aminah Brenda Lynn Robinson,* Columbus Museum of Art, Ohio, April 18, 2018–August, 25, 2019.

*Storybooks & Other Narratives,* Hammond Harkins Galleries, Columbus, Ohio.

### 2019

*Aminah Brenda Lynn Robinson,* The Ohio State University Faculty Club, Columbus, Ohio, February 28–April 26.

Havana Biennial, Matanzas, Cuba, April 12–May 12.

*Love, Aminah: Celebrating a Friendship,* Southern Ohio Museum, Portsmouth, Ohio. April 27.

*We're All Here! The Art of Aminah Robinson,* Houston Museum of African American Culture, Texas, September 21-November 2.

### 2020

*Tell Me Your Story,* Kunsthal Kade, Amsterdam, the Netherlands, February 7-May 17.

Armory Show exhibition, March 4–8

Establishment of the Aminah Robinson Residency, Shepard Community, Columbus, Ohio (fig. 30) in collaboration with Columbus Museum of Art and Greater Columbus Arts Council.

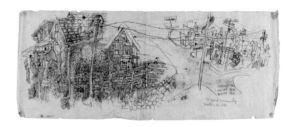

FIG. 30: *Shepard Community,* 1971, pen and ink with pastel on rice paper, 14¼ × 37½ in., Columbus Museum of Art, Estate of the Artist

### 2021

*Raggin' On: The Art of Aminah Brenda Lynn Robinson's House and Journals,* Columbus Museum of Art

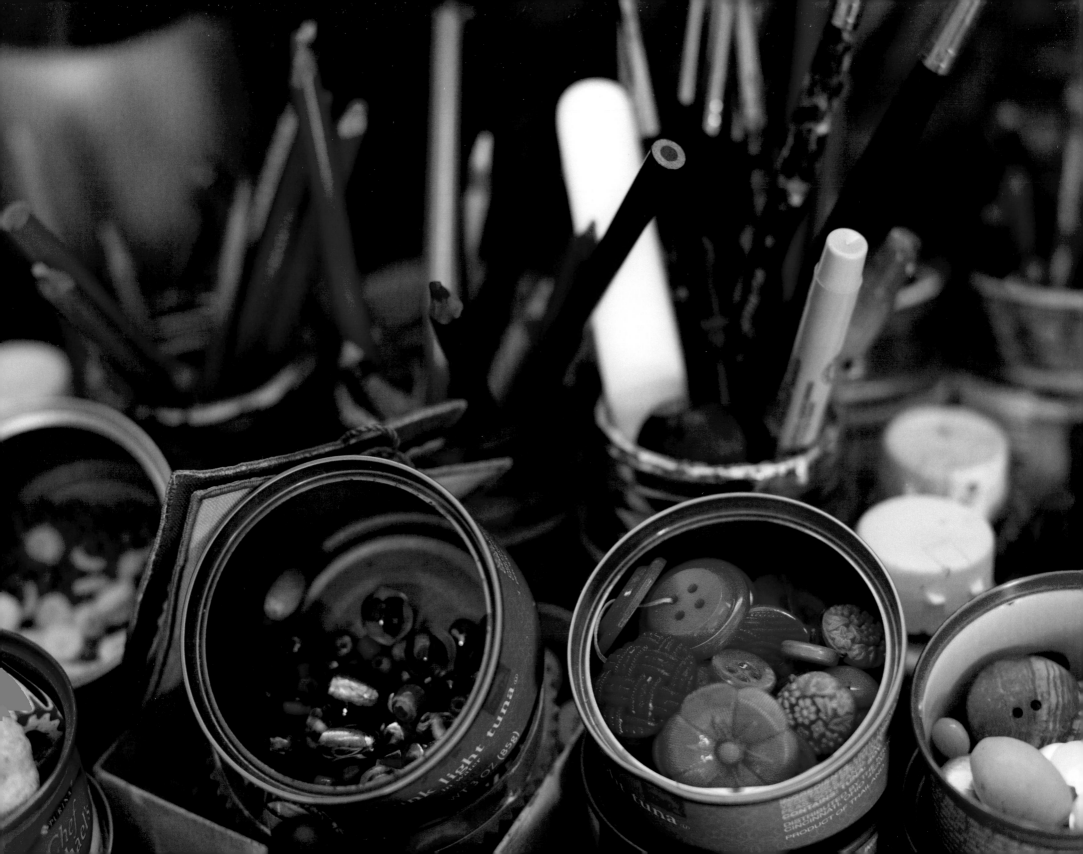

**Blackberry Patch** was the local name of the African American neighborhood in Columbus that the Poindexter apartment complex replaced.

**Gupa** is Robinson's word for pen and ink drawings of imaginary figures and designs representing the world of legends and spirits. They are often designed on irregular pieces of parchment or paper.

**Hogmawg** is Robinson's word for a mixture of mud, pig grease, dyes, sticks, and glue that she cooked on her stove and used in two- and three-dimensional work.

**Manuscript Pages** are Robinson's drawings and paintings created on the blank end pages carefully removed from books, or on parchment, with subject matter of great importance to the artist.

**Poindexter Village** was one of the first federally funded housing complexes in the country. Robinson moved there in 1940, the year she was born and the year the complex opened. She lived there with her family until 1957.

**RagGonNon** is Robinson's term for a complex work of art that takes years to research and create and that continues to evolve as viewers respond to it.

**Shepard Community** is the neighborhood where Robinson's house is located on the east side of Columbus.

**Themba** is the mythic figure Robinson created based on the stories of her Great-Aunt Cornelia (also known as Big Annie and Cordelia) in combination with the artist's research of African and African American history.

**Unwritten Love Letters** are Robinson's drawings and paintings on steamed-open envelopes and on letterhead stationery she received in the mail from individuals and institutions she highly regarded. The works honor people and events and are often embellished with cancelled stamps and other found objects.

OPPOSITE: Robinson's studio, detail

# Credits

## Photos

Ralphphoto/Alan Geho: front and back covers, front and back inside covers, pp. 6–7, 50, 84–5, 96, 97, 131, 132–3, 134–36, 137–39, 140–1, 142–3, 144–5 (PLATE 48), 146–7, 174

Heather Maciejunes: pp. 2, 22 (Fig. 4), 81, 89 (PLATES 6B; 6C), 91, 92, 94, 217

Columbus Museum of Art: pp. 12, 14, 25, 58, 60 (Fig. 4), 65, 66, 72, 76, 88, 93, 103, 105 (PLATE 19), 121, 148–49, 150, 216, 224 (Fig. 25)

Nicole Rome: pp. 23, 24, 28, 29 (Fig. 4), 32, 34, 36, 37, 38, 39, 41, 42, 43, 44, 45, 46, 56, 60 (Fig. 3), 61 (Fig. 6), 64, 62, 101, 151, 156, 157, 160, 161, 164, 165, 176, 177, 185, 186, 187, 188, 189, 190, 191, 192, 193, 194, 195, 196, 197, 198, 199, 200, 201, 206, 207, 208, 209, 210, 211, 212, 214, 218 (Fig. 5), 219 (Figs. 6; 10), 215, 221 (Figs. 16; 17), 222 (Fig. 19), 223 (Fig. 21)

Kara Güt: pp. 18, 48, 68, 70, 71, 82, 86, 87 (PLATES 5A; 5B), 90, 99, 100, 102, 104, 105 (right), 106, 107, 108, 109, 111, 112, 113, 114–15, 118, 119, 120, 121, 122–23, 124–25, 127, 128–29, 130, 152, 154, 155, 156, 159, 162, 166, 167, 169, 170, 171, 173, 174, 175, 178, 179, 180, 181, 182–83, 203, 204, 205, 213, 225 (Fig. 30)

Deidre Hamlar: pp. 20, 21, 22 (Fig. 3)

Hammond Harkins Galleries: pp. 26, 224 (Fig. 26)

Jeff Bates: pp. 29 (Fig. 3), 53, 74, 153, 163

Carole Genshaft: pp. 31, 52 (Fig. 2), 83 (Fig. 1), 89 (PLATE 6E), 95

Barbara Jemison (Estate of Aminah Brenda Lynn Robinson): pp. 41 (Fig. 8), 219 (Fig. 7)

Barbara Vogel: p. 87 (Fig. 2)

Aminah Brenda Lynn Robinson (Estate of the Artist): p. 179 (Fig. 4)

Estate of Aminah Brenda Lynn Robinson: Chronology, figures 1–4, 7–9, 11–15, 20, 22

Lori Rodman: pp. 197 (Fig. 5), 223 (Fig. 23), courtesy DeLynn MacQueen

Kojo Kamau (Estate of Aminah Brenda Lynn Robinson): p. 220 (Fig. 13)

Gary Kirksey: p. 223 (Fig. 24)

Rick Buchannan, courtesy the Columbus Metropolitan Club: p. 224 (Fig. 27)

Grace Oller: pp. 28 (Fig. 2), 52 (Fig. 2)

## Front, Back Cover; Section Images

Art by Aminah Robinson, Estate of the Artist, unless otherwise noted.

Front inside cover; *Midnight Torchlight Procession* (from *Themba: A Life of Grace and Hope* series), undated, mixed media on paper, 21 × 83 in.

p. 4 Box with found objects, Robinson kitchen studio

pp. 6–7 *Porch Livin'*, 2006, watercolor and gouache on paper, 45 × 137 in.

p. 18 *Come In*, 1999, cloth and thread, 24 × 21 in.

p. 32 ABLR 19–74, Journal, *Symphonic Poem, Doll House Story*, 2002–03, 11¾ × 7¾ in.

p. 48 *Untitled* (button beaded book), date unknown, 6½ × 12 × 2¼ in.

p. 226 Robinson's Sanctuary Studio art supplies, 2015

Back inside cover: *The Village Ceremony Celebrates the Ancestors* (from *Themba: A Life of Grace and Hope* series), 1996–2012, mixed media on paper, 17½ × 63¾ in.

## Quotes

p. 78 ABLR 19–5, Journal, January 1963.

p. 80 ABLR 19–78, Journal, *Bridges of Passion, Chilean Journey 2004.*

p. 83 ABLR 19–89, Journal, *A Memoir, Uncle Alvin Stories,* 2010.

p. 98 ABLR 19–73, Journal, *Poindexter Village As I Walk . . ., 2001–06,* p. 15.

p. 104 Artist's paper, July 26, 1960.

p. 108 ABLR 19–87, Journal (Composition Book), 2007.

p. 110 ABLR 19–32, Journal, *Studies,* 1972–73.

p. 126 ABLR 19–60, Journal, *Notes on Sea Islands; Pages in History Series 2,* 1982.

p. 131 ABLR 19–84, Journal, *Constant Companion Walks . . .,* 2006.

p. 144 *Symphonic Poem: The Art of Aminah Brenda Lynn Robinson,* Columbus Museum of Art, 2002, p. 137.

p. 158 ABLR 19–73, Journal, *Poindexter Village As I Walk . . ., 2001–06,* pp. 124–5.

p. 159 ABLR 19–67B, *Journal Notes,* April 1988.

p. 168 *Sellsville Circus Notes,* 1990.

p. 172 ABLR 19–9, Journal, *Symphonic Poem Panels,* 1963.

p. 175 Handwritten note dated July 20, 1998, in 2006 journal.

p. 177 ABLR 19–73 Journal, *Poindexter Village As I Walk . . ., 2001–06,* p. 46.

p. 181 ABLR 19–84, Journal, *Constant Companion Walks . . .,* 2006.

p. 184 ABLR 19–41, Journal, *Experimentation in Home Dyeing,* 1974–75.

p. 202 ABLR 19–2G, Sketchbook, 1961.

**Contributors**

**Ramona Austin** has over three decades of professional experience in the arts and arts education. A consultant in the museum field, she was also senior curator for the Baron and Ellin Gordon Art Galleries at Old Dominion University. From 2001 to 2004, she was the director of the Hampton University Museum, at one of the nation's leading historic black colleges and universities, and a foremost national art and archival resource. She was associate curator for African Art at the Art Institute of Chicago from 1987–1994; and the Margaret McDermott associate curator for African Art at the Dallas Museum of Art from 1994–2001. At both institutions, her position initiated the first full-time curatorship for her field. Her academic interests include the arts of the Kongo peoples of the Democratic Republic of the Congo (formerly Zaire), among whom she has done fieldwork as a Fulbright scholar, the African diaspora in the Americas, and African American self-taught and contemporary art. Her expertise is in African art, African retentions in African American art, and the artistic traditions of the African Diaspora. She wrote *History, Myth, and Memory: Africa in the Art of Aminah Robinson* for Columbus Museum of Art's exhibition catalogue, *Symphonic Poem: The Art of Aminah Brenda Lynn Robinson,* 2002.

**Lisa Gail Collins** is a professor in art history, Africana studies, and American studies at Vassar College in Poughkeepsie, New York. She received her BA in art history from Dartmouth College and her PhD in American studies—with graduate minors in Studies in Africa and the African diaspora and feminist studies—from the University of Minnesota. A member of the Vassar faculty since 1998, she teaches interdisciplinary courses in American art, social, and cultural history with an emphasis on African American lives; art and social change; creativity and everyday life; feminist thought and activism; and social and cultural movements in the United States. Ms. Collins is author of *The Art of History: African American Women Artists Engage the Past* (Rutgers University Press, 2002), *Art by African American Artists: Selections from the 20th Century* (Metropolitan Museum of Art, 2003), and *Arts, Artifacts, and African Americans: Context and Criticism* (Michigan State University, 2007).

**Lisa E. Farrington** is founding chair emeritus of the Art & Music Department at CUNY's John Jay College of Criminal Justice, coming to John Jay after fifteen years as senior art historian at Parsons, the New School for Design. She was the 2007–08 endowed scholar in the Humanities at Atlanta University's historic black women's college, Spelman, where her conference "Hottentot to Hip Hop: the Black Female Body in Art and Visual Culture" was a critical and scholarly triumph. She earned PhD and master of philosophy degrees from the CUNY Graduate Center, an MA from American University, a BFA from Howard University *magna cum laude,* and an honors degree from New York's School of Art & Design. Her museum and curatorial experience includes the National Gallery of Art in Washington, DC, and ten years at New York's Museum of Modern Art. Dr. Farrington specializes in race and gender in visual culture, African American art, modern art, and Haitian art & vodou culture. She has received numerous awards for *Creating Their Own Image: the History of African American Women Artists* (Oxford University Press, 2005; 2nd edition 2011). Most recently, she published a second seminal book with Oxford University Press: *African American Art: A Visual and Cultural History* (2016).

**Carole M. Genshaft** is curator-at-large at the Columbus Museum of Art. Genshaft enjoyed a close relationship with Robinson beginning in the late 1980s. Since Robinson's death in 2015, she has supervised the organization and documentation of the artist's estate which was left to the Museum. She has curated and co-curated many exhibitions about the life and work of Robinson, including *Symphonic Poem,* a retrospective of the artist's work that traveled nationally in 2006. In 2018, she organized *Kindred Spirits,* an exhibition about the relationship of Robinson and her friend and mentor, folk artist Elijah Pierce. In addition to contributing articles about Robinson to many publications, Genshaft has written *Aminah's World,* a children's book about the life and art of Robinson (Columbus Museum of Art, 2017). Genshaft has an undergraduate degree in art history from Syracuse University, a master in library science from Case Western Reserve University, and a doctorate in art education from The Ohio State University. In addition to her work with the art of Aminah Robinson, she has organized *Eye Spy: Adventures in Art* (1998), a ground-breaking interactive exhibition and has curated numerous exhibitions, including *Wonders and Miracles: Art of the Passover Haggadah* (2004), *Marvelous Menagerie: An Ancient Roman Mosaic from Lod Israel* (2012), *Shine On: Nurses in Art* (2015), and *Glass Magic Then and Now* (2015).

**Deidre Hamlar**, Columbus near east side native, is a lawyer, arts adminstrator, artist's representative, and independent curator. She holds a BA in sociology from UCLA and a JD from Howard University Law School. Following law practices with the National Labor Relations Board and Legal Services Corporation, her passion for arts, social justice, equity and inclusion, and community empowerment led her to found Peaceworks Gallery to support underrepresented artists in Central Ohio. She served respectively as multicultural educator for the Columbus Museum of Art (CMA) and Walker Art Center; director of diversity at The Columbus Academy; community engagement facilitator and co-curator of the Poindexter Legacy Project and exhibition; and various community-focused efforts to preserve and dignify African American heritage in Columbus, Ohio. She co-authored *Roads Diverge: William L. Hawkins and Elijah Pierce in Columbus* in *William Hawkins: an Imaginative Geography* (Skira 2018). Hamlar has worked with CMA since 2018 to archive and curate Robinson's art in preparation for the *Raggin' On* exhibition, catalogue, and launch of a residency program in Robinson's home studio.

**Nannette V. Maciejunes** is executive director and CEO of the Columbus Museum of Art. Under her leadership, the Museum acquired the Photo League collection and the Philip J. and Suzanne Schiller Collection of American Social Commentary Art, 1930-1970, which is considered to be the most important collection of its kind. In 2011, the Columbus Museum of Art opened the Center for Creativity, an innovative new space which demonstrates the Museum's leadership in the field of the visitor-centered museum experience and commitment to creativity. In 2013, the Museum was awarded the Institute of Museum and Library Services' National Medal, the Nation's highest honor for museums. This was followed by the Museum's completion of its major renovation and expansion, and the October 2015 opening of the Margaret M. Walter Wing. In 2019, the Museum grew with the addition of a second site, the Pizzuti Collection of the Columbus Museum of Art. Maciejunes has written extensively on American art and specifically on the life and art of Charles Burchfield. She was instrumental in furthering a meaningful and strong relationship with Aminah Robinson that resulted in the artist leaving her estate to the Museum.

**William "Ted" McDaniel** is professor emeritus at The Ohio State University, retired after thirty-five years. He holds a BA from Morehouse College and MA and PhD degrees from University of Iowa, all in music. A scholar of African American music, jazz history, and performance, "Ted" is the author of several published works on black music; has written over 200 jazz, R&B, and marching band arrangements; and his arrangements and liner notes appear on more than twenty recordings. McDaniel was born and raised in Memphis, Tennessee, where his father, a high school band director and professional band leader, made sure he absorbed and learned how to improvise the blues and other black cultural sounds that surrounded him. While trained in the Western tradition, in which artistic instincts are demonstrated by musical notation, McDaniel's approach to learning and performing music is as much about playing by ear as it is about using his capacity to read music.

**Debra Priestly** is a visual artist exploring themes of memory, ancestry, history, and cultural preservation. Her work has been widely exhibited and is represented by June Kelly Gallery in New York City. Collections include the Pennsylvania Academy for the Fine Arts, Petrucci Family Foundation, The Sandor Family Collection, and the Schomburg Center for Research in Black Culture. Awards include two New York Foundation for the Arts fellowships in painting, Art Omi Visual Artist Residency, The Marie Walsh Sharpe Art Foundation Space Program, and the Elizabeth Foundation for the Arts Robert Blackburn Printmaking Workshop Studio Immersion Project Fellowship. She holds an MFA from Pratt Institute and a BFA from The Ohio State University. Priestly lives and works in New York City and upstate New York, and is a professor in the Art Department at Queens College, City University of New York.

Note: Page numbers in italic type indicate illustrations.

**A**
Abubakari II, 75
*Adinkra* symbols, 21, 25n2
Adkins, Terry, 66
Africa, travel to, 44–45, 54, 73, 186, *186–87*, 220
Afrofuturism, 66, 67n23
Almon, Leroy, Sr., *KKK*, 75, 76
American Forum for International Study, 45, 220
Aminah Robinson Artist Residency, 16, 25n8, 225
Aminah Robinson Legacy Project, 16
Amos, Emma, *The Gift*, 66, *67*
ancestors and ancestral stories, 22, 24, 35–36, 42, 44–45, 46, 51, 59–60, 63, 74–75, 83, 130, 143, 144, 158. *See also* memory
Angelou, Maya, 65
Apollo Theater, Harlem, New York, 28

**B**
Bach, Johann Sebastian, 69
Baldwin, David, 41
Baldwin, James, 41, 190
Bates, Daisy, 66
Bearden, Romare, 54, 60–61
    *The Block*, *54*, 55
    *Watching the Good Trains Go By*, 60–61, *60*
Beatty Recreation Center, Columbus, Ohio, 37, 108
Beethoven, Ludwig van, 69
Belafonte, Harry, 41
Bellows, George, 15
Bethune, Mary McLeod, 66
Bishop, Anna S.

*Beyond Poindexter Village: "The Blackberry Patch,"* 220
*Beyond Poindexter Village PT. II: "Heroes" of the Blackberry Patch*, 220, *220*
Black Arts Movement, 55, 76
Blackberry Patch neighborhood, Columbus, Ohio, *28*, 35, 122, 227
Blackburn, Robert, 27, 221
black liberation theology, 76
bottle gardens, 21, 29, *31*, *81*
bottle trees, 21
Bradford, Mark, 224
Brooklyn Museum, New York, 216
Bryce, Edna, 121
buttons, 199 (plate 98B)

**C**
*Call and Post* (newspaper), 121
charms, 76, 77n6
Chile, travel to, 24, 44, 45, 54, 73, 176, *176–77*, 223
Chipo Village, 35, 124 (plate 37)
civil rights, 40–42, 46, 61, 190
Civil Rights Act (1964), 41
Clark, Septima Poinsette, 66
Cole, Willi, 66
Coleman, Michael, *224*
Columbus Art School, 13, 14, 53, 218, *218*
Columbus College of Art and Design (Columbus Art School) , 13, 53, 218, 222, 223, 224
Columbus Foundation, 17
Columbus Hall of Fame, 224
Columbus Metropolitan Library, 37, 62, 218, 221
Columbus Museum of Art, 13–17
Columbus Recreation and Parks Department, 219, 222

Cone, James H., 76
Congress for Racial Equality (CORE), 40, 61
Conwill, Houston, 66
Corn, Wanda M., 24
cowrie shells, 21, 150, plate 51
*Create-an-Ark* (school program), 14

**D**
Davis, Miles, 69
Davis, Ossie, 41
Dee, Ruby, 41
*Denkym* (crocodile) symbol, 21
drawing, 39–40

**E**
East High School, Columbus, Ohio, 13, 218
Engels, Friedrich, 61–62
Ethiopian Christians, 45, 174
*Eye Spy: Adventure in Art* (interactive exhibition), 15, *15*

**F**
feminism, 55, 62, 64–66
Ferris, William R., 36

**G**
*Gone with the Wind* (book and film), 63
Gorée Island, Senegal, Africa, 62–63, 144
Greater Columbus Arts Council, 16, 225
Great Migration, 61, 62, 73
Green, Renée, 66
Griffith, Denny, 224, *224*
*griots* (storytellers), 28, 36, 52, 65, 74
*gupas* (drawings of imaginary figures), 30–31, 206, *206*, 227

**H**
Hands, 55
Hanson, Howard, 69
Harlem, New York, 27, 28, 55, 60, 62, 221
Hays, Michael B., 47, Note 42
Hogan, Momma, 166
Hog Hammock community, Sapelo Island, Georgia, 60, 153
hogmawg, 21, 25n3, 30, 39, 51, 55, 86, 89, 120, 227
homelessness, 23, 24, 36, 112, 179
home studio, 21–25, 29–30, 51
    acquisition of, 219
    and Artist Residency, 16–17, 25n8
    bottle garden, 21, 29, *31*, *81*
    caddy for paintbrushes, 90, *91*
    Doll House studio (plate 9), 25, 30, 51, 82, 93, *93*, 222
    exterior, distant view, *219*
    exterior of home with bottle garden and carved and painted doors (plate 1), 21, *81*
    fence adjacent to Doll House studio (plate 9A), *93*
    flat iron collection, 21–22, *22*
    floor plan, *25*
    frame construction with Robinson's collection of thimbles (plate 6C), *89*
    front door surrounded by greetings from visitors (plate 3), 29, *50*, 51, *83*
    hand-carved and painted doors, 21, 29, 50, 51, 82, 83, *83*
    kitchen, *88*, 89
    kitchen mosaic floor (plates 6D, 6E), *89*
    living room (plate 4), 30, 52, *84–85*
    museum's stewardship of, 16–17

rabbit glue and other ingredients Robinson used in making hogmawg (plate 6B), *89*
    rock arrangement on window sill, 21, *22*
    Sanctuary Studio (plates 10A, 10B), *17*, *20*, 23, *94*, *95*, 95
    studio (plate 8), *92*
    The Writing Room (plates 11A, 11B), 23, 30, 45, 51, 96, *96*, *97*
Horne, Lena, 41

**I**
Israel, travel to, 24, 44, 45, 54, 73, 173, *174–75*, 188, *188–89*, 189, 214, *214–15*, 222
Italy, travel to, 44, 45, 54, 73, 178, *178–79*, 196, *196*, 223, *223*

**J**
Jackson, Mahalia, 41
Jemison, Barbara, 41
Johnson, Cornelia (Big Annie, Cordelia, Themba), 42–45, *43*, 47n39, 47n43, 65, 76, 130, 131, 194

**K**
Kamau, Kojo, 14, 220
King, Martin Luther, Jr., 41, 75, 152, 219
King, Percy C., *Aminah Robinson*, *58*
Kojo Photo Art Studio, 14, 220
Kouyaté, Mamadou, 75, 76
Ku Klux Klan, 134
KUUMBA Black Liberation Award in the Visual Arts, Malcolm X College, Chicago, 220, *220*

**L**
Lawrence, Jacob, 55
    *The Shoemaker*, 55, *56*

Leonardo da Vinci, 13, 37, 45, 69, 76
Lewis, Ursel White, 66, 219
Ligon, Glenn, 66
Logan Elm Print Press and Paper Mill, 28
Luckoff, Fran, 219

**M**
MacArthur Fellowship, 23, 45, 54, 63, 73, 95, 223
MacDowell, Edward, 69
Malcolm X (El-Hajj Malik El-Shabazz) 75, 101 (plate 14)
Manuscript Page, *9*, 36–37, 46, *214*, *215*, 227
March on Washington for Jobs and Freedom (1963), 40–41, 61, 190, 219
Marshall, Kerry James, 60, 61, 66
    *Watts*, 61, *61*
Marx, Karl, 61–62
masks, 65, 139 (plate 44), 143 (plate 46)
Materials for the Arts (MFTA), Long Island City, New York, 27
memory, 22, 24, 36, 44, 51, 59, 75, 83. *See also* ancestors and ancestral memories
memory maps, 29, 59, 114
Middle Passage, 35, 36, 43, 60, 62, 64, 67n4, 75, 146
Minority Artist Fellowship, National Endowment for the Arts, 221
Mitchell, Margaret, *Gone with the Wind*, 63
Morrison, Toni, 51
Mount Vernon Avenue, Columbus, Ohio, 23, 42, 53, 55, 114, 121, 191
Museo Nacional de Bellas Artes, Santiago, Chile, 176

music, 37–39, 68–71, 74–5, 201
    (plate 100A)
Myers, Susan, 222

**N**

National Association for the
    Advancement of Colored
    People (NAACP), 40, 61
National Endowment for the
    Arts, 27
Neo-Expressionism, 61, 66, 67n7
Neo-Pop, 65, 67n19
Niane, Djibril Tamsir, 75
Nicholson, Barbara, 16, 25n2
Nill, Annegreth Taylor, 61
*Nserewa* (cowrie shell) symbol, 21

**O**

Obama, Barack, 15, 39, 46, 148
Ohio Arts Council Individual Artist
    Fellowship, 15, 220, 221, 222
Ohio Arts Council residency,
    176, 223
Ohio Arts Council Visual Arts
    travel fellowship, 45, 173, 222
Ohio Governor's Award for the
    Visual Arts, 15, 220
Ohio State University, 53, 219, 220
Ohio University, 223

**P**

*Pages in History: The Art of Aminah
    Robinson* (exhibition), 15
penetration, 42 (fig. 9), 53–4, 193
    (plate 95B)
Peru, travel to, 44, 45, 54, 180,
    *180–83, 181, 197, 197,* 223, 223
Picasso, Pablo, 24
Pierce, Elijah, 13–14, 15, 29, 42,
    43–44, 75, 76, 86, 219, 220
Pindell, Howardena, 66
Piper, Adrian, 66
Poindexter, James Preston, 62
Poindexter Village, Columbus,
    Ohio, 21, 23, 29, 35, 45, 53, 61,
    62, 98, 106, 108, 199, 218, 227
Pollock-Krasner Foundation
    Grant, 222
Priestly, Debra, *26*
    *mattoon5,* 29, 30 (detail)
printmaking, 27, 216, 217, 221
prophetic tradition, 75–76
PS1 Contemporary Art Center,
    Long Island City, New York,
    27, 221

**R**

racism, 36, 37, 39, 40–42, 46,
    76, 190
RagGonNon, 15, 22, 25, 30, 39, 54,
    59, 64, 67n3, 74, 75, 84, 84–85,
    128, 128, 176, 223, 227
Rembrandt, 13
Ringgold, Faith, 51, 52, 55, 62, 63, 224
    *Help: Slave Rape Series #16, 63, 63*
    *Woman on a Bridge #1 of 5: Tar
        Beach, 55, 55*
Robinson, Aminah Brenda Lynn
    artistic autobiography, 35
    awards/honors received, 15, 23,
        27, 45, 54, 73, 95, 173, 176, 218,
        220–24, 220
    childhood, 13, 36–37, 52, 98, 100,
        192, 218
    death, 15, 16, 36, 225
    education, 13, 218
    Honorary Doctor of Fine Arts
        degree, Ohio Dominican
        College, 223
    Honorary Master's Degree,
        Columbus College of Art and
        Design, 222
    love of books, 13, 16–17, 21–23,
        25, 29–30, 36–37, 51, 52, 55,
        62, 75
    marriage, 13, 40, 43, 105, 219, 219
    music, 37–39, 69–71, 74–75, 96,
        163, 201
    name change, 45, 54, 220
    "penetration" concentration
        technique, 22, 42, 53, 193
    photographs of, *12, 15, 16, 17, 26,
        31, 41, 72, 87, 93,* 218–24
    relationship with Columbus
        Museum of Art, 13–17
    son, Sydney Edward Robinson,
        15, 23, 24, 27, 43, 105, 219,
        220, 222
    travels, 15, 23, 24, 44–45, 54,
        62, 172
    *See also* home studio
Robinson, Aminah Brenda Lynn,
    art works
    *Afrikan Amerikan Women Life &
        History* (plate 64), 66, *159*
    *Amos H. Lynch, Sr.* (from
        *Unwritten Love Letters* series)
        (plate 109), *211*
    *Artist Walking the Streets in the
        Old City of Jerusalem (Self-
        Portrait)* (plate 79), 54, *173*

*Atrium Circus Study* (from
    *Sellsville Circus* series)
    (plate 75), *169*
*Basketmaker* (from *Sapelo*
    series) (plate 60), *157*
*Bedouin Woman of Jericho*
    (plate 81), *175*
*Big Annie Makin' a Quilt for Baby
    Roy* (plate 40), 43, *130*
*Birthing on the C-Train,* 28, *29*
    (detail)
*Blossom, Folk Life in Poindexter
    Village* (plate 67), *161*
*Bottle Garden Study,* 21, *23*
*Bo Walking First Family Through
    the Rose Garden* (from the
    *Presidential Suite* series), *225*
*Boxes* (plate 101), *157*
*The Breadman* (plate 21), *106*
*The Broomstick Ritual, Slave
    Marriage Celebrations, Marryin'
    with a Lamp* (plate 52), *151*
*Brownyskin Man, 53*
*Brownyskin Man,* (back view)
    (plate 31), *118*
*Brownyskin Man,* (front view)
    (plate 30), *118*
*Bryce Florist* (plate 35), *121*
*Button Beaded Dolls* (plate 102),
    *204*
*Button Beaded Dolls* (plate 103),
    *205*
*Chickenfoot Woman* (back view)
    (plate 33), *119*
*Chickenfoot Woman* (front view)
    (plate 32), *119*
*Chicken Yard in Sapelo* (from
    *Sapelo* series) (plate 57), *154*
*Chilean Suite* series, *176*
*Christmas Day in Poindexter
    Village* (plate 23), *108*
*Circus,* 221
*Circus is Coming* (from *Sellsville
    Circus* series) (plate 78), *171*
*A Clutch of Blossoms* (series),
    66, *160*
*The Columbus Foundation
    Celebrates 50 Years, 1993,* 222
*Cotton Pickers* (from *Sapelo*
    series) (plate 62), *157*
*Dad's Journey* (plate 39), 64, 76
    (detail), 127, 128, *128–29*
*A Day for the Pigions, Venice,
    Italy, St. Mark's Square*
    (plate 84), *178*

*Dear Columbus Community
    Today Is The Grand Opening*
    (from *Unwritten Love Letters*
    series) (plate 106), *208*
*Easter Egg Hunt* (plate 24), *109*
*Elijah Pierce Woodcarver, 43*
*Ethiopian Village and Orthodox
    Monastery on the Rooftop of
    the Holy Sepulcher Church, the
    Old City of Jerusalem Afrikan
    Village* (plate 80), 45, *174*
*Farm Study* (from *Sapelo* series)
    (plate 58), *155*
*Field Hand—Hands of an Artist*
    (plate 74), 61–62, *167*
*15th and High,* 222
*Gift Eggs* (from *Sapelo* series)
    (plate 61), *157*
*Gift of Love* and details, (plates 5,
    5A, 5B), 83, 86, *86, 87*
*The Going Home in Memory of
    My Son Sydney,* 24
*Goin' to Work* (plate 26), *112*
*Gupas* (plate 104), 30–31, *206*
*Harriet Tubman* (plate 53),
    64, *152*
*The Hevens, Tunquén, Chile*
    (plate 83), *177*
*History of Early Springfield,* 222
*A Holy Place,* 14 (details), 15
*Incantations* (from *Themba: A
    Life of Grace and Hope* series)
    (plate 44), 65, *137–39*
*Italian Cantos,* 68, 69–71, *70, 71*
*I Touched the Divined* series, *180*
*Journeys,* 223
*Life Along Water Street,* 43, 224
*Life and Times of Momma Hogan
    on the Mississippi Bayou*
    (plates 71, 73), *166*
*Life in the Big Boat* (from
    *Themba: A Life of Grace and
    Hope* series) (plate 49), 75,
    *146–47*
*Luci* (plate 27), *112*
Manuscript Pages, 37, 46, 227
*The Man Who Crossed the River
    with a Fox, a Chicken, and a
    Bag of Grain* (plate 6E), *89*
*Maya Angelou* (from *Unwritten
    Love Letters* series) (plate 108),
    65, *210*
*Muslim Woman, Old City of
    Jerusalem, Sacred Manuscript
    Page* (plate 115), *215*

*My Parents* (plate 17), *103*
*My Sister Sharron* (plate 15), *102*
*New York Homeless Woman
    (Study),* 61, *61*
*Ohio Legislature Enacted the First
    Black Laws,* 64, *64*
*An Old Custom from the
    Blackberry Patch Unwritten
    Love Letter* (from *Unwritten
    Love Letters* series), *28*
*One Day at the Walefare Sitt'in
    Room* (plate 28), 113, *113*
*One Day in 1307 A.D.: King
    Abubakari II, 1985–92,* 74, *75*
*One Day in the History of Brook-
    lyn, New York* (plate 116), *216*
*Orthodox Jew at the Western
    Wall, Sacred Manuscript Page*
    (plate 114), *215*
*Pages in History,* 220
*Passion Songs* (plate 25), *111*
photograph of a homeless
    woman in Rome, *179*
*Poindexter Village* commission,
    Ohio University Baker Center,
    223
*Poindexter Village* series, 220
*Praying Homeless Woman outside
    the Vatican Museums, Rome,
    Italy* (plate 85), 23, *179*
*Presidential Suite* series, 15, 148,
    148–49, 201, 225, 225
*Quilt Meetin'* (*Catchin' Up on the
    Gossip*) (plate 68), *162*
RagGonNons, 15, 22, 30, 39, 54,
    59, 67n3, 84, *84–85, 128,* 227
*Reminiscence,* 218, *219*
*Rev. Martin Luther King Feet-
    Hand Puppet with Person
    Working It* (plate 55), *152*
*Roots Begin with Gorée Island*
    (from *Afrikan Pilgrimage:
    The Extended Family* series)
    (plate 47), 62–63, *144–45*
*Roots Begin with Gorée Island,
    study* (from *Afrikan Pilgrimage:
    The Extended Family* series)
    (plate 48), 62–63, *144–45*
*Sacred Pages* (box) (plate 7), *90*
*Sapelo* (box) (plate 7), *90*
*Sapelo Island Hog Hammock
    Community Quilt* (plate 56),
    60, *153*
*Sapelo Series,* 154, 155, 157, 220,
    221

*Sapelo Walkers: Pogo Hop,
    Crabber, Resting* (plate 59),
    *156*
*Satchel for Debra Priestly,* 27–28,
    *28*
*School Days in Columbus, Ohio*
    (from *Songs for the New Mil-
    lennium* (*Millenium*) series)
    (plate 36), *122–23*
*Seaweed at Tunquén, Chile*
    (plate 82), *176*
*Self* (*Self-Portrait*) (plate 12), *99*
*Self-Portrait* (1958), *218*
*Self-Portrait* (1971), *219*
*Self-Portrait* (1989), *221*
*Self-Portrait* (1993), *222*
*Self-Portrait* (2003–06), *223*
*Self-Portrait with Rabbit*
    (plate 18), *104*
*Sellsville Circus Polkadot School*
    (from *Sellsville Circus* series)
    (plate 76), *170*
*Shepard Community,* 225
*Silences of the Heart* (from *Folk-
    life in Poindexter Village* series),
    55, 57
*Sockman* (plates 34, 34A), 120,
    *120*
*Sojourner Truth* (plate 54), *152*
*Songs for the New Millennium*
    (*Millenium*) series, 43, *122–25*
*A Street Called Home* (charac-
    ters) (plate 29B), *116–17, 117*
*A Street Called Home* (plate 29A),
    *14,* 15, 53, 54–55, *54, 114–15*
*Studies into the Folk Costumes
    of the Blackberry Patch/
    Poindexter Village
    Community, Early 1800–1957*
    (plate 70A–F), *164–65*
*Sue* (plate 16), *102*
*Sunday Afternoon Art Lessons
    with Uncle Alvin* (plate 22), *107*
*Sydney* (plate 20), *105*
*Sydney, 4 yrs, Puerto Rico*
    (plate 19), *105*
*Symphonic Poem,* 38–39, *38*
*The Teachings,* 39, 55, 57, 163, 222
*Themba* (plate 41), *131*
*Themba: A Life of Grace and
    Hope* series, 43, 65, 76, 130,
    132–43, 146–47, 194, 227
*Themba Bears Witness* (from
    *Themba: A Life of Grace and*

Hope series) (plate 43), 76, 134–36

Themba: Healer, Herbalist, Prophet (from Themba: A Life of Grace and Hope series) (plate 42), 132–33

Themba: Sunrise (from Themba: A Life of Grace and Hope series) (plate 46), 142–43

A Tree Grows in Brooklyn (plate 6A), 21, 88

21 Piece Sells Circus Band (from Sellsville Circus series) (plate 77), 170

Uncle Alvin Says . . . in 1200 AD . . . (from Songs for the New Millennium (Millenium) series) (plate 37), 124–25

Untitled (Child and Malcolm X?) (dedicated to Pepo Vitani) (plate 14), 101

Untitled (Exterior doors) (plate 2), 21, 82

Untitled (from Unwritten Love Letters series) (plate 106), 209

Untitled (Lamp) (from Flying Squadron Pencil Tablet sketchbook), 37

Untitled (man and woman on horse) (plate 111), 213

Untitled (man on horse) (plate 111), 213

Untitled (migration) (plate 51), 150

Untitled (Peruvian woman) (plate 87), 181

Untitled (plate 86), 180

Untitled (plate 105), 207

Untitled (portrait from the Clutch of Blossoms series) (plate 65), 160

Untitled (portrait from the Clutch of Blossoms series) (plate 66), 160

Untitled (Portrait of an Arab man) (plate 113), 214

Untitled (table) (plate 7), 90

Untitled (Two Houses) (plate 13), 100

Unwritten Love Letters series, 27, 28, 208, 208–11, 227

Ursel White Lewis—A Clutch of Blossoms, 66, 66

The Vegetable Peddlers (from

Sapelo series) (plate 63), 157

The Village Ceremony Celebrates Ancestors (from Themba: A Life of Grace and Hope series) (plate 45), 140–41

Village of Abu Dius, Market Woman, Jericho, Sacred Manuscript Page (plate 112), 214

A Way of Life is Slowly Passing Away (from Sapelo Series), 60, 60

Wings for Our Ancestors; The Slaves who Labored and Built the Nation's Capital in Washington, D.C. (from the Presidential Suite series) (plate 50), 148–49

See also home studio; Robinson, Aminah Brenda Lynn, books; Robinson, Aminah Brenda Lynn, journals and memoirs

Robinson, Aminah Brenda Lynn, books, 62

Afrikan Amerikan Women Life & History, 66

I Touched the Divined, Journey to Peru (plate 88), 182–83

James Preston Poindexter 1819–1907, 62, 62

Life and Times of Momma Hogan on the Mississippi Bayou (plate 72), 166

Music Score, Book of Revelations accordion book cover (from Presidential Suite series) (plates 100A, 100B), 39, 75, 201

Nightmare of Horrors: The Atlantic Slave Trade (from Dad's Journey series) (plate 38), 64, 76 (detail), 127

Pages in History, 28–29

Pages in History, John T. Ward, 29

Poindexter Village Ragmud Collection (plate 99), 200

Ragmud Collection, 200

A Street Called Home, 15, 114, 117, 222

The Teachings (cover) (plate 69), 39, 163

Uncle Alvin Says, Thorn Alley (plate 110), 212

See also Robinson, Aminah Brenda Lynn, journals and memoirs

Robinson, Aminah Brenda Lynn, journals and memoirs, 35–46,

96, 185, 185–99

The Afrikan in the People's Square (from A Spirit of My Soul journal) (plate 96), 196

Afrikan Journal (plate 90), 44, 186

Back to Dadda (from Poindexter Village As I Walk . . . journal) (plate 95B), 22, 53, 193

Bedouin Woman Stringing Beads (from Jerusalem Studies Sacred Pages journal) (plate 92A), 189

A Day in the Streets of Old Jerusalem (from Sacred Pages, Israel Journey journal) (plate 91A), 44, 188

First Art Studio (from Poindexter Village As I Walk . . . journal) (plate 95A), 192

The Healing Rite (from Poindexter Village As I Walk . . . journal) (plate 95D), 195

Inner front cover of In this Field, 39

Jerusalem Studies Sacred Pages (plate 92), 189

Looking Back into the Future (from Afrikan Pilgrimage: The Extended Family journal), 44

March on Washington, 41

Offerings (from an untitled journal), 34

Palace of the Oba (from Afrikan Journal) (plate 90A), 44, 187

Poindexter Village As I Walk . . ., 22, 46, 46, 52, 53, 192–95

Sacred Pages, Israel Journey (plate 91), 44, 188

17th and Mt. Vernon (from Timelessness of Life journal) (plate 89), 185

Sitting in the small Poindexter Village Kitchen (from Uncle Alvin Stories journal) (plate 98C), 199

Strawberry Picker (from Quilt of Humanity journal), 39

Symphonic Poem, My Constant Companion, Studies, Doll House Story journal cover (plate 94), 191

Themba's Gift (from Poindexter Village As I Walk . . . journal) (plate 95C), 43, 194

To my children . . . (from the March on Washington journal) (plate 93), 41, 190

Umbrellaman (plate 94A), 191

Uncle Alvin Says (from Uncle Alvin Stories journal) (plate 98B), 42, 198

Untitled (Ethiopian Village Priest) (from the Journey to the Holy-land journal), 45, 45

Untitled (from Poindexter Village As I Walk . . . journal), 46

Untitled (Penetration) (from Afrikan Pilgrimage: The Extended Family journal), 42

Welfare Drawings (Puerto Rico) (from an untitled journal), 36

Woman Artisan of Chincheros, Peru (from I Touched the Divined . . . Journey to Peru journal) (plate 97), 197

See also Robinson, Aminah Brenda Lynn, books

Robinson, Clarence, 40, 43, 105, 219

Robinson, Helen Elizabeth Zimmerman, 52, 66, 86, 153, 198, 199, 218, 222

Robinson, Leroy, 36–37, 42, 44, 52, 53, 76, 86, 130, 153, 193, 218, 220
Untitled, 52

Robinson, Sandra Sue, 102, 218

Robinson, Sharron Elizabeth, 102, 218

Robinson, Sydney, 15, 23, 27, 43, 105, 219, 219, 220, 222

Roth, Moira, 63

S

Saar, Alison, 66
Nocturne Navigator, 64–65, 65

Sankofa, 21, 21, 31, 59, 63, 86

Sapelo Island, Georgia, 21, 42, 43, 60, 134, 153, 220, 222

Saturday School, Columbus Art School, 13

Schomburg Center for Research in Black Culture, New York City, 27–28

Sells Brothers Circus, 171, 221

Seventeen Magazine, 218

Sharpe, Christine, 31

Shepard neighborhood, Columbus, Ohio, 16, 21, 82, 219, 225, 227

Shostakovich, Dmitri, Symphony #6, 38

Simmons, Xaviera, One Day and

Back Then (Sitting), 59, 59, 63

slavery, 29, 35, 36, 39, 42, 43, 45, 59–60, 62–64, 75–76, 128, 143, 144, 148, 151, 163, 167

Songs for a New Millennium, 1812–2012: Works by Aminah Robinson Celebrating Columbus200 (exhibition), 15

Spirituals, 39, 163 (plate 69)

studio. See home studio

Studio Museum, Harlem, New York, 27

Stull, Bettye, 16

Symphonic Poem, 38–39

Symphonic Poem: The Art of Aminah Brenda Lynn Robinson (exhibition), 15, 83, 216, 223

T

Terrell, Mary Church, 66

Thomas, Mickalene, When Ends Meet (Oprah Winfrey), 65, 65

Themba, 9, 43, 45, 47n39, 60, 65, 76, 227. See also works of art

Thurman, Howard, 76

Toledo Museum of Art, 200

Truth, Sojourner, 152

Tubman, Harriet, 64–65, 75, 152

Turner, Nat, 75

U

Unwritten Love Letter, 27, 28, 208, 208, 209, 210, 211, 221, 227

W

Wahlman, Maude, 77n6

Walker, David, Appeal to the Coloured Citizens of the World, 76

Walker, Kara, 63, 66
Gone: An Historical Romance of a Civil War as It Occurred b'tween the Dusky Thighs of One Young Negress and Her Heart, 63, 63

Ward, John T., 29

Wheatley, Phillis, 66

William, Mary Ann, 220

Williams, Pat Ward, 66

Wilson, Edward, 36

Wordsworth, William, 35

Z

Zimmerman, Alvin, 42–44, 47n38, 76, 125, 151, 198, 199

Published in conjunction with the exhibition *Raggin' On: Aminah Brenda Lynn Robinson's House and Journals*, Columbus Museum of Art, Ohio, curated by Carole M. Genshaft and Deidre Hamlar

LIBRARY OF CONGRESS CATALOGING-IN-PUBLICATION DATA
Names: Columbus Museum of Art, author. | Genshaft, Carole Miller, editor.
Title: Raggin' on : the art of Aminah Brenda Lynn Robinson's house and journals / edited by Carole M. Genshaft, essays by Ramona Austin, Lisa Gail Collins, Lisa Farrington, Carole M. Genshaft, Deidre Hamlar, Nannette V. Maciejunes, William "Ted" McDaniel, Debra Priestly.
Description: Columbus, Ohio : Columbus Museum of Art, 2020. | Includes bibliographical references and index.
Identifiers: LCCN 2020012328 | ISBN 9780578687360 (hardcover)
Subjects: LCSH: Robinson, Aminah Brenda Lynn—Exhibitions. | Columbus Museum of Art—Exhibitions. | Art—Ohio—Columbus—Exhibitions.
Classification: LCC N6537.R5738 A4 2020 | DDC 709.2—dc23
LC record available at https://lccn.loc.gov/2020012328

PUBLISHED BY COLUMBUS MUSEUM OF ART, OHIO
480 East Broad Street
Columbus, Ohio 43215
columbusmuseum.org

PRODUCED BY LUCIA | MARQUAND, SEATTLE
www.luciamarquand.com

Edited by Elizabeth Hopkin
Assisted by Jordan Spencer
Image production by Nicole Rome

Designed by Thomas Eykemans
Typeset in Ideal Sans by Tina Henderson
Proofread by Bruno George
Indexed by Dave Luljak
Color management by iocolor, Seattle
Printed and bound in China by Artron Art Group
Distributed by Ohio University Press

Greater Columbus Arts Council

Nationwide Foundation

THE COLUMBUS FOUNDATION

Ohio Arts COUNCIL

NATIONAL ENDOWMENT for the ARTS
arts.gov

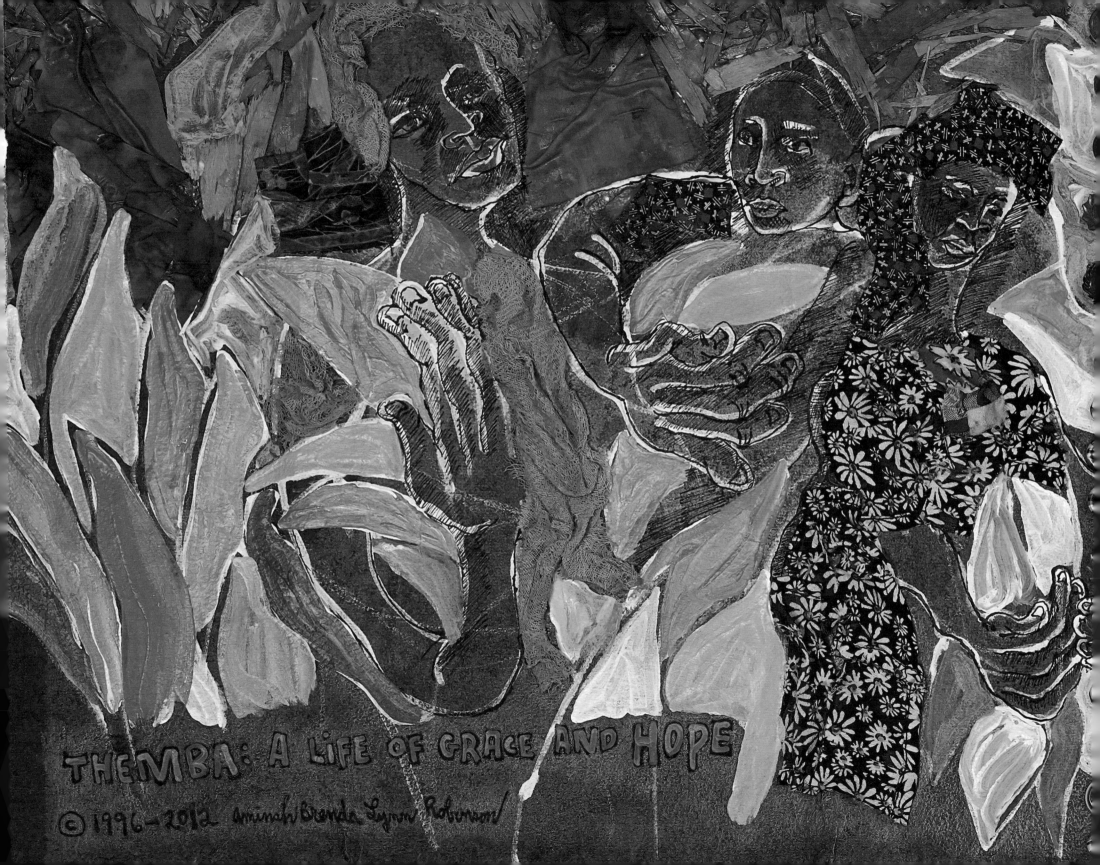

THEMBA: A LIFE OF GRACE AND HOPE

© 1996–2012 Aminah Brenda Lynn Robinson

THE VILLAGE CEREMONY CELEBRATE THE ANCESTORS